VANISHING IRELAND

Recollections of Our Changing Times

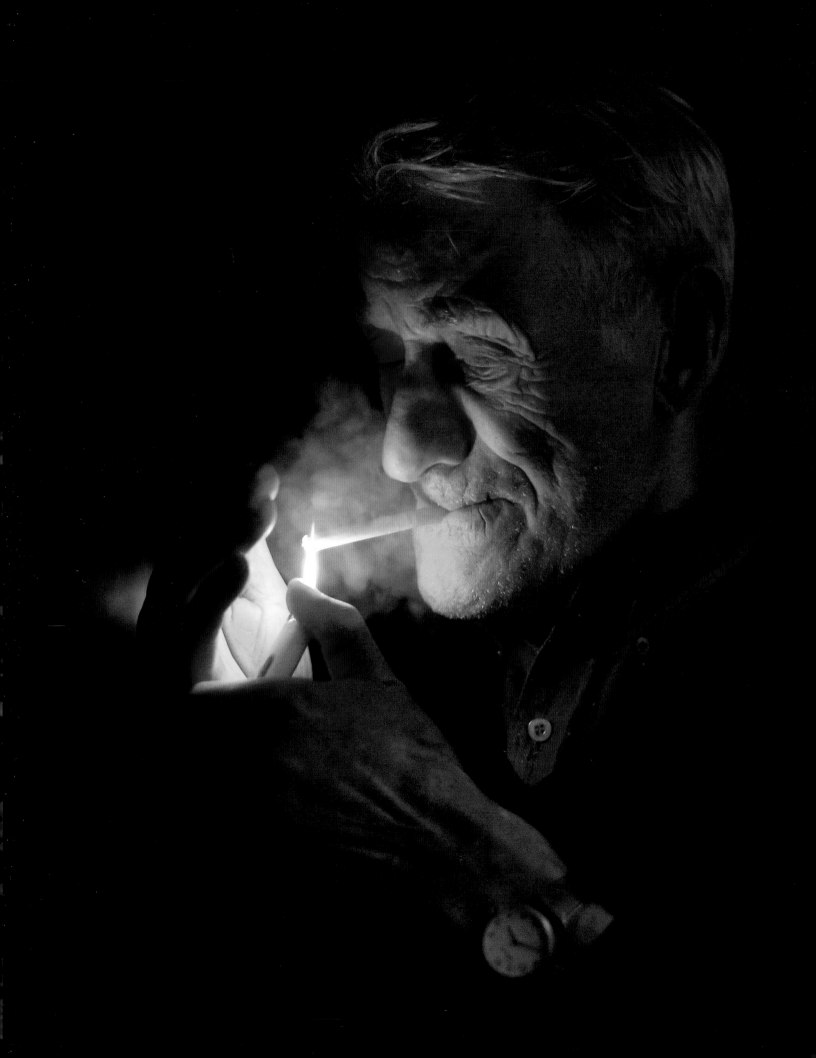

VANISHING IRELAND

Recollections of Our Changing Times

JAMES FENNELL AND TURTLE BUNBURY

HACHETTE
BOOKS
IRELAND

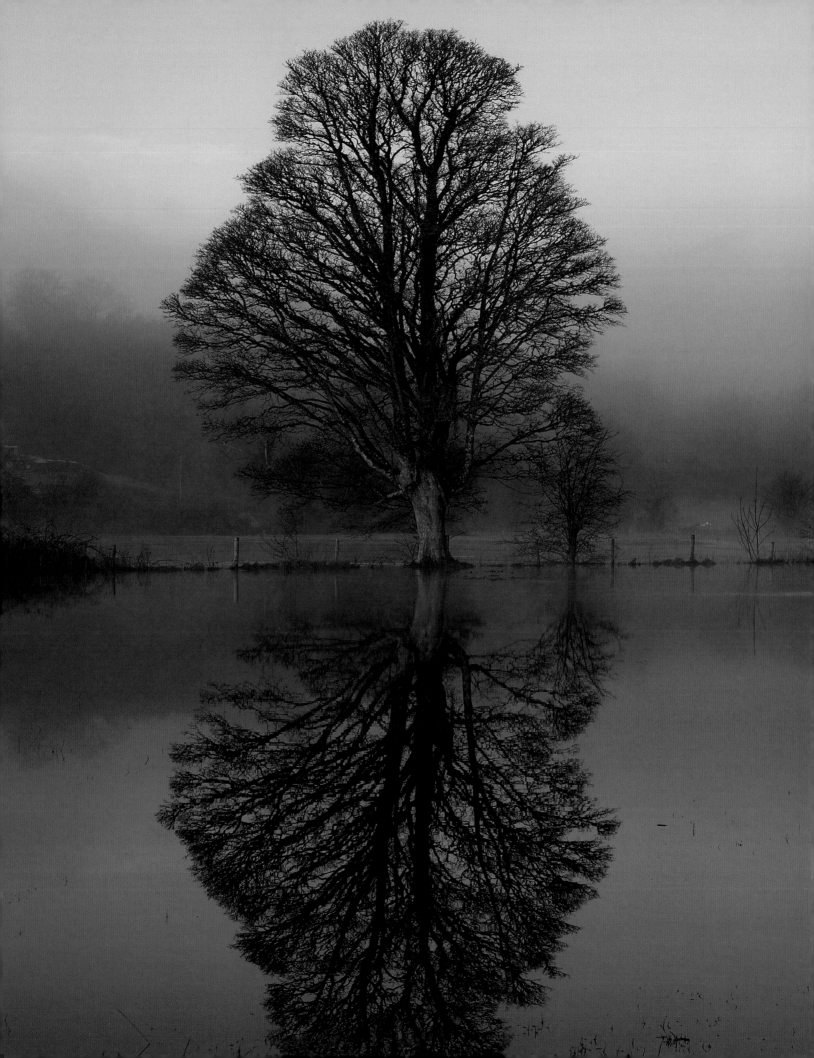

This book is dedicated to the memory of
Johnny Golden (1937–2010)

And we would also like
to applaud the remarkable Anastasia Kealy
who celebrated her 108th birthday in July 2011

Copyright © 2011 photographs, James Fennell
Copyright © 2011 text, Turtle Bunbury

First published in 2011 by Hachette Books Ireland
An Hachette UK Company

1

A CIP catalogue record for this title is available from the British Library.

ISBN 978 1444 733051

Typeset in Garamond by Anú Design, Tara
Cover and text design by Anú Design, Tara
Printed and bound in Italy by L.E.G.O. Spa

Hachette Books Ireland policy is to use papers that are natural, renewable and recyclable products and made from
wood grown in sustainable forests. The logging and manufacturing processes are expected to conform to the
environmental regulations of the country of origin.

Hachette Books Ireland
8 Castlecourt Centre
Castleknock
Dublin 15
Ireland

A division of Hachette UK, 338 Euston Road, London NW1 3BH, England

Contents

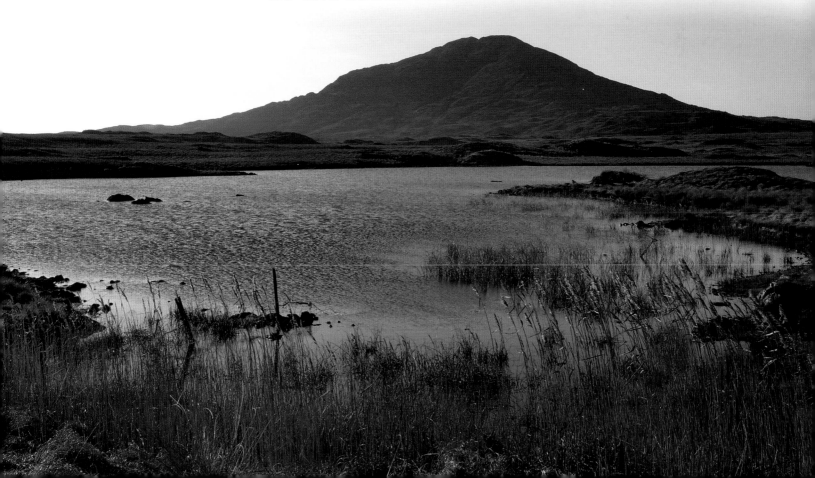

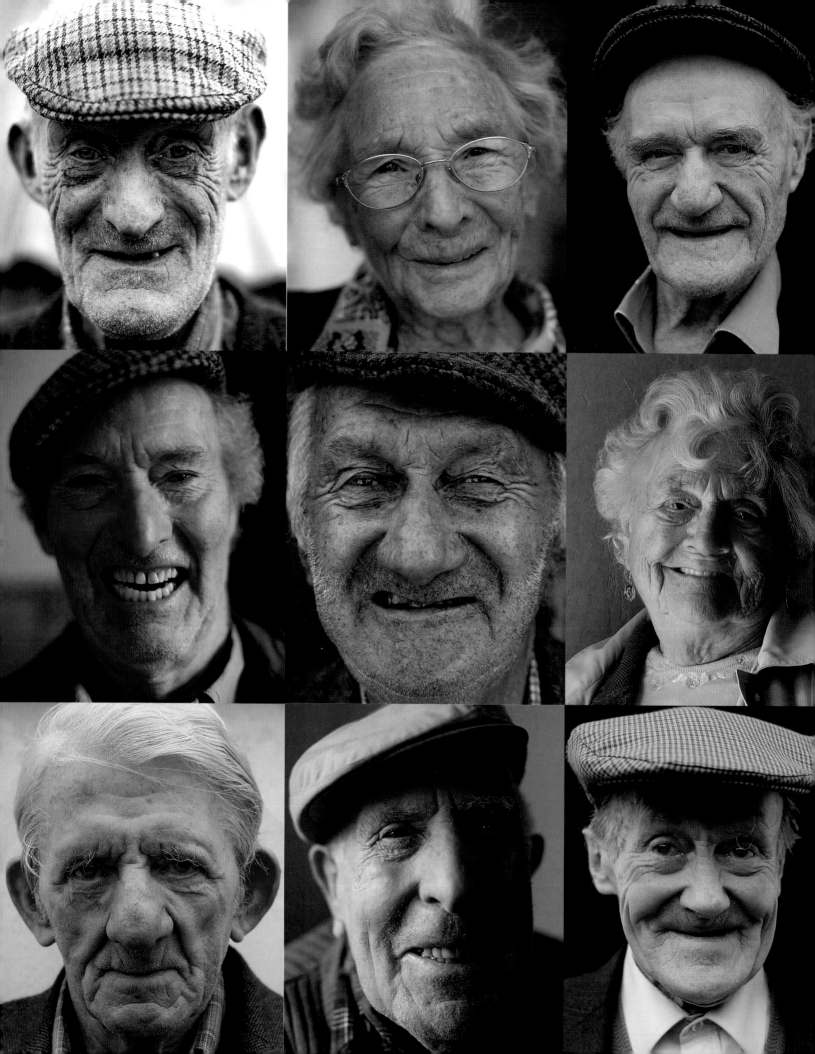

Introduction

Many years ago, when the *Vanishing Ireland* project was in its infancy, I found myself alone in a rural pub in County Meath. My eyes were drawn to a cloth-capped senior citizen, clad in a crumpled green suit, with an impeccably ancient face. I nod-winked at the old man, wished him a good evening, took out my little black notebook and began scribbling a few observations on life.

'Writer, are ye?' asked the old man.

'That sort of thing,' I confessed. 'I'm a historian.'

'I'm a great fan of the Long Fellow,' said he gruffly.

'Ah yes, the Long Fellow,' I replied, with a conspiratorial smile, just to let him know that I was aware that Éamon de Valera was blessed with that elongating moniker.

The old man looked at me directly, cleared his throat and spoke: 'Skilled in all the craft of hunters, learned in all the lore of old men, in all youthful sports and pastimes, in all manly arts and labours.'

'Um, yes,' I replied uncertainly. 'I guess he was.'

'Swift of foot was Hiawatha,' he continued. 'He could shoot an arrow and run forward with such fleetness that the arrow fell behind him.'

'Hiawatha' was the giveaway, of course, and soon the old man, a farm labourer, was telling me how, as well as the Long Fellow, he also greatly admired the poetry of Tennyson, Byron and Thomas Moore.

The Irish have always had an extraordinary empathy for language, its convolutions and its nuances. In these pages a County Clare farmer employs extraordinary dialogue in his off-the-cuff chronicles, while a County Carlow native becomes so absorbed in storytelling that he practically metamorphoses into his cast of characters, adopting personas and dialects without missing a millimetre of detail.

We also meet with a roadside ganger, whose parents who could neither read nor write, and yet his father was a brilliant old world storyteller. Music was never far away as we hear tales of waltzing, ceilidh and all-night sessions [sic] in Connemara.

In the era before cars and televisions, most people lived an outdoor life, rising with the dawn, working in the fields, strolling the roads, always in tune with both the landscape and the weather. The people we have

met during this project have invariably been hardy and healthy. This undoubtedly stems from their childhood where, without exception, they walked – and, in several cases, rowed – to and from school.

Horses, ponies and donkeys had been the backbone of rural Ireland for thousands of years. On the farms they ploughed fields and carried turf. They transported people on carriage and cart. They hauled goods along rail, road and canal. All that came to an abrupt end with the invention of hydraulics and the combustion engine. When the Fordson New Major tractor arrived in Ireland in the 1950s, no farmer could ignore its claim to have the power of 45 horses. Some mourn the passing of the horse and the onset of the mechanical age. Certainly it presented blacksmiths with a challenge when people stopped bringing their horses to the forges. But the enterprising reacted accordingly and turned to making gates, fences and machinery instead. Saddlemakers, likewise, adapted to making belts and luggage straps while clockmakers saw their future prospects diminish as computerised and vulcanised models replaced the tick-tock cogs and wheels of old.

The prospects for anyone who grew up in the early decades of independent Ireland were always limited. The island continued to be one of the poorest countries in Europe in the 1950s and, aside from those involved with the rural electrification scheme, it was a time of glum despair. De Valera once hoped Irish firesides would become 'forums for the wisdom of serene old age' but many of the younger souls who might have sat and listened had instead emigrated. England topped the list of destinations as hundreds of thousands crossed the Irish Sea to work in shops, factories, breweries and on building sites.

For most of those we interviewed, there is still a wistful innocence about childhood days when boys messed about with horseshoes, marbles and cards, while girls played hopscotch on the street. Some maintain that despite the poverty, people were happier back then; others maintain that life is much more enjoyable today. All seem to think the end of the Celtic Tiger and the onset of a recession was a useful wake-up call for a country that had lost the run of itself.

It is tempting to think that the older generations were somehow better immunised against the inevitable sorrows of life than ourselves. Many of those interviewed for this book grew up in an era when warfare and deadly epidemics blighted the land. A little 21st-century recession seems like small fry in comparison. But melancholy is a relative emotion, its depths hard to grasp.

There is always humour too. We have dedicated this book to Johnny 'Gouldy' Golden, a wonderful character who featured in the second volume of the 'Vanishing Ireland' series. While Gouldy's dreadful murder in 2010 remains a source of great sadness to all who knew him, stories from his life continue to entertain his friends. One such anecdote concerns a failed attempt by three Catholic missionaries to convert the famously oil-covered Protestant mechanic. 'They were trying to convert Gouldy?' chortled a neighbour. 'To what? Diesel?'

I have long ago lost track of how many times James Fennell and I have criss-crossed Ireland to meet the people who feature in these books. I close my eyes and I see a kaleidoscope of turf piles, white swans, long grass, rich blue lakes, craggy rocks, squelchy bogs, wicked black crows and deserted villages. But above all I see the faces, because they have been immortalised in photographs and I see them again and again.

The people whom we have photographed and interviewed for this book were, without fail, inspirational and charming to talk with. They opened their doors and filled us with biscuits, tea and, on occasion, eye-watering spirits. They told us of their lives, their highs and their misfortunes, their ancestors and their descendents. I cannot overstate what a joy it is to become so well acquainted with the past and to hear such stories first hand. It is our hope that the words and photographs that follow will convey our ongoing passion for this project. We also urge all readers to take a moment to think of old timers whom they know and to phone them or meet up for a chat about days gone by.

Turtle Bunbury

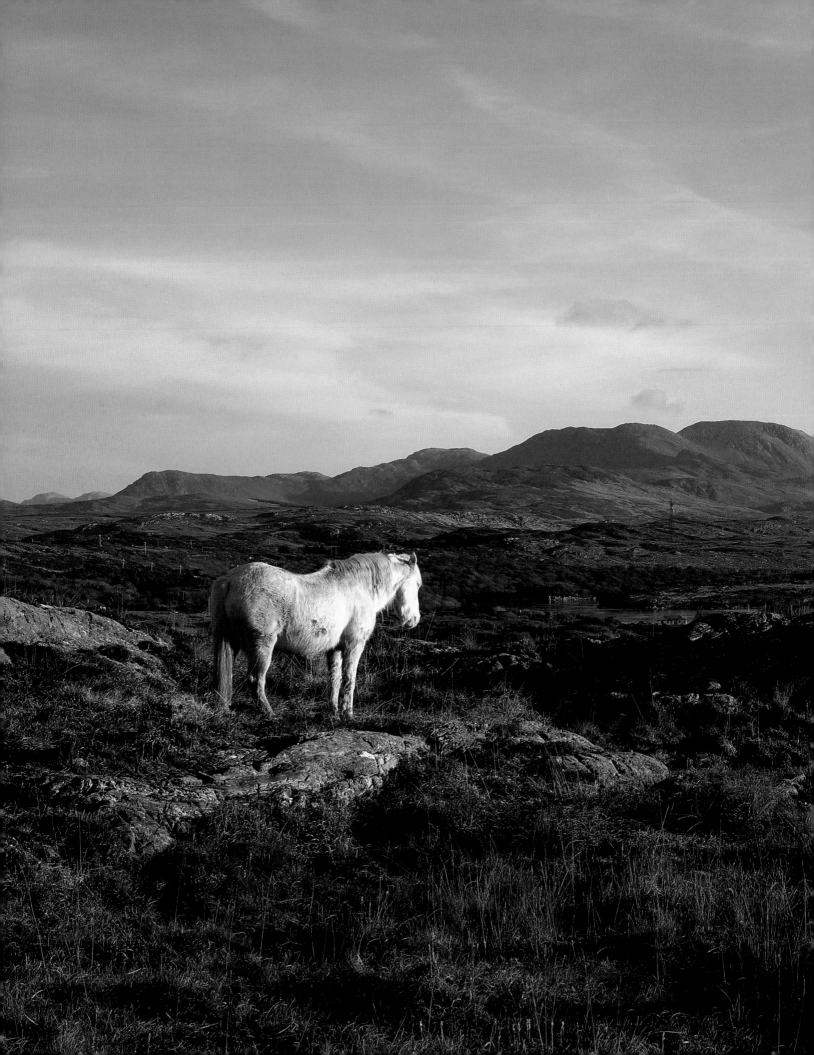

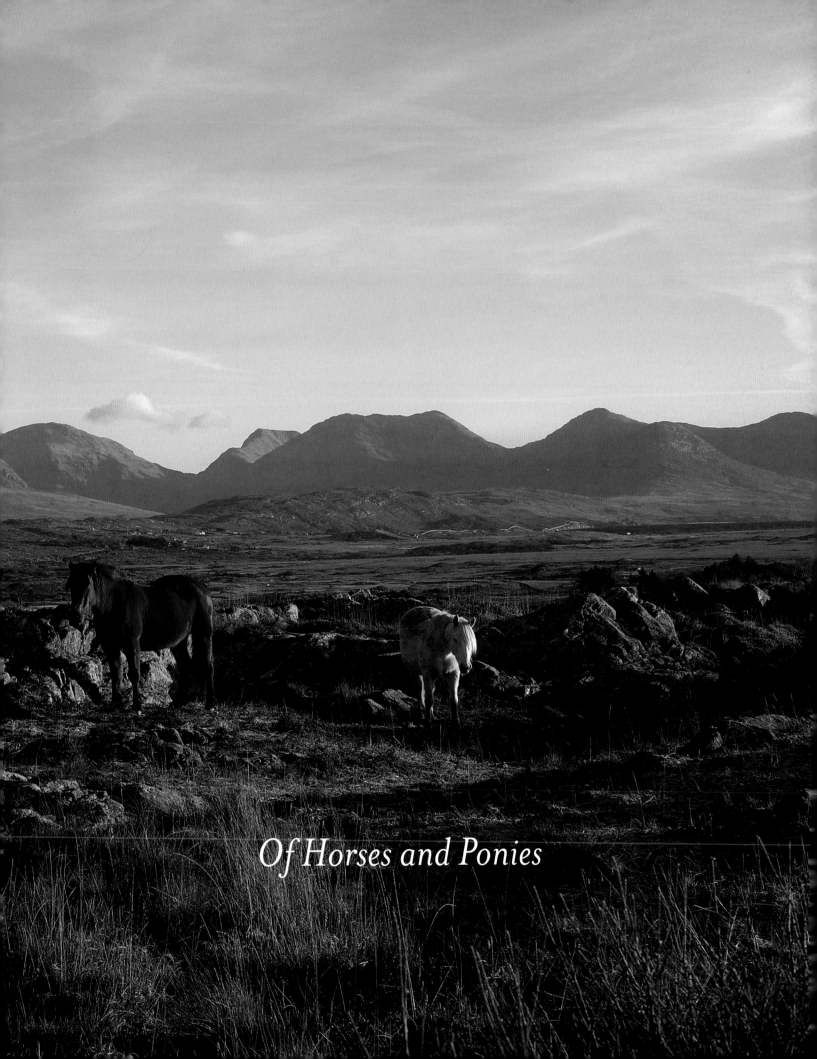

Of Horses and Ponies

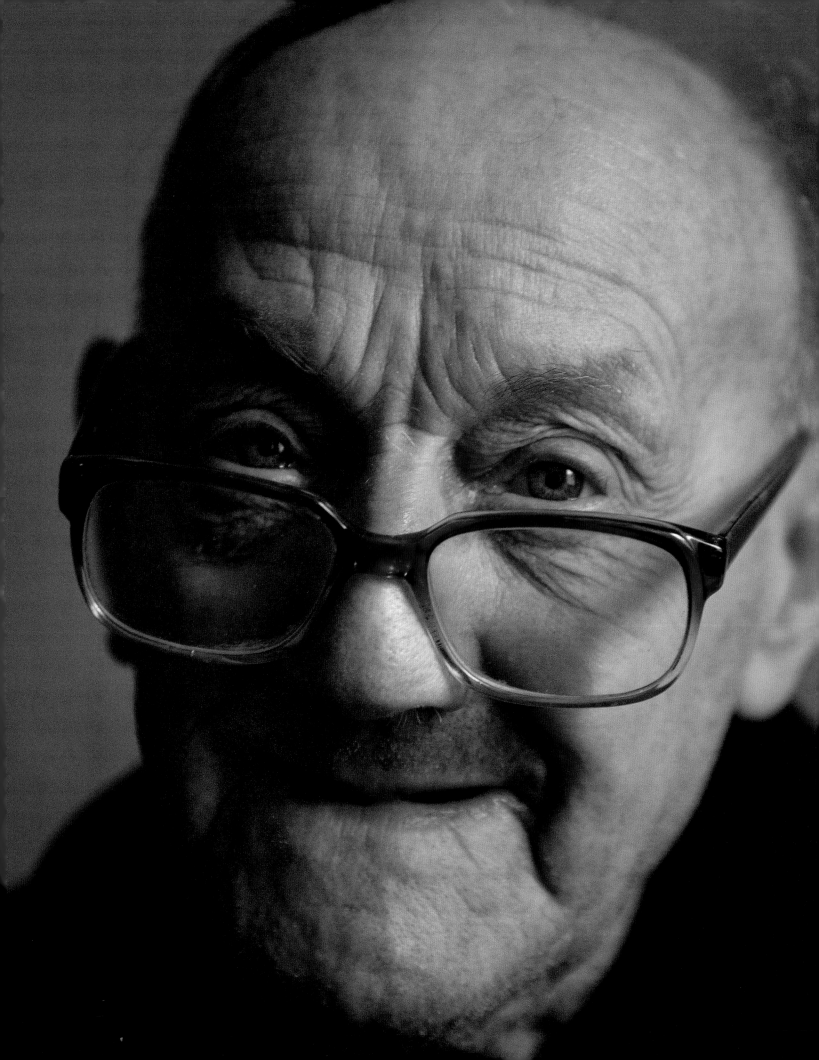

Aidan 'Ogie' Nolan

Enniscorthy, County Wexford

Saddler & Harness Maker

Born 1922

Ogie Nolan crouched beneath the speaker's platform and watched with mounting astonishment as more and more Blueshirts piled into Enniscorthy's Market Square. It was the summer of 1932, just a few months after de Valera's Fianna Fáil party had swept to power and launched Ireland into the Economic War with Britain. 'Burn everything British except their coal,' laughs Ogie. 'That was the motto.' But Ireland was by no means a country at peace with itself and, as Ogie recalls, there was 'a lot of old trouble with politics at that time'. The Blueshirts were a quasi-militant organisation opposed to de Valera. Ogie was all set to watch the whole rally when, from nowhere, his mother's hand appeared, 'caught me by the ear and brought me home'. The Nolans lived above a sweet shop on Weafer Street at the time and Ogie remembers the sound of his mother slamming down the shutters. 'I wondered why she did that, but the Blueshirts come up Weafer Street and got halfway up when a crowd of Sinn Féiners with stones came down from the top. They met and the stones flew. Somebody had warned my mother!'

As he rolls into his ninetieth year, Ogie Nolan is showing no signs of letting up. His stern countenance and gruff tone belie a man who adores keeping abreast of the happenings in his town, of the ins and outs of local politics, and of the opportunities to throw his colourful opinion into the mix.

He is not a man without influence. Indeed, his very birth brought the Irish Civil War to a brief halt. Well, in Enniscorthy at any rate. He was born on the east side of the river on 29 March 1922. His twin sister died at birth and Ogie's father was eager to bring his wife and baby son back to their home on the town's west side. With the war between the Free Staters and de Valera's Irregulars still raging across Ireland, Bridget Nolan and her baby son were given safe passage across the River Slaney under a white flag of truce.

'My mother's family were a rebel crowd,' says Ogie. 'Her house was a safe house during the 1916 Rising and she always said that two of her great-uncles were hung during the '98'. They were all Fenians that time. No matter what Irish person you met, if you went deep enough, they were all Fenians.'

Under some roofs, Enniscorthy still reverberates with the revolutionary zeal that inspired so many of the town's population to take on the might of the British Army in the summer of 1798. When a 20,000-strong rebel army gathered on the slopes of Vinegar Hill, which overlooks the town, the Redcoats began shelling

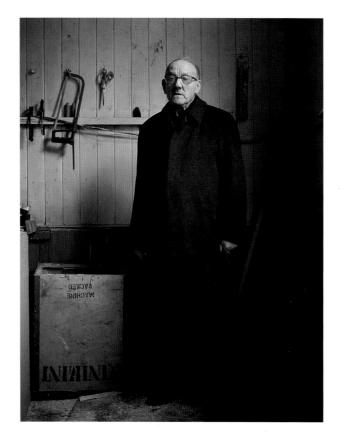

them from all sides. As the rebel army broke and fled, the British cavalry cantered after them, their razor-sharp swords gripped firm and ominous. Nearly a thousand people died that grim summer's day, including many women and children.

As such, it's not surprising that the inner walls of so many buildings in the town are bedecked with images of the heroes of '98, and of those who carried the Republican torch through to the awkward triumph of 1921. Established in 1922, Enniscorthy's Catholic Working Men's Club is one such place. The club, of which Ogie is secretary and treasurer, once boasted a membership of 140 working-class men from the town. Largely unused today, its big, empty old rooms echo with the past. The click of a Bakelite switch. The crackly purr of a Romus heater. The clatter of a shilling coin dropping into the electricity power box. The fizz of the strobe lights blinking overhead. The thwack of ivory balls shooting across green felt. The cackles, the jibes, the tall tales and the hushed whispers rebounding around the shadowy corners.

The Nolans, Ogie's father's family, were saddlers in Borris, County Carlow, for many generations. 'Or "wax arses" as we used to call them,' says Ogie. His great-grandmother was housekeeper in Borris House to Arthur McMurrough Kavanagh, MP for Carlow, famed across Europe as 'The Incredible Mr Kavanagh'. Born without arms or legs, this extraordinary gentleman learned how to write, paint, fish, shoot and ride horses. At the age of twenty-two, he made an overland horseback journey from Norway to southern Iran, then sailed to Bombay and spent six months, strapped into his saddle, working as a dispatch rider. A prominent member of the Carlow Hunt, he was often to be seen leaping over the high walls and grassy banks at the same pace as any other rider. Mr Kavanagh's tailor-made saddle chair is still to be seen in Borris House today.

Michael Nolan, Ogie's father, was born in 1885, and was initially employed as a saddler to Mr Kavanagh's grandson, Major Dermot McMurrough Kavanagh. In 1911, Michael married Bridget Shiel, a coachman's daughter from Templeshannon, or 'the Shannon', on the east side of Enniscorthy. Shortly after the wedding, the couple moved to Enniscorthy where Michael began working for James Donohoe, the manufacturer of Star Mineral Water. 'Well, he wasn't a month in Donohoe's when the place went on fire, so he started up his own saddle and harness workshop then,' says Ogie.

Ogie, the third of Michael and Bridget's seven children, was christened Aidan after St Aidan, the founder of the monastery on the island of Lindisfarne for whom Enniscorthy's cathedral is named. As a nod to his mother's father, Moses Shiel, he was also given the name 'Mogue'. 'Mogue changed to Oge and that's what the Christian Brothers called me. Then other young lads put the "gee" on it. Whenever I won at poker, they'd say, "Ogie is the Bogey."'

One of Ogie's earliest memories is from 1927 when Enniscorthy 'filled up with men', mostly German, 'putting up the poles and the lights all over town'. Shortly afterwards, he began his schooling with the Christian Brothers, or 'the Black Marauders' as he calls them. 'Ah, they were all right. I was as big a cur that ever went to a Christian Brother School. I was a pup and anything I got I deserved. There were a few bad cases and there was abuse going on, but that was all kept under cover. Ninety-nine per cent of them was good people. They had to be very good to teach us!'

In 1940, aged seventeen, Ogie left school to join Nolan & Sons as a harness maker and boot repairer. Every July, he and his father returned to Borris to restore all the riding tackle and saddleware for Major Kavanagh's hunting horses and polo ponies. From a workshop in the farmyard, they also repaired the harnesses for the fourteen work horses. One day, Ogie was in the workshop when a thin, slightly balding American appeared in the doorway holding a golf bag with a rip down one side. Michael twitched his head in Ogie's direction and suggested the young fellow could maybe do something with it. Ogie duly stitched the bag up but when the American came back for it the next day, he failed to leave any payment. When the Major asked how he got on with the bag, Ogie said that he had fixed it 'but the American gave me nothing for it'. Major Kavanagh deftly produced a pound from his wallet and said, 'That's for helping Fred Astaire.'

'I knew I knew the man but I just couldn't put a name on him,' says Ogie.

Ogie was particularly intrigued by the Kavanaghs' babysitting practices. The workshop stood near a square lawn at the back of the house. One day, 'the nurse came out, put a baby child on the square, left it out there and off she went. I thought, well that child is going to crawl away. But the next minute a sheepdog come up. The babba started to creep off and the sheepdog caught it by a catch on the back and brought it into the middle again. That happened fourteen or fifteen times. I was fascinated.'

During the Second World War or 'the Emergency', Ogie served with the Local Defence Force. 'They gave us a gun with a bayonet, but very few bullets,' he laughs. 'It was quiet enough but there was a few scares. Mr

Churchill and de Valera didn't get on and you never knew who you might have to fight. An awful lot of Irish were pro-German.'

In 1945, Michael Nolan relocated the business to a roomy warehouse on Weafer Street, the walls of which are still lined with Irish tricolours and portraits of Michael Collins and Robert Emmet. During the late 1960s, the Enniscorthy Dramatic Society was based in this same room. But while Ogie is a drama enthusiast, he says he is no thespian. 'I never acted anything but the fool.'

At their peak, the Nolans employed fourteen men. As well as making and repairing harnesses and saddles, they manufactured belts, dog collars, luggage straps and shoes. 'I was often in Dublin buying leather, rubber and all that,' he says. 'We also did a lot of work for the Travellers, making harnesses mostly.'

In 1980, Ogie retired after forty-two years in the business. He remains a well-known sight in the town, not least amongst the card-playing community as this wily soul is both a founder member of the Enniscorthy Bridge Club and a Bridge Master. Cards have taken over from his other great passion, swimming. In his younger years, he and his friends often stopped to swim at the 'Headwire', or head weir, on the River Slaney. One gorgeous blue-skied afternoon, when the riverbanks were smothered in blackberries, he found himself alone at the weir. 'So I went in for a swim with no bathing togs.' To his considerable surprise, the wife of a well-to-do Wexford gentleman appeared out of the bushes and, claims Ogie with defiant octogenarian vigour, she remarked, 'By God, Ogie, you're a fine man stripped.' He stresses that there was no Lady Chatterley-like conclusion to the occasion.

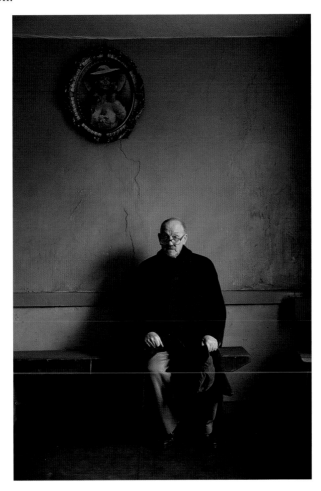

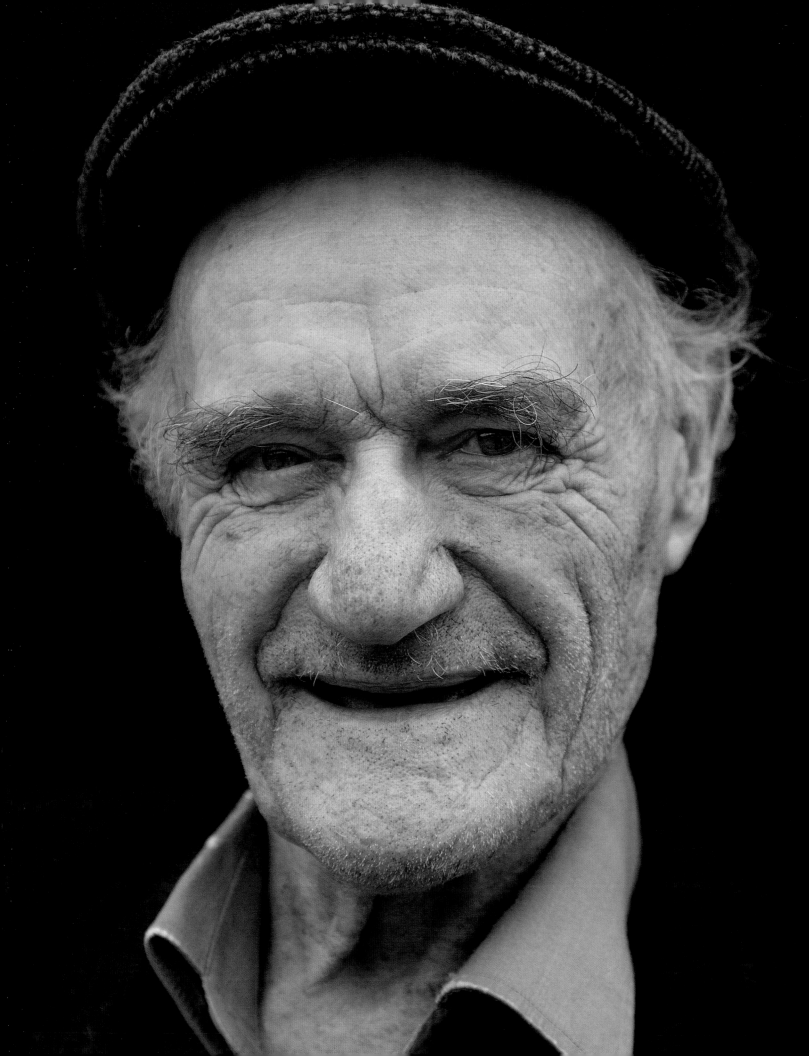

Sam Codd

Aughrim, County Wicklow

Bonesetter, Farmer & Horse Breeder

Born 1926

Should you ask Sam Codd what a bonesetter does, he is quite likely to suggest that you throw your leg up on a stool so he can break it and then show you how to set it again. 'If a leg is broke,' he explains, 'I put a splint on it, tie a bandage around and put you in plaster of Paris. The bone will fix then.'

He learned the skill from his father. 'He used to set bones and I'd be tinkering around with him.' At length, he began bonesetting himself and 'then one lad would tell another' so that before long, 'they started to come here from all over the country'.

'In cattle you have to leave the bone in plaster for about six weeks. In sheep, it's a little less, about a month. But it's hard to set a horse's leg unless they are under five years old. A horse has no marrow in his bone. The day a horse is foaled, its leg is as long as it ever will be. It never grows anymore but it thickens up. If you look at a horse the day it's foaled, there's a certain place to measure, from the point of the shoulder to the fetlock. Turn that up and that's the height he will be when he's done growing. It's curious of them, isn't it?'

Horses have been a massive part of Sam's life since he acquired a stallion pony at the age of twelve. His home, Granite Lodge Stud, is well known in equestrian circles as 'The home of Sammy's Pride', referring to the sturdy stallion that Sam bought as a foal and stood at the stud for many years. 'He has foals and fillies all over the place! One went to England and won Horse of the Year three years running.'

Sam was also famed for the manner in which he trained his horses upon the hilly meadows rolling around his home. He was often to be seen exercising them in his blue trap, pulling at his braces, tipping his cap at passers-by. He also farmed the land with his horses. 'Now it's all tractors and pressing buttons but in that time everything was done with horses, working and walking alongside them all day, ploughing, harrowing, raking hay and everything.' Sam continued to work his horses after he 'got a tractor, same as everyone else'. But eventually he conceded defeat and gifted his last two mares to his daughters.

He has a handful of well-thumbed photograph albums in which his beloved equines graze, jump and occasionally dance. 'Anything I asked that lad to do, he'd do,' he says of one trusty steed. 'If I told him to lie down, he lay down. If I told him to roll, he'd roll. I told him to stand on his hind legs and he done that too.'

Sam was born and reared in Ballysallagh, near Hacketstown, County Carlow, on a farm which his

brother now runs. 'My people were there six or seven generations', he says. His father William Charles Codd married Susan Hawkins, a farmer's daughter from Killybeg on the western slopes of Keadeen Mountain. Susan's grandfather was a rugged Protestant mountain farmer called Sam Hawkins who married twice. He had twelve children by his first marriage and thirteen by the second. 'It wasn't just Catholics who had big families,' concludes Sam. 'At one time, I had forty-eight first cousins and forty of them were living around the Glen.'

Sam was the youngest of William and Susan's children. 'You could say I was reared on goat's milk,' says he, referring to a pocán (goat) he owned from an early age. 'I always had goats.'

He left his school in Hacketstown shortly before his fourteenth birthday to help an elderly neighbour with the harvest and threshing. 'And I was never short of a day's work after that,' says he. He always made sure he earned his keep. 'If you didn't mind your job, you'd get a kick in the arse on a Saturday night and someone else would be in on Monday morning. You can't sack anyone like that now – you have to give them redundancy!'

Days were long and there wasn't much to do in the evenings. 'You might sit by the fire and that'd be it. Next thing, you'd get up in the morning and go back to work. We didn't go to the pub at all really. There might be an odd card game or something in a farmer's house. And there used to be dances after the threshing. They were great auld craic. I remember one lad, a fecker for doing tricks, who wasn't asked to the dance. So he got a ladder up to the house and threw a grain sack over the chimney and smoked out the people inside. He said, "They asked me to the threshing, but they didn't ask me to the dance."'

In 1945, a bachelor cousin of his father passed away and Sam, aged only twenty, 'fell into this place', the 40-acre farmstead on the road to Aughrim where he now lives. The house was thatched at the time but when combine harvesters took over from manual threshers, 'all the straw was broken up so we done away with the good thatching' and went for asbestos instead. In the summer of 2010, 85-year-old Sam replaced the asbestos with proper slate.

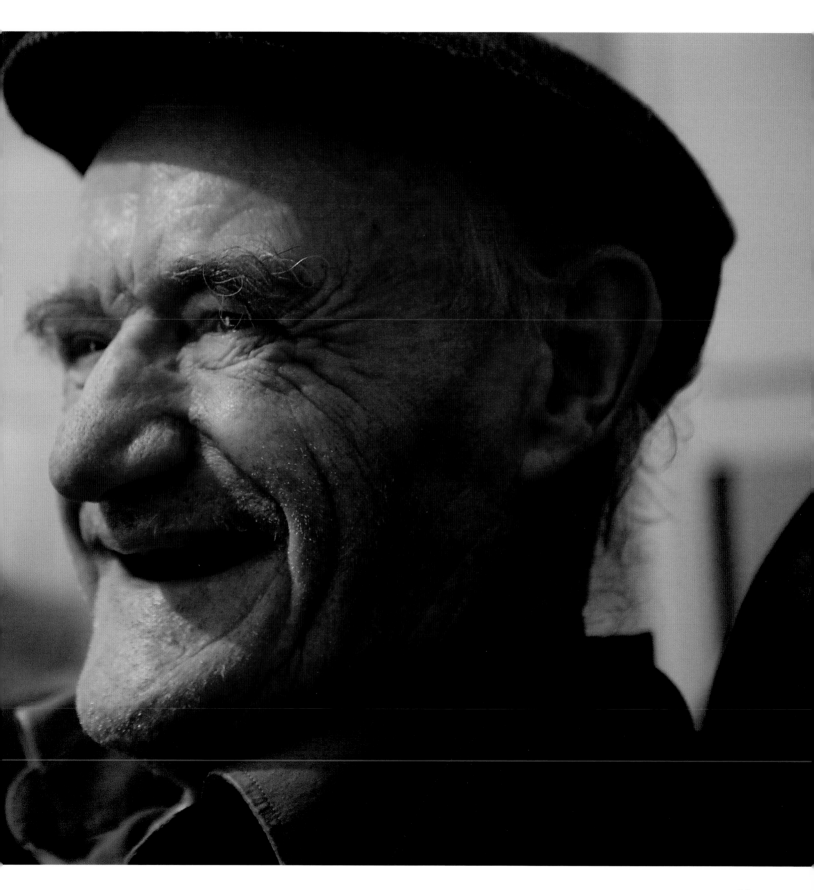

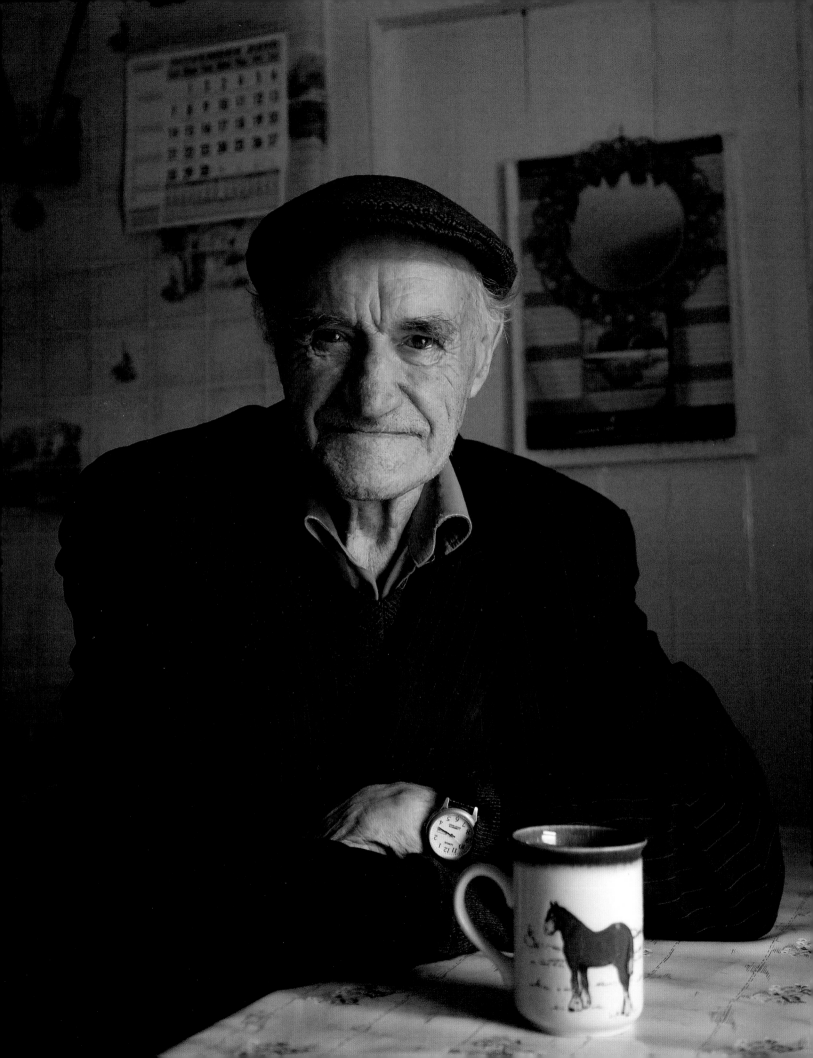

'You had to be very fit to farm,' says he. 'That's why I'm so fit still. I was never sick in my life. We used to be up at six o'clock every morning and to bed at ten or eleven at night. That was the custom. We had to work for a living. But we were all happy and healthy that time. It was a great old life. People had very little money but they were happy.' One particularly stocky job involved carrying grain barrels. 'We'd be lifting the barrels and there'd be maybe twenty-three stone in a barrel. It'd take two people to lift it but there was a certain way of doing it.'

For a long time, Sam farmed cattle, thirty, maybe thirty-five, at a time. He milked them all twice daily, pumping the milk into tall aluminium cans which he then wheeled out to the roadside in a barrow. 'The lorry came then and took the milk off to Inch Creamery.' As technology evolved, so the creamery was able to pump Sam's milk directly into a bulk tank and that was the end of the can.

'We were paid on the milk according to the quality, the butter fat and all that,' he recalls. 'I was very lucky as I had the highest butterfat going into the creamery. That was because of the sort of cows I had. I started with Shorthorns – they gave good creamy milk – and I had an odd Jersey among them. Then I started on the Friesians and I built up a great herd from around here.'

When the cattle were not in the fields, he kept them in a cow house beside his home. 'Nowadays, cattle are all in on concrete floors and you might have three of four of them to a cubicle,' he says disapprovingly. 'That's why they're slipping around and getting hurt.'

'You can train a horse, but there's no great way of putting manners on pigs,' says Sam of his time as a pig farmer. 'You just have to put up with them and give them the odd skelp with a stick.' At his peak, he had ten farrowing sows and a couple of breeding boars that 'went all over the country'. Sam ran a tight ship and if a sow did not perform according to plan, she was liable to be 'hanging up by the leg in Duffy's bacon factory' before the next full moon.

'You'd always have a fat pig that time,' he says. 'You killed it and took two stone of salt to cure the bacon. You'd rub them on the table every night for a few nights, and when you'd be done rubbing and getting it cured, you'd hang them up on the ceiling. You had nothing to do then only cut off a rasher and throw it into the pan. And you'd have gravy enough to fry an egg. That time, you wouldn't kill a pig until it was about twenty stone weight. Now they wouldn't eat it because they'd think it's too fat. They'd cut the fat off it! We lived off the fat!'

In 1947, Sam married Jenny Coe, a kinswoman of the bachelors who owned his farm. She passed away in 1987, leaving him with a son, three daughters and, at last count, fourteen grandchildren and half a dozen great-grandchildren. 'The auld years do slip by,' says he.

As well as his bonesetting and horse-training prowess, Sam is well known in the locality as the Morris Minor man. 'The first car I had was a Morris Minor and I never had anything else,' he says. 'I used to travel around a lot, as a bonesetter, and I do be in a lot of the old farmer places and all that craic. I had two cars here one time, one for taking the girls out on Sunday and one for everyday.'

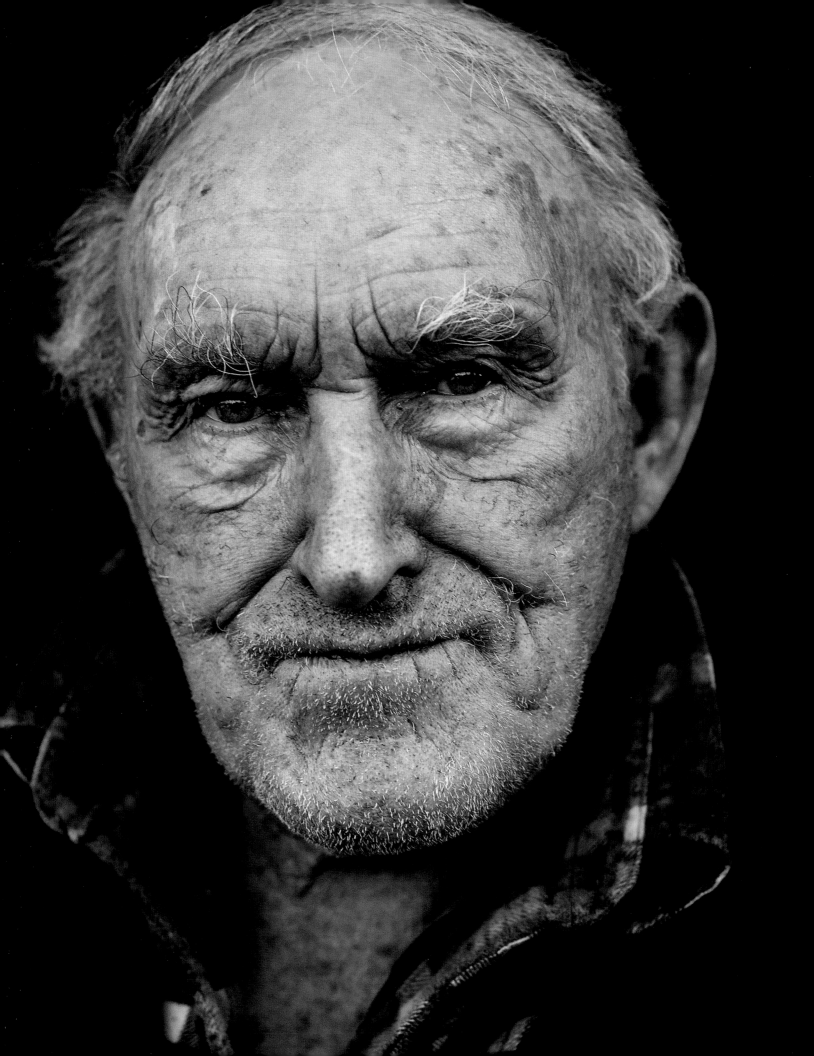

Eamon Madden

Blacksmith & Farrier

Athenry, County Galway

Born 1924

In the summer of 1249, Jordan de Exeter, the wily sheriff of Athenry, slipped into his chainmail, trotted out of the town gates at the head of a cavalry regiment and annihilated a besieging Irish army. Nearly seventy years later, another Anglo-Norman force of a thousand men completely overpowered the Irish allies of Edward the Bruce just outside the town at a second Battle of Athenry. Amongst the hundreds of Irishmen who lay dead on the battlefield was Bruce's comrade, the King of Connaught.

The shape of both of Athenry's battles, and indeed of every battle fought in the Middle Ages, was greatly influenced by blacksmiths. These were the men who manufactured and sharpened every deadly sword, spear and axe-head. They were also highly skilled in the making and maintenance of chainmail. In medieval Athenry, the leading blacksmith family was the Tannians. When Thomas Tannian died in 1682, he was buried beneath a slab engraved with two bellows, a horseshoe, an anvil, a set of pincers and a claw-head hammer.

Eamon Madden is not certain how long his family have been blacksmiths but he reckons there were at least five generations before him. 'That would bring you back a bit,' he smiles. They started at Baunmore and then moved to Knockaunglass, outside Athenry, where his grandfather Thomas Madden was born in 1833.

By the time Eamon was born in 1924 his father Edward was running the forge at Knockaunglass and the family lived on a modest farm leased from Lord Oranmore.

The War of Independence ripped through Athenry during Edward's day. Eamon, the eighth of Edward's nine children, grew up listening to tales of how, when British soldiers spotted a Sacred Heart glowing in somebody's house, they would shoot through the windows to knock it down.

Eamon left school in 1938 and came straight into this forge to serve his three-year apprenticeship. 'In any job, it's a matter of studying,' he counsels. 'To watch a fellow building a wall, you might think it comes naturally, but it is a skill and he has to check it over and over again. Experience is the thing that makes you. You can either be good about it, or you can be careless and you wouldn't be heard of. 'Tis up to yourself in your ways of life and how you present yourself to people. You're either a nice lad or you're a contrary lad.'

Over the course of the 1940s and 1950s, the Maddens' forge became what Eamon calls 'the central pivot of operations'.

'We were shoeing cart wheels, making carts and traps, making fences, gates, farm equipment, ploughs, harrows, scufflers, everything. Farmers came to us anytime they had a job with any connection to iron, welding or fitting And we also manufactured tongs and cranes for the fire, and the crooks and hooks that used to hold up the pots for boiling potatoes and bacon.'

'It was a good job but heavy work,' says Eamon, who cycled to the forge every day. 'You'd start about half nine. And you did your day's work. Whatever time you finished, you did as good as you could. You were always meeting with people, hearing all the local gossip.'

Eamon evidently enjoyed the banter. He is at all times polite and inquisitive, always learning, devouring papers, reading books, absorbing information.

As well as being a blacksmith, Eamon was a farrier, shoeing up to five horses a day for farmers and gentry alike. 'Most of the horses were for working the land, ploughing, cultivating, carting, harvesting, that sort of thing. Others were for bringing the family into Sunday mass or to visit relations up the road or to come into town for the weekly market or the horse fairs.'

Amongst his more well-to-do customers were the members of the Galway Blazers, the local fox hunt, who kept their kennels at nearby Craughwell.

Eamon must have shoed more than 20,000 horses in his lifetime and was never once kicked. He is a tall and powerfully built man with massive brawny hands. But he has the sort of temperament that would calm the wildest stallion. He also has a vital empathy with the animals, as evidenced by his insistence that his forge had a wooden floor. As a young man he noted that horses tended to be easily spooked by the echoes which reverberated around forges with concrete floors.

Athenry was a peaceful town in the 1950s. 'The people back in the times lived and bought and did everything here, or else they went to the next house to get what they wanted. Our forge was beside the shop where you'd get your week's messages and pay for them at the end of the week. There was a drapery, a butcher, a grocer, a couple of tailors, two saddlers and a hardware store. We were very self-sufficient and it was a nice way of life.'

Inevitably, the blacksmith's focus changed. In 1949, local engineer James Ruane was awarded the agency for Ferguson tractors. It was Ruane who had introduced home-generated electric light to Athenry. The tilly lamps and oil lamps which lit the unpaved streets at night were replaced by electric lights, just as the open fires in people's homes were converted into sturdy ranges. But it was the coming of the tractor that made the greatest impact. Eamon recalls how many a farmer arrived at the fair with a horse for sale, only to return home bemusedly seated upon a Ferguson 20.

In the 1960s, Eamon made his way to northeast Herefordshire in England where he spent several years working as a blacksmith for the farming and fox-hunting community around Bromyard. By the time he returned to Athenry to take on the forge, 'it was a new world'. But Eamon was quick to step up to the mark. 'The farmers still needed to repair their ploughs and grubbers and the harrows and the grilles that kept the cattle in. But they also needed us to work with the tractor and all the implements that followed, to adjust them or put a piece onto them or, if they were broken, to fix them.'

Like many of his generation, Eamon prefers the world of the past. 'Our town has changed so much. Our ways of business are so different. People go to Galway to shop now because there is more of a selection. Athenry was nice when everyone knew each other – but everyone moves so quickly now. New people come in but just when you're getting to know them, they move on again.'

Eamon's nephew now owns the old forge. He does not operate as a blacksmith.

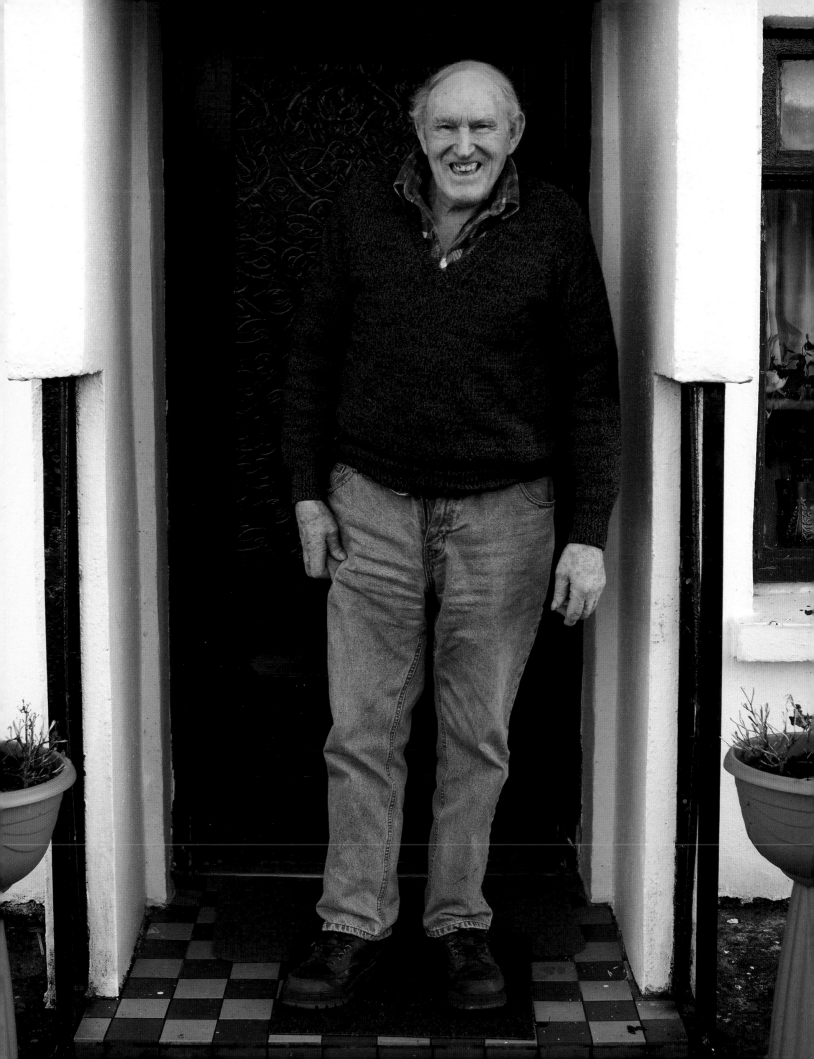

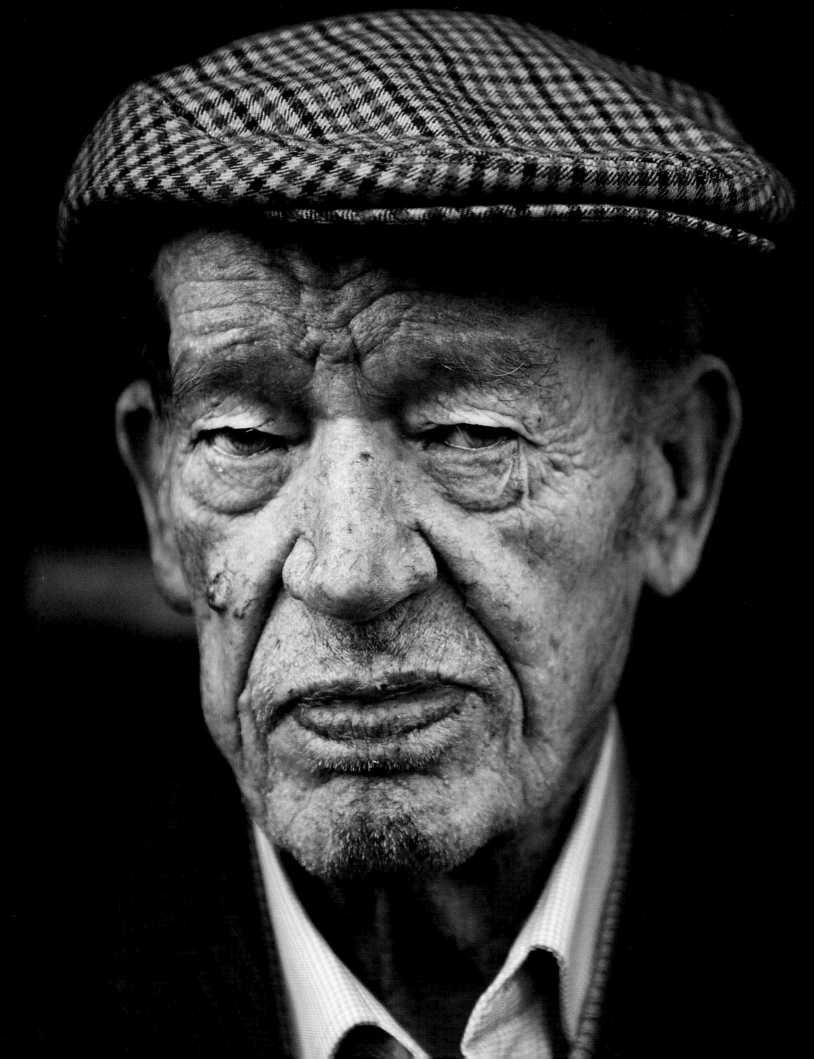

Maurice Fitzgerald

Glin, County Limerick

Farmer

Born 1919

There is a shelf in Maurice Fitzgerald's townhouse upon which an impressive number of small but gleaming trophies sparkle at passers-by. As I walk towards them, Maurice puts out an authoritative arm and instructs me to take a seat beside him.

'I was a great boxer,' he confides. 'A heavyweight. Oh, yes, I was highly dangerous and the whole town knows it. I'm Maurice Fitzgerald. One of the Normans. Did you ever hear of them? I'm a tough man. My right arm is a ten-pound sledge. Did you ever get a belt from a sledge? And my left arm is a kick from a mule. Do you know what a mule is?'

There have been Maurice Fitzgeralds in these parts for many long centuries. The first of the line was Maurice FitzGerald, the son of Gerald of Windsor and his wife, the beautiful Welsh princess, Nesta. He was a companion-in-arms to Strongbow and his progeny duly established the Fitzgeralds as one of Ireland's most exalted Anglo-Norman families. Perhaps it is no coincidence that the present-day Maurice's home is so close to the castellated stronghold of the Knights of Glin, one of the most senior branches of the Fitzgerald clan. 'I suppose I must be related to the Knight,' he muses.

Maurice's forbears were based for many generations at Killacolla House, a large nineteenth-century house, surrounded by trees, located some two miles east of the town of Glin. Killacolla translates as the 'church by the shore' but the original church has long since vanished. There was a small colliery on the land 'but the low-grade coal was better suited to building walls than providing heat.

Maurice has a photograph of his parents on his mantelpiece. His father, also Maurice, farmed some 200 acres at Killacolla and managed the creamery at the local Glin Co-op. He married Catherine Normile from The Lodge in the village of Glin. Catherine bore her husband seven children before his untimely death in 1933. 'He died sudden at the age of sixty,' says Maurice. 'He had a heart attack inside his own bed.'

Maurice was born in Killacolla House in 1919. 'It was a lovely old two-storey house and we had the hardest rock in the whole of Ireland beneath us. There was a beautiful lawn there and my father planted a lot of trees around it a long, long time ago.'

His childhood was spent helping out on the farm, herding cattle, harvesting turf and going down to

the shore to collect periwinkles for dinner. He was one of five children. His older brother Jack inherited the farm at Killacolla, which is now owned by Jack's son. Maurice's younger brother Patrick joined the Gardaí in west Cork, while his two sisters Agnes and Anna married locally. Two more children Kitty and Cornelius died in early childhood.

Maurice was schooled in Glin during the days of Masters Seamus Duggan and David O'Leary. Master Duggan was a useful footballer and lined out for Glin GAA during the club's glory days between 1926 and 1934 when they won seven county football championships. Maurice himself was no slouch on the pitch, going on to play full-back for Glin. 'I was a very strong player and I had a good long kick, forty-five yards,' he says. 'God knows, we won a lot of matches.'

His footballing skills were evidently the foremost legacy of his school, which he left aged fourteen. 'I was able to write my name and that was about it. But I was delighted to be gone from it. And, well, now, can you guess what age I am? I am 102.'

'No, you are not 102', says his wife Mary, patiently. 'You are only ninety-two. And you were once 5 foot 10.'

Maurice grins back at her. This is how they play together. Born in 1929, Mary grew up in Glin. Her father was an auctioneer and a hackney driver, well known for taking people up to matches at Croke Park in Dublin.

'And driving at an average speed of ninety-five miles per hour,' adds Maurice.

Minnie Dillane, Mary's mother, came from Kinnard townland and had married another Fitzgerald, Tommy, with whom she settled in a two-storey house on the Mall in Glin. There was no running water in the house, so young Mary and her six siblings were regularly found filling buckets by the village pump. Mary's only brother Jimmy died as a young man and four of her five sisters emigrated to England. Her fifth sister was a national school teacher at schools in Ballyguiltenane and Glin.

Maurice and Mary met in Glin in the late 1940s when all the action was out 'on the street'. Much of the greatest craic was to be had at the dances which took place at the bottom of the town, and occasionally on the

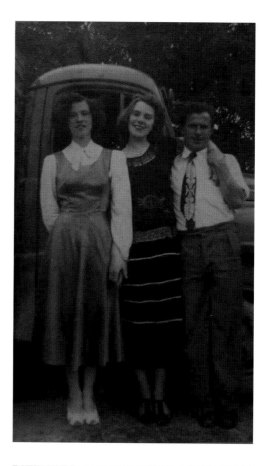

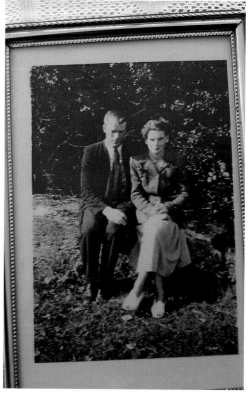

nearby jetty. 'I was a fairly good auld dancer,' says Maurice. 'And I was singing all my life, but I was never a good singer. Here's one for you:

"Somewhere, my love, there will be songs to sing,

Although the snow covers the hopes of spring

Somewhere a hill blossoms in green and gold

And there are dreams, all that your heart can hold."'

During one such night of merry-making Maurice and Mary became betrothed. They were married in 1950 and had five children in the following eleven years.

Shortly after the wedding, Maurice's mother provided £1,100 which enabled him to buy three fields near Glin and this is where Maurice farmed until he retired.

It was always Maurice's dream to be a farmer. 'As a boy I was living out the country in a big old house, working away the whole time on the farmland. My mother would tell everyone, "There was nothing troubling him, only cows and calves." We had forty cows at one time. And we had two brood mares, which my father bred. They were great jumpers and we were getting good money breeding off them. Every year the mare had a foal up in the Black Field at Killacolla but you had to sell them on quick or they'd eat all the grass before the cattle got in there.'

Greyhounds also played a significant role in Maurice's life and he was often to be seen at the races in Limerick. 'The greatest dog I owned was Katie Rose and I won a £3,300 sweep with her in Limerick one night. Wasn't that good money to take home long ago?'

But dairy cows were his main business. 'I had a few cows and I brought them on to the creamery,' he says. 'I had a motor car and a trailer and I would come into the creamery with the milk. We got good money back then and I had a fortune in the bank one time. But I thought, 'What good is money in a bank?' and so what did I do with it all then? I put up two milking machines. I suppose I was being too smart. What happened to all the money?'

'There's still enough to bury you,' his wife remarks dryly.

While Maurice was working on the farm, Mary was being a housewife. She also spent close to thirty-five years working part-time at the library in Glin.

'We had a great life, the two of us,' says Maurice. 'She says she knows nothing about farming but she knows everything. And she is one of the best wives in Ireland.'

But now Maurice wants to talk about his boxing career and why it ended. 'The doctor said to me, "You must be careful. It isn't your fist that will do harm. It's your big shoulders. You have big shoulders. If you do not mind your big shoulders, you will kill a man and go to prison for life."' He casts a wistful eye back at his boxing trophies and says, 'So that was the end of my boxing days.'

Sometime later, as we leave, Maurice's daughter Marie advises me that my leg has been pulled. The trophies in the cabinet are nothing to do with Maurice's boxing. In fact, he never boxed. The trophies are awards he won for having extra-speedy greyhounds. And the big one in the centre was won by himself and Mary in a waltzing contest at the old cinema in Glin in 1962.

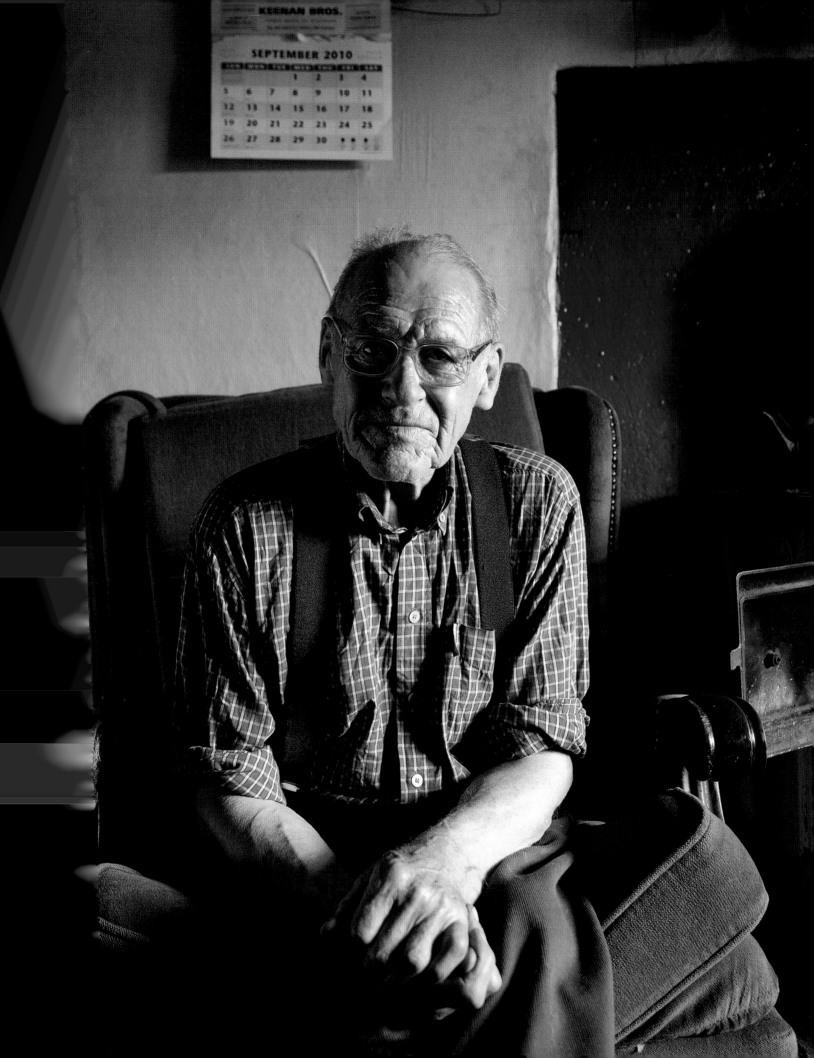

J.J. Hackett

Harness Maker & Poet

Ballinakill, Moate, County Westmeath

Born 1937

There is no doubting that J.J. Hackett is one of the more unusual farmers in the parish: he quotes Wordsworth while stoking the Stanley stove; he has a pet crow who can recognise strangers; he is a fan of the philosopher Edmund Burke; and he knows plenty about the Abbé Edgeworth from Longford, who blessed King Louis XVI as he awaited his execution. He's also written his own memoirs, *Days Gone By*, for which he is justly acclaimed across the county. His tales are thoughtful but upbeat, and give considerable insight into the rough ride he's had along the way.

'I was born with a deformity,' he says. 'My right hip was out and it's still out. I didn't walk until I was seven years of age simply for the reason that I couldn't walk. And to this day I do tire easily, especially walking behind a funeral. But I can still ride a bicycle and I have ridden one from here to Tullamore, Mullingar, Athlone, to Cork twice and to Dublin city twice.'

The Hacketts were a Norman Irish family who 'came into Galway', only to be 'pushed off by the de Burghs' to Hacketstown, County Carlow. It is not known when or why they came to Westmeath but the house where J.J. lives was built for his great-great-great-grandfather in 1742. It stands at the centre of a sixteen-acre farm upon Ballinakill Hill, just south of Moate. 'You're in the very central plain of Ireland,' says J.J. 'We're only eight miles from the Shannon Valley and 150 yards from the Bog of Allen.'

J.J.'s grandfather James J. Hackett was the schoolteacher in the nearby village of Horseleap for which he was paid twenty-four shillings a month. James also owned some surveying chains, twenty-two yards long, which enabled him to measure acres, roods and perches for the letting of land to tenants. J.J. still has the chains, which have not been used since 1907.

James Hackett was heir to the family farmstead on Ballinakill and, by 1901, he was living on the property with his elderly bachelor uncle Thomas. However, in 1908, James was stricken with diabetes and died. His twelve-year-old son Daniel became heir apparent and inherited the farm when old Thomas died seven years later. Daniel served his time with the local IRA during the War of Independence and then settled down to run his small farm.

He also dabbled in boot making, shoe cobbling, clock fixing and bicycle repairs. 'And he was a great man at castrating calves and pigs,' says J.J. proudly. 'I held many a pig for him. He'd make an incision on the testicle

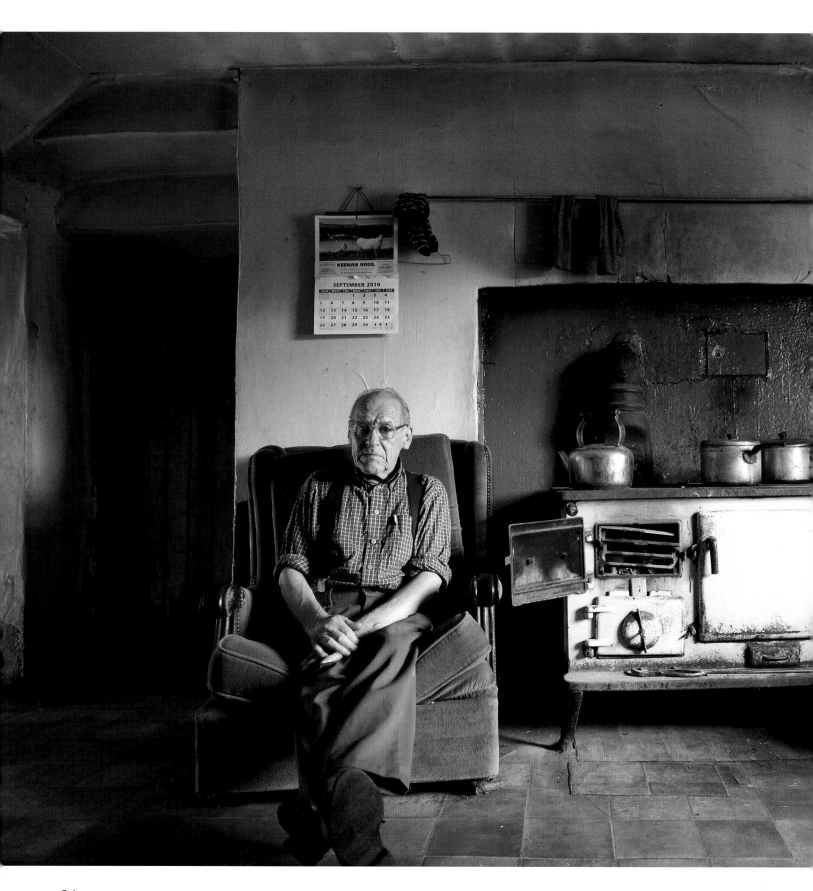

with a knife, pour on the paraffin, take out the testicle and tie it up tight with hemp to stop the bleeding. It was painless. You hardly heard a squeal.'

In 1936, Daniel married Margaret Bradley, a neighbour's daughter, fourteen years his junior. J.J., the eldest of their nine children, was born in 1937, the year Ireland voted in favour of de Valera's Constitution.

'And I'm living here ever since,' he says with a flourish. 'The old time customs were just fizzling out when I came along but my late father told me a lot about them. They were a different breed in them times. There's an air of arrogance with people today. You get it in shops and in pubs. They're very well educated in one way but not in their manners. Life is very short. There is no use going around with a face that's grim and sour, dim and dour. Civility costs nothing!'

In 1944, J.J. went to school at the Convent of Mercy in Moate, after which he went to Master Cox's national

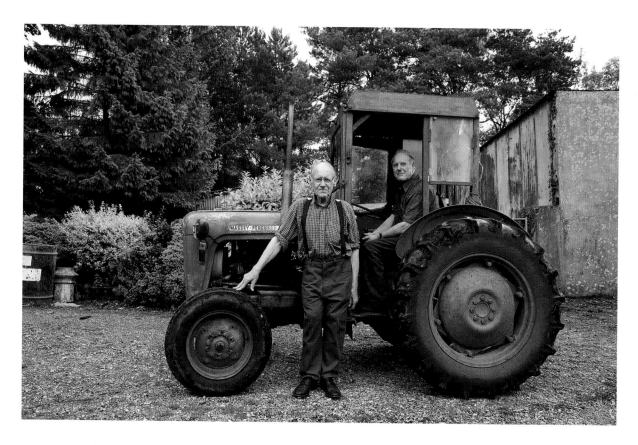

school. However, calamity struck in early 1949, the very same dark winter's night that his younger sister Margaret was born.

'We weren't long home from school but a tree fell on top of me. It broke the collarbone, the cranium and it done in the right knee. I was put in a wheelbarrow and taken to Mullingar Hospital, broken up. I never went back to school. I was in hospital for about a year and ten months and I couldn't walk for about two years.'

By the close of 1950, J.J. was able to move about for the first time since the accident. 'I was still very feeble in the leg but I could ride a bicycle, a small girl's bicycle!' A few months after J.J. left hospital, Daniel secured his son an apprenticeship as a harness maker with a saddlery and upholstery business in Moate. His co-workers were an unusual trio whom J.J. refers to as 'the three deaf mutes'. None of them could speak or hear. And one of them, John Casey from Limerick, was operating with a single eye. 'He lost his left eye with a needle when he was making mattresses,' explains J.J. 'That taught me to keep the face turned away when I made them. And yet he could turn a collar for a horse, a mule, a donkey or a jennet.'

'They were the elite of harness makers,' he continues. 'They specialised in turning the rims of a collar and they were absolute professionals. What they lost in hearing and lack of speech, they had in other ways, in other instincts.'

The silence of the workshop appealed to him. He mastered sign language and was rewarded when the trio taught him everything they knew about stitching, cutting collars and making patterns. 'I focused completely on what I was doing, and the day flew. I was a good worker, but I had one fault – I was slow. I'd have to do the job right. There was no such thing as "get it done and get it out".'

By 1956, 'the deaf mutes were gone old' and had returned 'to the places they came from'. Within a few years, all three were dead. Meanwhile, J.J. returned to his father's farm and set up as a saddler. 'I was getting better, you see. I was nearly able to walk.'

From the 1960s to the 1990s, J.J. Hackett sat at home, making and restoring saddles. The tools of his trade are still close at hand – the thimble, the compass, the leather samples. 'The best leather is the back hide of a bullock,' he advises. 'But most saddles are half rubber these days.' The house was a hive of industry, with his father cobbling and another man 'making tubs and buckets, wooden spoons and wooden churns'. After their father's death in 1975, J.J.'s younger brother Michael took over the running of the farm, sallying out in a 1962 vintage Massey 35X, which remains his absolute pride and joy.

Meanwhile, J.J. looked after his aged mother, whose last nine years were spent contending with Parkinson's. J.J. allows that his chances of finding a wife were consequently reduced. 'I never became involved in the nuptial circles,' he says. 'I'm at the terminal point now – the point of no return! Like Alfred, Lord Tennyson, I have crossed the bar! Evening and sunset, all is one.'

Poetry sometimes comes to him when he is planting potatoes, 'the fruits of the earth' as Paddy Kavanagh called them. J.J. met Kavanagh in Dublin a few times in the 1960s, the pair of them sinking pints amidst the academics and the newspapermen who frequented McDaid's of Harry Street. 'Such a dive I had never entered! Very uncouth looking with the paper falling off the walls, but that's the way they wanted it. It was all intellectual conversation interspersed with an odd swear word or two. Kavanagh took a liking to me. 'O stony grey soil'. But there was one man in Dublin he didn't like and that was Brendan Behan. Behan called him a gutter-snipe from Monaghan.'

J.J.'s father was a renowned storyteller in the locality. 'He'd sit down all day talking over tea.' J.J. opens a door to reveal a room stuffed with books and plucks one at random, a dishevelled copy of *The Colleen Bawn*, which once belonged to his grandfather. 'All my life I had an interest in writing. I could write at four years of age. It was my childhood aspiration to be a schoolteacher. My dad had that hope too, but it wasn't to be, because of the accident. And also the economics of the time. In 1949 when the Carmelite college secondary school opened, it was twelve pound per year to send a child to it and my late father wasn't able to get that money.'

J.J. and Michael live today in the house of their ancestors with two sheepdogs, Jack and Jill. Sheltered beneath an ancient lime tree, their home is well poised above the boggy meadows, with corrugated sheds and stables spilling left and right. The Hacketts have a plentiful supply of turf from the nearby bog.

The farmstead was originally a long, low thatched cottage with 3-foot-thick walls made of lime, sand and stone. The kitchen floor was kelp, made with blue clay brought in wet from the fields and tapped in with a shovel. Beneath the thatch, J.J.'s forbears spread furze (gorse) from the bogs upon the rafters, providing insulation and a foundation for the straw. Every decade or so, they would add a new layer of straw so that the thatch was 2 feet thick by the time J.J. decided to renovate the house in 1966. They poured concrete on the kitchen floor and galvanised the roof. 'I was sorry to see the thatch go,' says J.J., 'but it had to go because of the rain. The blackbirds were divils for coming in and digging holes in the thatch for the worms. I often seen rain coming in during a thunderstorm and we'd have buckets catching the drops.'

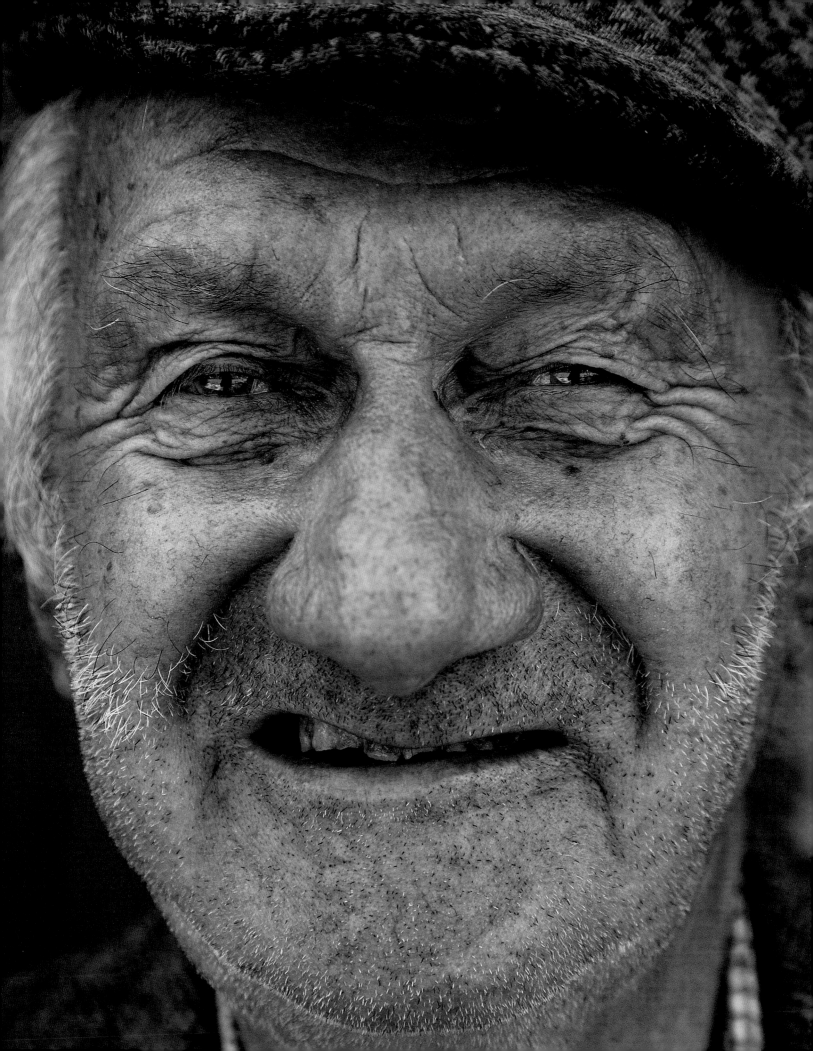

Jack Lonergan

General Factotum

Tickincor, County Tipperary

Born 1930

'In my young years I went around on a horse and trap, but there's no living for a horse and trap on the road now. When the motor car came in and the petrol got plentiful, that was the end for the horse and trap.'

As if on cue, a car whizzes by and Jack's eyes narrow. 'I never drove,' he says, watching the car vanish over the horizon. 'I could never have been a driver. The Raleigh bicycle is my machine. I was six or seven when I got my first one. A man's bike. You'd get more falls off it, but you'd get a greater idea of balance then.'

Jack is the 'general factotum' at St Joseph's Industrial School outside Clonmel. The job title means someone who has many diverse responsibilities and derives from the Latin *fac totum*, meaning 'to do or make everything'. The name is a legacy of the Rosminians, the Catholic order who have run the reformatory school since it was established in 1884.

Better known as Ferryhouse, St Joseph's was the brainchild of the Home Rule politician Count Arthur Moore who represented Clonmel in Westminster from 1874 to 1885. Moore loathed the dreaded workhouses to which offending boys were traditionally sent and conceived St Joseph's as a place where such children might learn some of the skills necessary to improving their general lot in life. Sadly, the Count's legacy was ultimately to be perverted and St Joseph's was one of those institutions exposed in the Ryan Report of 2009 for the systematic abuse of the boys there.

Jack Lonergan (pronounced Londrigan) and his friend Jimmy Walsh started at Ferryhouse in the 1970s. 'I was in and out of here for a long time and then I became a constant,' he says. 'We were helping out on the land, picking spuds and saving hay. There were thirty-five cows at one time and they were milked every day.'

Jack was also assigned to look after the school ponies which graze today in a meadow behind the school playground. 'That one is a bully for his belly,' he says, watching a hefty piebald called Magnum throw his head into a hayrick.

Jack has worked with animals all his life. His father was a cattle farmer. 'We always had seven cows for milk and butter. We'd give some of them funny names. There might be a light, thin cow and we'd call her "the Heavy One".'

As children, Jack and his sisters made butter which their father sold to the creamery. Jack often helped

his father drive the cattle into Clonmel for the monthly fair. On those days, the Tipperary town was awash with farmers from the outlying parishes herding their cattle down the streets with great roars and considerable humour. 'We'd sell the cattle up in the Mall,' he recalls. 'Big cattle were up Johnson Street by the chapel, small cattle were up the Main Street, sheep were above at the West Gate and horses were back in the Mall again.'

'The fair was always busy but there were no great prices going,' he says. 'It was a day out, I suppose, but we were young and we looked forward to anything. If they made the money, they'd celebrate. Some wouldn't come home afterwards at all if they could avoid it.'

John Lonergan, Jack's grandfather, came from Ardfinnan, a village between Clonmel and Cahir on the River Suir. He was a modest farmer and kept a few pigs and cattle. During the 1920s, Jack's father Daniel relocated to the townland of Tickincor on the outskirts of Clonmel. The nearby ruins of Tickincor Castle were all that was left of a once-formidable three-storey fortress built during the reign of James I. Its last inhabitant Sir John Osborne died in 1743.

Jack's mother Maggie was a Kelly from Rathgormack, County Waterford. She grew up beside the ruins of the Augustinian-built Mothel Abbey. In her grandfather's day, many from Rathgormack left for the 'New World', settling in Nova Scotia and Newfoundland, as well as New York and Boston.

Jack and his sisters were all born at Tickincor. As well as cattle, their father kept a horse and a cob. 'The one horse is no good,' says Jack. 'You'd have to have the second one to get anything done.'

Jack often rode up on the cob to get around. The family had no car although if there was a funeral far away, Daniel would hire one for the occasion.

Jack was educated on the opposite side of the River Suir in Newtown Anner. To get to school during the fishing season, he often went down to Derrinlaur where he met the Walsh brothers, Paddy, Johnny and Jimmy. The four of them would lower a long, narrow fisherman's cot into the river and paddle across from one bank to the other, keeping their eyes (and occasionally

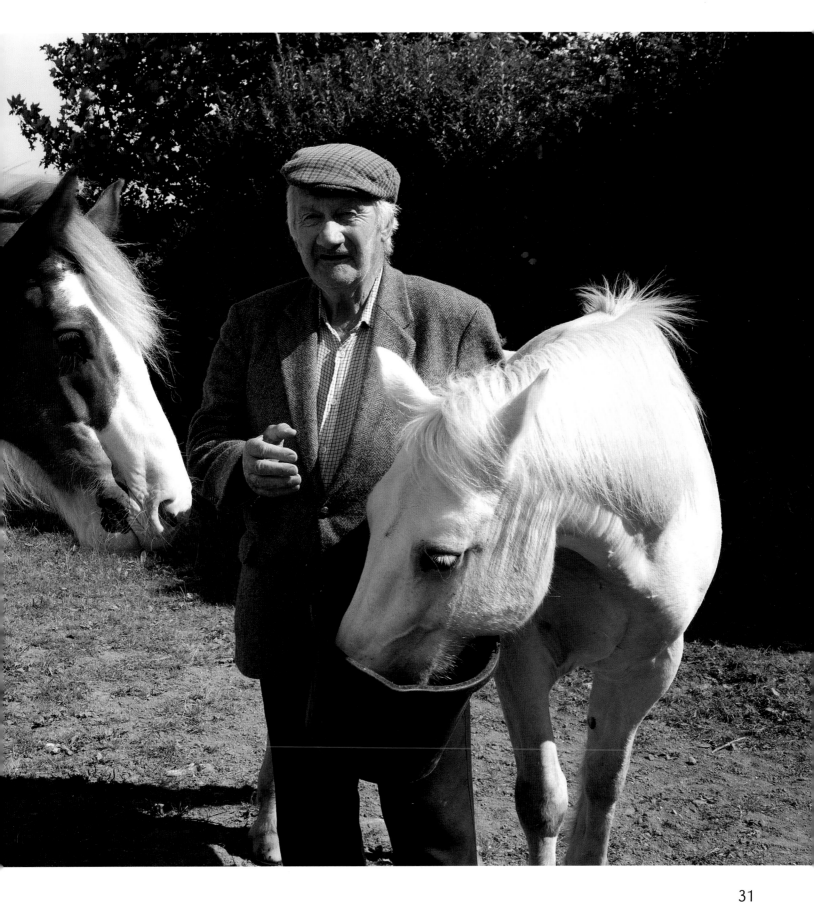

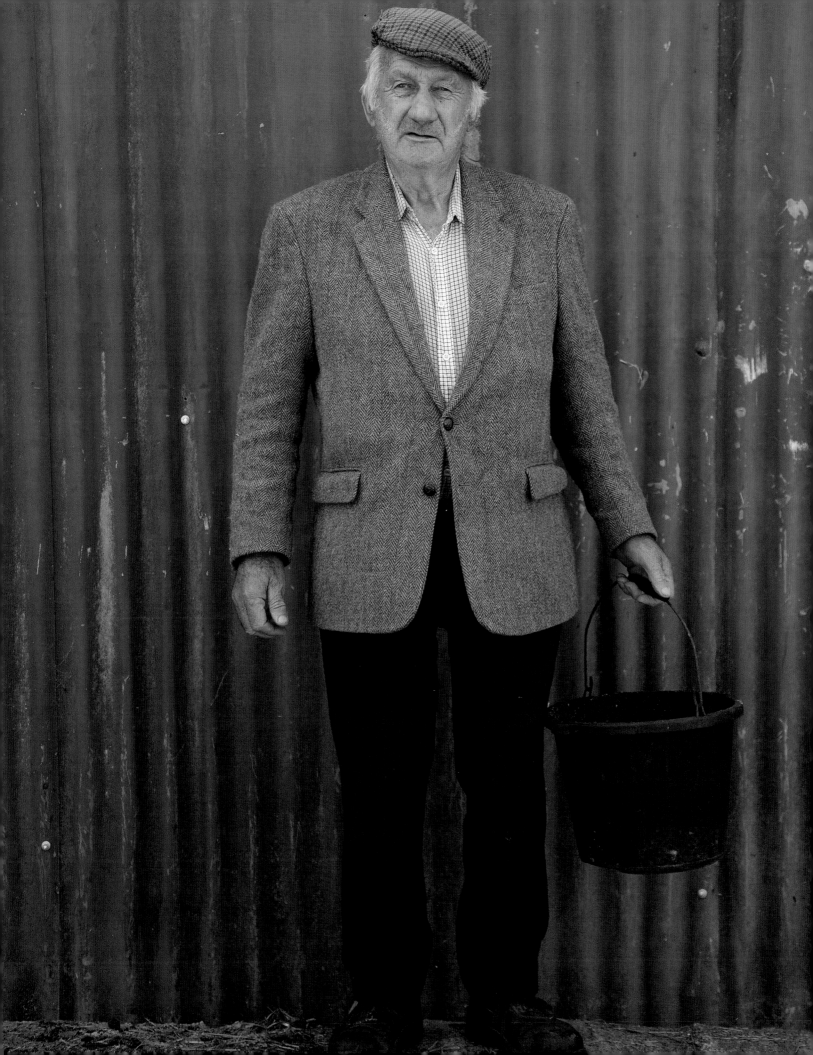

their nets) alert for any passing salmon. Amongst those whom the boys met on their daily voyage were some of the dexterous cot fishermen from the Suir whose skills were prized as far away as Newfoundland.

Jack realised that if he was to earn a living after school, it would be up to his own initiative. The Lonergan farm was too small to bring in any real income. He joined forces with Jimmy Walsh and the two became something of a double act. They started off picking stones for Geoffrey Wilkinson, who had been gifted the Gurteen Kilsheelan estate by his uncle Count Edmond de la Poer in 1968. 'Mrs Wilkinson would come for us in the morning, about ten o'clock, when we had our jobs done at our home place.'

The Wilkinsons then gave them other work – making silage, erecting fencing around a paddock, harvesting corn. 'The weather was an awful drawback,' Jack recalls. 'It could put a lot of work and hardship on you.'

During one fearful wet season, he remembers Mr Wilkinson eyeballing 70 acres of rain-sodden barley with dismay. 'If I could just get enough barley to do the cattle, it would be okay,' he pleaded. When the corn was eventually cut, Jack was impressed when Mr Wilkinson hired an enormous electric fan to successfully dry the crop out. After Mr Wilkinson's premature death in 1982, Jimmy Walsh 'stayed on constant' at Gurteen, while Jack became 'constant' at Ferryhouse.

Jack has a strong empathy for the Ferryhouse boys. 'There were up to two hundred here at one time. Their parents weren't able to provide for them, so they came here and stayed until they were old enough to get a job. A lot of them went into the army afterwards and some headed off to England.'

Jack never married 'and thank God for that', says he. With eighty years under his belt, he is perhaps at maximum ease when ambling around the paddock of a mild spring morning with Magnum and the other horses.

'There was a barber in Clonmel who used to say, "When you've gone over forty, your years are getting scarce." We have no value on our youth. It goes too quick. But youth is great. You can hope when you have no hope.'

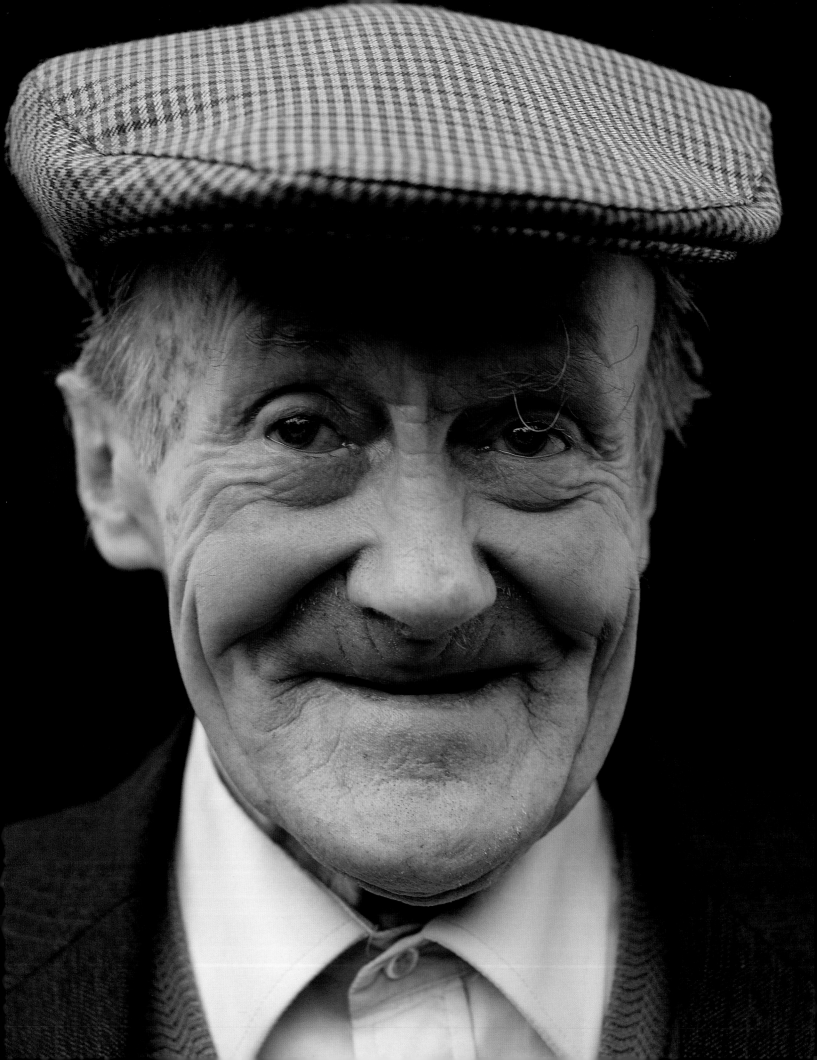

John Joe Conway

Knockanedan, Kilfenora, County Clare

Cattle Farmer & Horse Breeder

Born 1935

The short avenue leading down to his cottage is treacherously icy but that doesn't stop John Joe from skating across the frozen puddles like a fearless toddler. 'By God and you're welcome, lads. Come in out of the cold and make yourselves comfortable.'

John Joe's home lies amid the hills of west Clare in a place called Knockanedan which, rather cryptically, translates as The Hill on the Brow of Another Hill. The other hill is Knockalunkard, the hill of the long fort, where John Joe's late mother grew up. Located along the old Lisdoonvarna to Ennis road, memories of ages past still linger over these remote green hills. Pitched between two ancient ringforts are the grass-covered rumps of an abandoned village. 'I knew an old man who could remember the women from the hill village,' says John Joe. 'There is still contact with those times but so much of what was around here has gone over to forestry since. The Forestry Department didn't give a tinker's damn for the past. They would have planted trees on this kitchen floor if they could.'

John Joe's forbears came from the townland of Ballycannoe, just northeast of Lidsoonvarna, which was once called Conwaystown 'and there was no one there except Conways'. They were 'cleared out of it in the troubled times and moved up to Galway'. They returned to Clare in the nineteenth century and Michael Conway, John Joe's grandfather, arrived in Knockanedan from Miltown Malbay. He was essentially adopted by his uncle Paddy Conway and his wife Bridget, who had no children of their own.

It had been Michael's intention to join the civil service in Dublin. However, as he prepared to depart for the city, Paddy pleaded with him to stay and offered him the farm. The young man reluctantly bade farewell to his administrative dreams and stayed.

Michael married Bridget Donoghue from Maurice's Mills and she bore him three sons and three daughters. However, she died giving birth to their youngest girl in 1901. Michael then reared the six children himself, in the same house where John Joe lives now. Two of the six later emigrated to England – John to work on the railways in Manchester and Mary to work in catering in Luton – but the other four remained in County Clare, including Michael's oldest son Patrick who was John Joe's father.

John Joe's kitchen is a large, open-plan room with a concrete floor and a strobe light overhead. Bags of

turf encased in yellow plastic gather behind a settee between the staircase and the Stanley range. Along one wall runs a 1950s dresser, laden with chipped teacups and tick-tock clocks. He has a fine collection, including one with a barometer, and another with an hourly ring that kept him awake all night until he turned it off. 'I'm a clockaholic,' he confides.

Another wall is adorned with portraits of Padre Pio, Mother Teresa and Pope John Paul II, whom he went to see at Ballybrit in 1979, 'the greatest day in my life'. Amongst other photographs is a 1940s shot of the Conway family standing beside the hay barn at Knockanedan in their Sunday best, taken by a visiting nurse from England. John Joe, his parents and his four brothers. The boys all wear shorts; no young man wore long pants until he reached his sixteenth birthday.

'It wasn't easy to rear a family in those times,' says John Joe. 'But they did it, however they did it.' His father

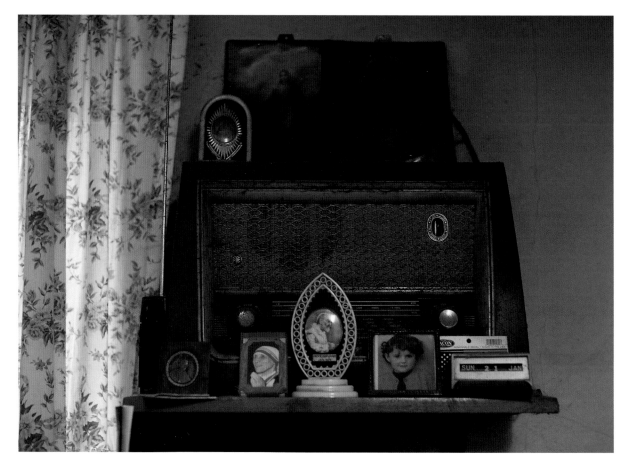

was evidently a towering figure. 'And terrible strong too,' he says, with a respectful nod of the head.

As a youngster, John Joe often helped his father with the cattle. The prices were sometimes so low that they had to take the stock to two or three fairs before they found a buyer. While they awaited a sale, they lived on credit with the local shop like everybody else. 'They were so terribly honest in them times that they all did pay because if they didn't, the shopkeeper wouldn't be able to keep going.'

The Conway sons were all educated in Inchovea, a handsome nineteenth-century building which was demolished in the 1950s because it was deemed too damp. 'A bucket of mortar would have sorted the leak out,' says John Joe indignantly. 'The tradesman who knocked it nearly failed because it was such a fine structure. It didn't want to be knocked. He made more money selling the lead flashing than it cost him to buy the place and knock it down.'

By the time he left school in the mid-1950s, John Joe knew the family farm was headed his way. Two of his brothers had emigrated to Luton, one to work with Vauxhall, the other to become a plasterer, and there they both remained until they died a few years ago. Another brother Patrick joined the Christian Brothers and settled in Clara, County Offaly.

The fourth brother Martin played flute with the Irish Army No. 1 Band for nearly thirty years and now lives nearby. During the 1960s, Martin was based at Batterstown, County Meath, and the biggest journeys of John Joe's life were his annual 500-kilometre round trip to visit him. This coincided with the much-relished 'Clareman's Do' in Harry's of Kinnegad, a gathering of all the farming men of County Clare who had moved east and settled in Meath and Westmeath. 'We used to let our hair hang down – full length,' he laughs, eyes crinkling as he reels off the names of the lads he met for the 'dancing and sing-song and that carry on'.

Like his grandfather before him, John Joe was not particularly excited by the prospect of taking on the farm. 'I felt it would be nothing but hardship,' he says. 'But I got used to it.' When his mother's brother passed away in 1962, he acquired a second farm on Knockalunkard Hill. 'So I doubled up, but it was still small, about 60 acres in total, and not the best land in the world.'

He bred pedigree Shorthorns and he has a quiver full of scary tales about cows and bulls that have run amok. The pick is probably the one about his neighbour, 'a strong man who was never afraid of anything', who fetched up the wrong side of a bull. This is how John Joe tells the story:

'One day the wife looks out and she sees the bull is going down on him, trying to crush him to bits. So she runs over to the paddock with an apron and throws her apron at the bull. The bull turned and went down on the apron and was satisfied to be belting away at that instead. She got her husband up and began dragging him out but, as they were leaving, she looked back and she said, "Michael, could you ever hasten, he's coming again …" and he was thundering up the paddock after them, breathing up the back of their necks, for to give them the doubts. They got out the gate, she pulled it shut and the bull banged his head on it after. Michael had six cracked ribs and was scratched and bruised all over his face. Michael's two brother-in-laws would not believe the bull was so bad. They brought a heifer along and stuck her in the field with the bull. He took no notice of her so they went in after her with their forks. The first lad didn't even get to draw the fork the bull hit him so hard. Took the two legs up from under him and lifted him. The other lad stuck his fork in the bull's guts then and that worked. That's what he had to do or the bull would have killed the two of them. The bull started trying to wrench himself until he got rid of the fork and that gave them enough time to get out. They had to put the bull down after that.'

'You would have to be alert to the bulls,' he warns. But cows can also be extremely dangerous, particularly Limousin cows. 'When they are calving, they have some temper. For three days after the calf is born, they

are terrible.' He recalls a friend being chased up the field by one such cow. 'Only for that he was an athlete, she'd have had him. She chased him a hundred yards or more. I was watching him twisting and turning and zigzagging but I couldn't do anything. I think it took more out of me than him.'

John Joe is more at ease in the company of horses. 'They used to say there was a four-leaf shamrock wherever a mare foaled. I love horses. Their intelligence is something else. They know your step. They know your voice. They know if you are grumpy and they keep out of your way! The very moment you handle the reins, they know to a T what you're made of. And when you ride them, they know when you're in charge and they know when they can dump you. And dump you they will!'

'I had a breeding mare, a draft horse. I bred foals from her and I brought them to the fairs in Ennistymon and Ennis. I often hopped up on her, with no bridle or anything, for a gallop through the fields. She was a nice mare with plenty of speed. But until she wanted to stop, you couldn't come off. We were out once and her leg went down a closed drain. She scrambled and scrambled so much that I thought she was damaged. I never rode her again after that. I realised this country was too dangerous for her.'

John Joe also had a couple of workhorses. 'The trick with the workhorse is to keep him working. When they aren't working, they start acting up, plunging and rearing and shying at this, that and every other thing they meet on the road. But when they are working they are lovely and they really can work.'

John Joe sold his last 'little mare' in 2005. He was anxious for her health because she had developed water scabs on her back and he did not know how to cure her. 'She was never trained but she was a beauty to lead. After she was gone, I put down eight or nine terrible nights. The line was broken. Every morning I would bring her feed … but when she was gone, I was put off my stride.'

He found some consolation in music. 'Oh the Lord, yes, I am stone crazy mad for traditional music. I played a tin whistle back in the past and I used to sing, with porter. Aye, when the medicine was on, I'd sing. "Putting on the Style" by Lonnie Donegan. That was one of my songs.' In fact, John Joe frequently hosted céilidhs in his kitchen, drawing crowds of anything up to forty people. 'A couple of lads would play and they'd dance a few sets and waltzes and maybe sing a few songs. Everybody would be to and fro and there was the occasional romance out of it. It wasn't men on the one wall and women on the other.'

That said, John Joe never married. 'It was a pity for all the bachelors in this area that all the women left – for England and America. Or they married the bigger farmers. I suppose they were afraid of the drudgery of marrying a smaller farmer.' The population duly tumbled and many local businesses were no longer viable. In the past decade, the creamery, the shop and the school have all closed. 'This area has been turned upside down,' says John Joe. 'But there was nothing we could do. Like a lot of the country areas, it came so gradual at first that no one took any notice.'

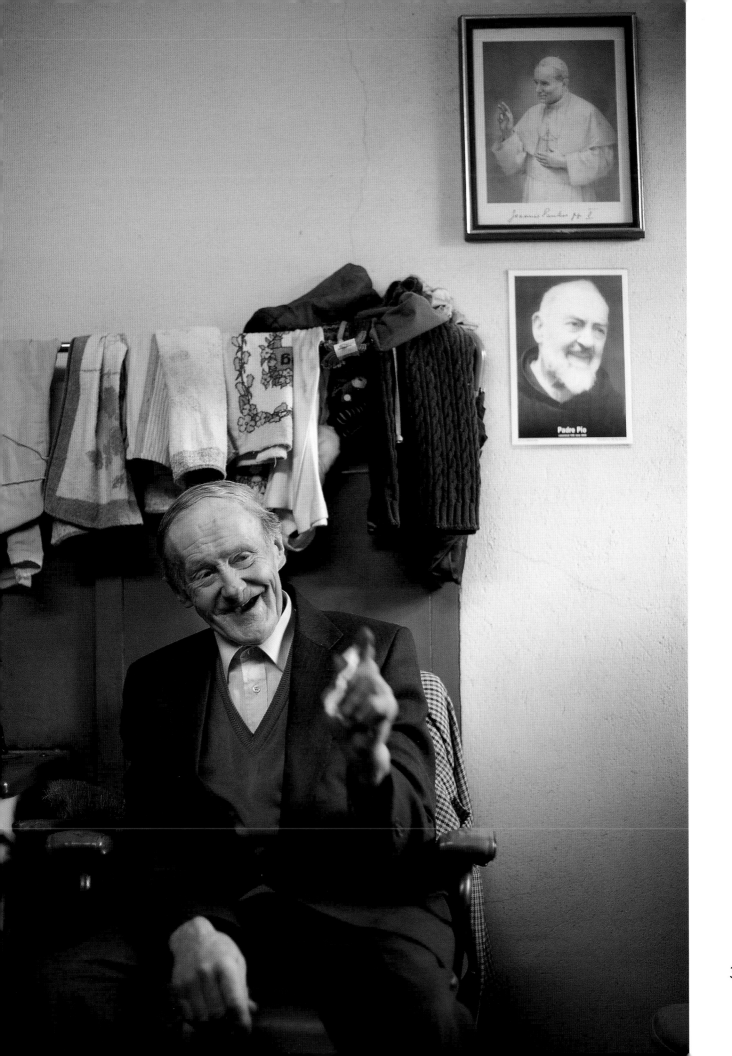

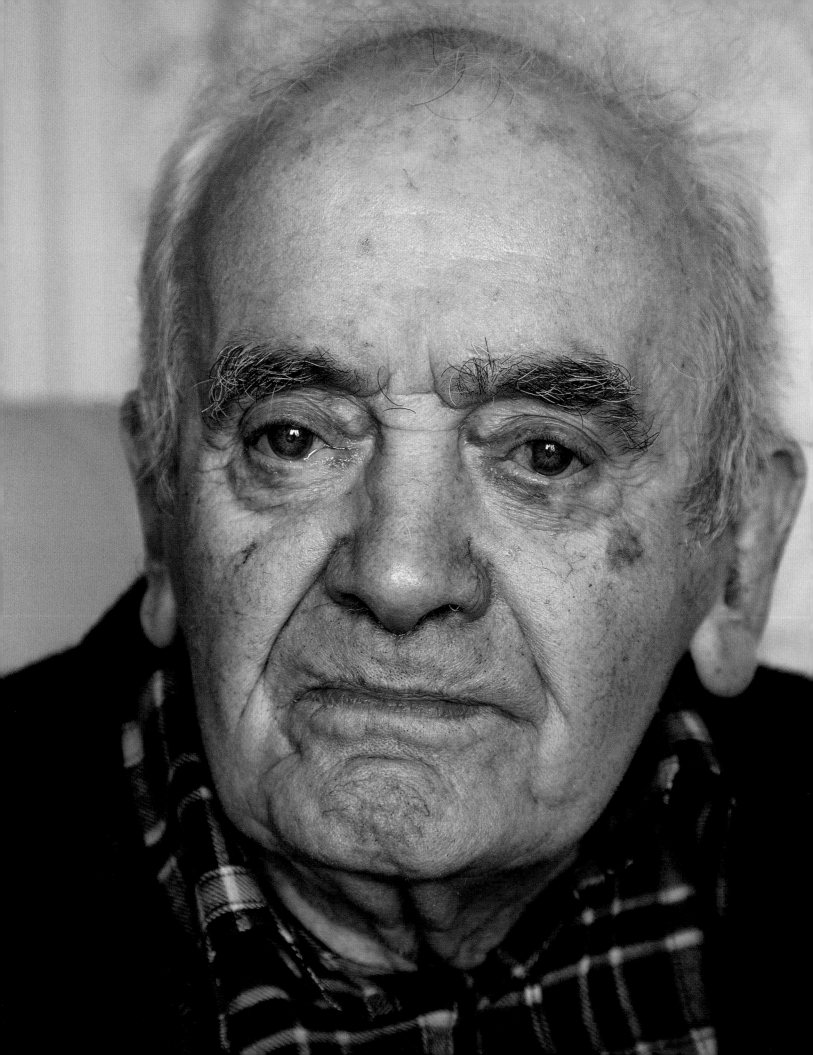

Danny Cullen

Gortlee, Letterkenny, County Donegal

Haulier

1920–2009

Danny Cullen was eleven years old when he first started showing up at the railway stores in Letterkenny with his donkey and cart. His mission was straightforward. The shed was full of margarine, the new butter-like spread which was being advertised by companies such as Stork, Floss and Bluebell. Letterkenny's bakers had taken a shine to the spread and young Danny had stolen a march on his rivals to ensure they were supplied accordingly. If he played his cards right, he could deliver two cart loads of margarine every evening. And if the margarine stock was low, he could always take a load of 16-stone bags of sugar up to the Oatfield sweet factory on the Ramelton Road instead.

'The margarine came down every Friday,' he recalled. 'There'd be six, maybe eight, tons of it. It all had to go. So I went all round, delivering it to the bakers and shops and houses. Me and Neddy. That was the donkey's name. I'd sit up on the trap and whistle and sing and off we'd go on our rounds.'

Based at Rosemount Lane, just off Letterkenny's Main Street, Danny's family had been in the delivery game for at least three generations. 'My great-grandfather was going around with a horse and cart long before the railways came,' he said. 'So it was always something I was going to do. But I started young, when I was still at school. I used to get out of school at three o'clock and that gave me an hour to run through a garden and a field and get Neddy and the cart.'

When Danny left school in 1934, he graduated to a pony and a slightly bigger cart, and his younger brother Vincent duly took charge of Neddy.

Danny's father Paddy Cullen was a Catholic haulier who lived out on the Port Road. His mother Minnie Kerrigan was the daughter of a Presbyterian publican who had served as a sergeant major in the British Army.

'I was raised as a Catholic,' says Danny. 'But, as my mother always said, one religion is as good as the other and there is no difference between anyone. My grandfather was the same. He was a Presbyterian, but he held that it was the same God who listened to your prayers no matter who you were. But when he came to Letterkenny before the First World War, he took a walk around the town. He noted that the Protestants and Presbyterians had much bigger shops than the Catholics, and that the Protestants wouldn't employ a Catholic. He thought that was a terrible mistake. It wasn't like that when he grew up there, before he joined the army,

when nobody knew what religion anyone was. But when he saw how it had changed in Letterkenny, he turned Catholic and he never missed a mass after that.'

Paddy and Minnie had eight children, seven boys and a girl, of whom two boys died at birth. They lived down the Major's Lane, near Puddle Alley, an area that is today more fragrantly known as Rosemount.

Danny was always a cheerful soul, with a long and frequent belly-rumbling laugh. As we talked, he constantly ventured back into his memory to find anecdote after anecdote that made him, if not everyone else, chuckle.

Danny says life in twentieth-century Letterkenny was often a hard slog. 'When I was a young fellow, there was very little work here. There were no factories and it was a very poor town. I remember once I was helping a man from the P&T [the Department of Posts and Telegraphs, which was divided into An Post and Telecom Éireann in 1984]. We had the big drums for the telephone cables and a woman came out from one of the estates and asked if she could have the drums for a bed. And she wanted the chaff to stuff a mattress. Some people literally had nothing in them times.'

'I was twenty-two years with a horse and cart,' he said. 'And then I was twenty-three years with a lorry. I went into competition with the guys I worked for.' He was actually invited to become manager of the same railway stores from which he had been gathering sugar and margarine for all those years. However, Danny could see which way the future was headed and he strongly suspected that the days of the railway were at an end. Sure enough, in 1960, the railway line between Strabane and Letterkenny was closed. Henceforth, Letterkenny's main access channel was by road.

In 1955, Danny bought his first lorry, a second-hand Ford. 'I had luck with her. She done well for me and I got a good start. I was well known to all the firms in Letterkenny because I had been on the deliveries for so long. I gave a good service. I was always on time. If I promise someone I will be there at a time, I will always be there on time. Punctuality. Being late is a habit but so is being on time.'

With the lorry, Danny was now frequently journeying down the long road to Dublin, a round trip of nearly 500km, gathering up crates and boxes of anything and everything. 'I was sixteen years on the Dublin run. We'd go down, get the crates and make sure they weren't damaged and that they got to the firms on time. It was heavy work. But I did powerful well with it.'

Danny married Nuala McGarvey in 1947 and they raised seven sons and a daughter in a house which he built at Gortlee, Letterkenny.

Danny was thirty-two years old when his father passed away. Paddy Cullen's demise prompted something of a religious awakening in the youngster. 'My father was not a very healthy man,' he said. 'He was a heavy smoker and then he got ill and he was riddled with cancer. He was suffering terribly, night and day, with terrible pain. And then one day he asked for the Green Scapula.'

Green Scapulas are unofficial Catholic devotional charms, the origin of which is traced to a revelation by the Blessed Virgin Mary to Sister Justine Bisqueyburu in Paris in 1840. The charms reputedly do much to resolve inner healing, specifically for those suffering from diseases like cancer. Danny had his own Green Scapula and passed it over to his father. When he returned three days later, Paddy was sitting up in the bed with a broad smile.

'How are you?' Danny asked, somewhat incredulously. Paddy held up the Scapula and replied, 'Between this and a few prayers, I'm sleeping night and day.' He died some days later but Danny insisted there was no pain.

For the last six months of his life, Danny Cullen kept the Green Scapula pinned to his vest and constantly rubbed it upon his lips. He passed away peacefully in his own bedroom, with his family by his side, in September 2009, and was buried wearing the Green Scapula. Cullen Transport is now run by his sons Cyril and Danny Jr, continuing Donegal's oldest haulage business into the fourth generation.

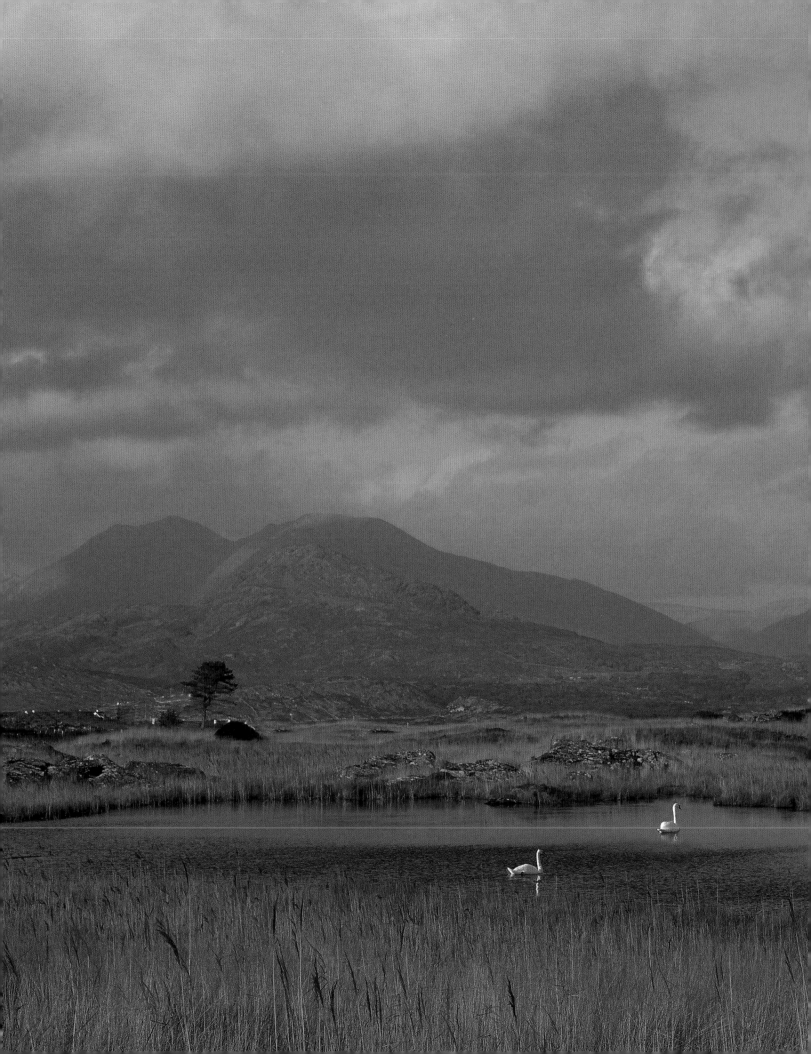

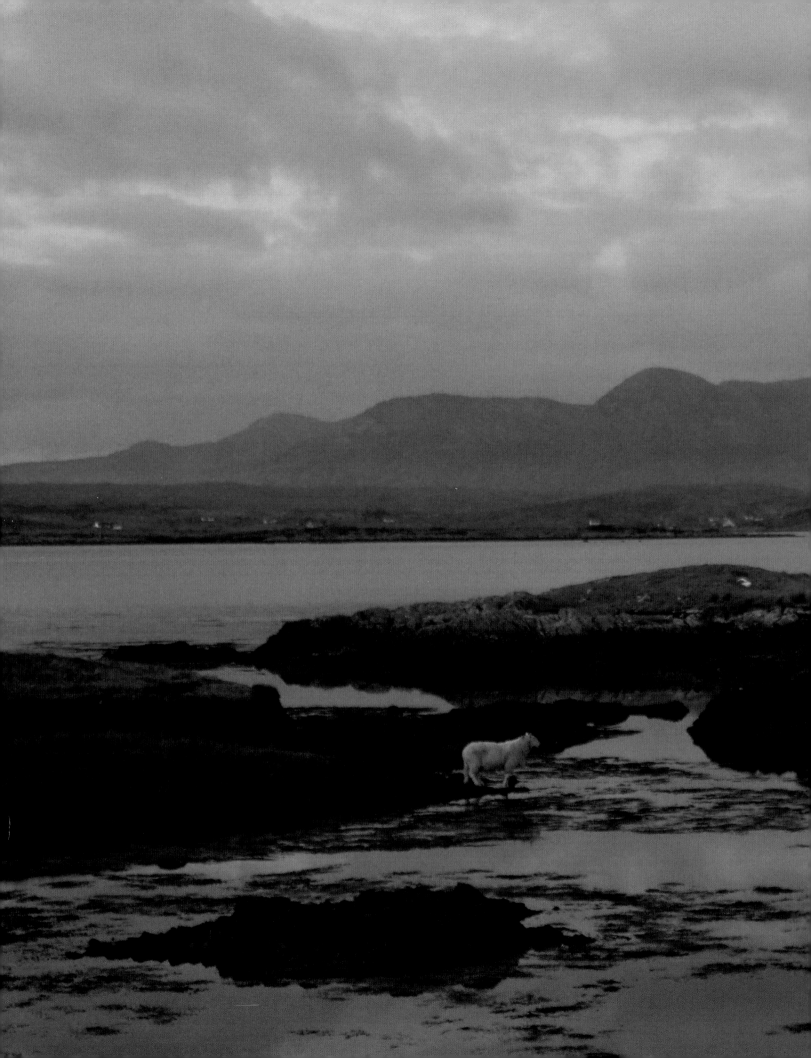

Of Music and Craft

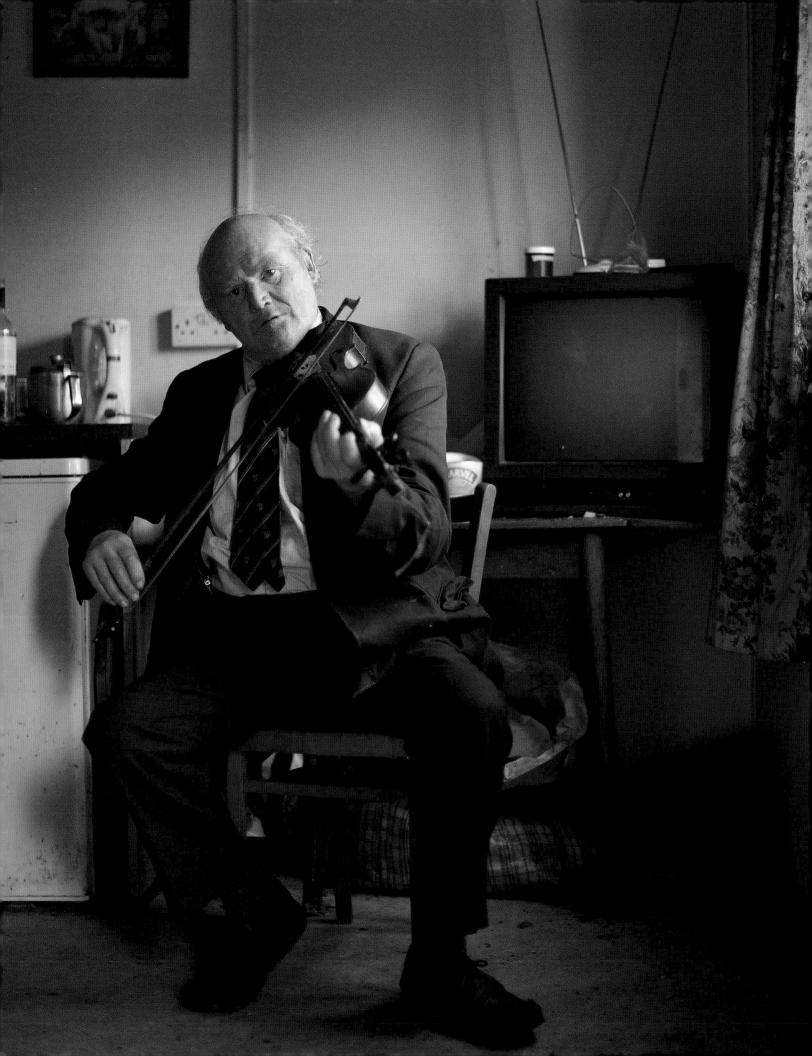

Jimmy Fanning

Glenballyvally, County Kilkenny

Fiddler & Farm Labourer

Born 1942

'It's a bright world covered by darkness, but a dark world can be covered by brightness.' Jimmy Fanning is in philosophical form. During our two-hour encounter, I count twenty-one pearls of wisdom that drop from his lips, without a hint of pretence.

Most appear to be his own invention. 'Money is not everything but tis a lot,' he says, during a conversation about the fall of the Celtic Tiger. 'Like the fellow with the ha'penny, it might not be much to have, but it might be a lot to want.'

Some were imparted by a wise uncle, a prison inspector in England. 'Don't ever mind your own capability but mind the capability of others.'

Others are vaguely familiar and slightly skew-whiff. Ben Franklin, 'Those that have them self as a teacher have a fool for a master.' The skew-whiffery matters not. Jimmy likes to play around, to mash the lines so that, for instance, Shakespeare meets Yeats to 'Cast a cold eye on dead horseman pass by, for all that glistens is not gold.'

On the subject of Irish politics, he counsels, 'There are three things in this world to beware of – the heels of a horse, the horns of a bull and the smile of an Englishman.' And then, smiling broad, he adds, 'Tis all over and done with now but when I see the Dáil and the Irish parliamentations today, I think that – as bad as the English were – our Irish is far worse. A Fianna Fáil minister retired at Christmas and they gave him €150,000 a year on top of his pension. They're bigger fuckers than the Tans ever was.'

Between the lines, Jimmy recounts the story of his life from his birth in the midst of the Second World War. His father Ambrose 'Amby' Fanning was a well-known fiddler in the lands through which the River Nore flows. He was born in Fulham, London, but came to Ireland at eleven years of age 'on account of a bad chest'.

Amby first learned the fiddle from a big-fisted man called Sonny MacDonald 'who used to throw a 56-pound weight like Big Tom Roche'. When Sonny placed his fingers on the bow, it covered the whole thing, so 'it took my father a long time to figure out what he was doing'. He later trained with a fiddler from Inistioge called Davey Gore 'who instructed him in the very same style' as Shaun Maguire, the Belfast-born All Ireland fiddle champion famous for 'The Mason's Apron'. 'The way to learn,' advises Jimmy, 'is to have somebody with you when you play.'

On the wall of Jimmy's home hang two photos of Michael Collins and Kitty Kiernan, side by side. 'Twas as Dan Breen said, "We have men to fight but when Collins got shot, the brains is gone." What a loss. Oh, Christ, t'was more than living words can ever, ever express.' And then, pointing at Kitty, 'that's the lady he was courting'.

Amby was a Collins man. They met occasionally 'above in Dublin' and perhaps knew one another in London. In 1932, Amby joined the Blueshirts and marched against de Valera's new Fianna Fáil government and its economic policies. When Irish cattle prices subsequently collapsed, the government began distributing 'free beef' to the poor, sending the hides to the tanneries. For the cattle farmers it was a disastrous policy. When Amby learned that a 'free beef' auction was to be held nearby, he felled some trees across the road and erected a blockade. The gardaí duly arrested him – on Christmas Eve, while he was plucking a turkey – and brought him into the barracks for questioning. 'They threatened him with everything,' says Jimmy with veneration. 'But not an inch would he give.'

Jimmy's maternal great-aunt was a grandmother to the Irish dancer Michael Flatley. 'There isn't a drop of American blood in him, only he was born over there,' says Jimmy loyally. Mr Flatley and Jimmy are mutual cousins of a bishop of whom, at a family wedding, Jimmy once enquired, 'Would you like to go to Heaven, being a bishop and that?'

His Excellency deftly replied, 'Sure everyone wants to go to Heaven.'

Sometime later, while the two men watched Amby Fanning perform on his fiddle, Jimmy leaned over and asked, 'And would you like to die?'

'Jimmy, no one likes to die,' replied the bishop.

'And yet, your lordship, you told me you'd like to go to Heaven.'

Jimmy does not expect a laugh at this punchline. He just tilts his head in a contemplative manner. Some time later, he exclaims, 'We have plenty of religion but god damn little Christianity.'

Amby Fanning farmed 40 acres in a few fields above where Jimmy lives today. They were a small family, just

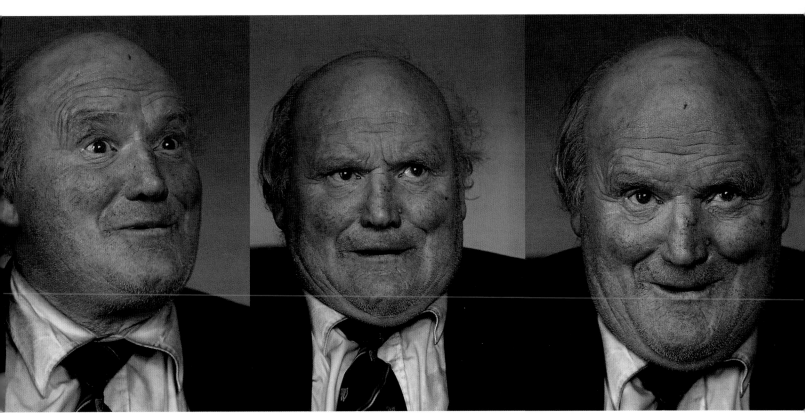

two sons, Jimmy and John Christopher. A baby sister died at birth. Jimmy went to school nearby and enjoyed it. However, when he was sixteen, his mother was stricken with multiple sclerosis and he left school to help her. 'The teacher said tis a pity you have to leave us. I would like to have stayed. By all means, yes. But I stayed with my beloved mother, God rest her.' There is also mention of a young nurse who wanted him to travel to London with her. But tempted as he may have been, he stayed.

Jimmy's mother died in 1958 and he spent the next few years farming the land with his father and brother, ploughing the fields with horses. In 1964, Amby sold the farm and, together with John Christopher, he sailed for London, where John Christopher joined the police.

It was Jimmy's intention to join his family. Indeed, the 22-year-old was headed out the door, destination London, when the man who bought the farm asked him to stay. Jimmy had already been helping him cut the harvest. 'What would the conditions be?' asked Jimmy.

'And he said, "I'll give you a pound a day and your grub and a room to stay", and, by God, I'm here from that day to this – the house I was born in – until I got my own house and now I have the pension! Maybe I did the right thing and maybe I did the wrong thing but, anyhow, now you have the full detail!'

Amby Fanning died in 1976 aged seventy-six. 'He was a lovely fiddler,' says Jimmy. 'He played the hornpipe too.' At which point, Jimmy starts simulating a hornpipe with his lips. He soon has a nimble whispery tune called 'Dunphy's Hornpipe' echoing around the room. 'Variations,' he says with a wink when he's finished. 'Variations, oh God, you can be sure of it.'

Jimmy can expertly simulate the hornpipe despite the loss of several teeth which occurred while he was 'testing cattle'. 'I reached down to grab the animal by the nose and the beast lifted its head and struck my chin.' And then, feeling his scalp, 'Jesus, I had a grand head of hair too and now it is gone as well.'

Traditional music is what delights him most. Amby used to say there must be something wrong with anyone who doesn't like music. 'A bitter heart hath no melody,' opines Jimmy. Like Amby, he is a whizz on the fiddle, performing on a rickety instrument he inherited from an aged relative. 'I hear tunes and I come on then and I play them by ear,' he says simply. 'My father and brother used to do the same, God rest them'.

When asked if he ever sings, Jimmy abruptly transforms himself into a tenor and launches into a full croon about courting a rose-cheeked young girl 'on the banks of the Foyle'. He can't help but think of his schoolteacher who was from Derry when he sings the song. But he keeps it humorous too. 'I worked hard for a living,' he warbles, then whispers, 'which I didn't.'

Jimmy continued to work on the land his father owned until the day he retired. He never married. 'I went for a lot of ladies,' he says soberly. 'And respected them, but I never got married still.' But, as he says himself, 'You never know who you'd meet anywhere; tis a thing accidental and you may yet get the biggest surprise.'

'You can make life very miserable,' he suggests. 'Or you can make it very good. Tis up to yourself, but you never miss the water till the well goes dry.' Jimmy is a wonderful man, honest, kind, gracious, immediately intimate, eyeball to eyeball, no agendas. Mere seconds will pass before he is straight into a chat with a stranger about local names, local places and the feisty fiddlers that amble in between. There is much eyebrow wobbling, chin stroking and cheery whistling but he delivers his lines with heartfelt panache, leaving you to ponder all the cryptic riddles contained within. 'Tis a bright world but we're still walking in the dark.'

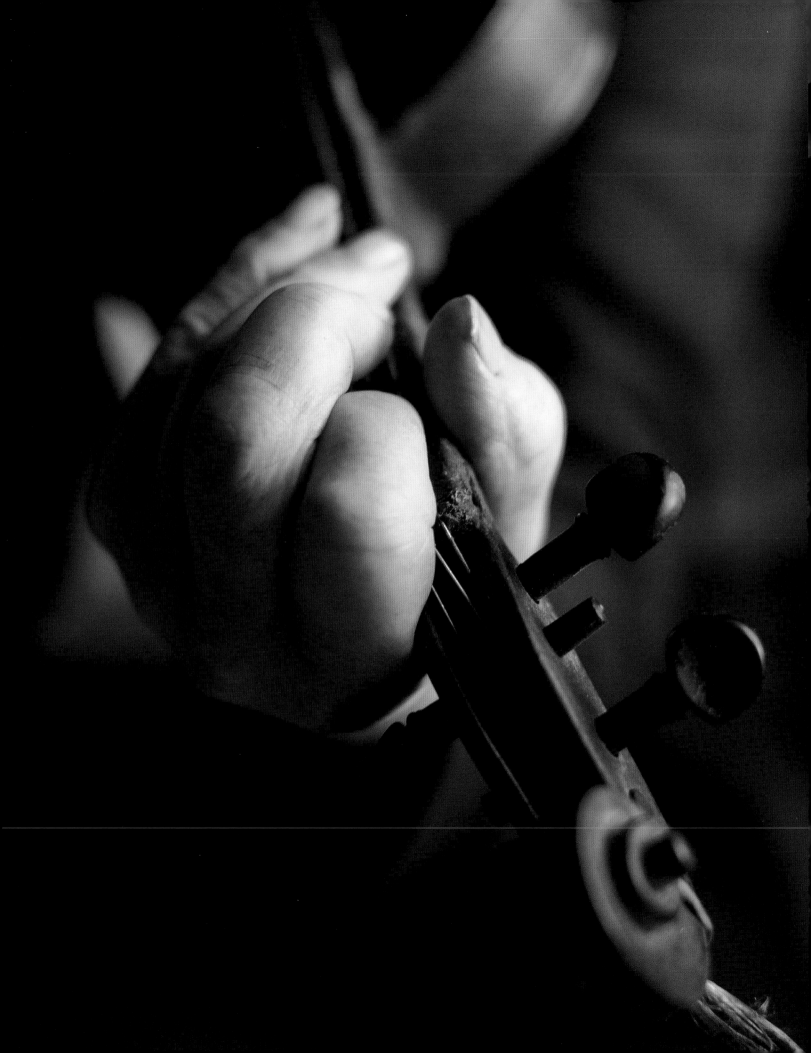

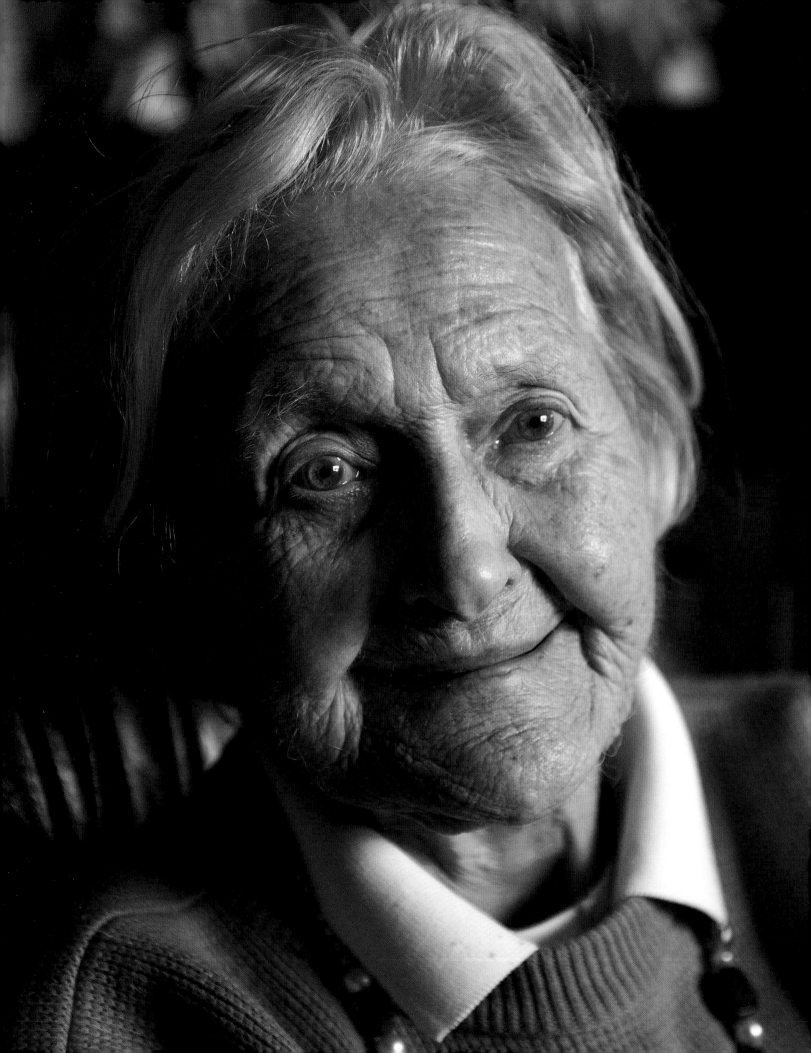

Nellie Shortall

Fethard, County Tipperary

Shopkeeper

Born 1913

'My mother told him not to go. Every night something awful happened and she knew how dangerous it was. "Paddy, don't go down tonight. They'll kill you." But my father said, "Ah sure, I'll manage." He went on then, down to the level crossing. But he came back on a trolley with a white sheet over him. We still don't know what happened. My mother wasn't able to talk about it. He was found dead on the line with his skull split.'

Ellen 'Nellie' Shortall was six years old when her father, Patrick Fitzpatrick, was killed in 1919. Paddy was employed by the Great Northern Railway as a gateman on the Meigh level crossing, a border posting on the line between Newry, County Down, and Dundalk, County Louth. Precisely why he was targeted is unknown, but perhaps his service with the Irish Guards, a British regiment, during the First World War stood against him.

Nellie remembers her father as 'a very tall and good-looking man'. Born in Grangemockler, County Tipperary, he was a champion ploughman in his youth. However, when the farm was seized for non-payment of rent, the family fragmented. One of his brothers became a policeman in Australia, while Paddy joined the Irish Guards. In about 1910, he left the army, returned to Ireland, married Nellie's mother and settled outside Clonmel where they had five children.

With the outbreak of war in 1914, Paddy rejoined the Irish Guards. Over the next five years, he bore witness to the terrible carnage of the Western Front. 'He was the last man to stand on the battlefield,' says Nellie with unmitigated pride. 'They were all dead around him and he was only wounded in the right wrist. He would have got the Victoria Cross but there was nobody to witness it.'

After the war, Paddy returned to Grangemockler, hopeful that the changing political situation in Ireland might lead to a re-grant of the family farm. With his military pension, he secured a house in Marlfield village, just west of Clonmel. Marlfield House was owned by John Philip Bagwell, general manager of the Great Northern Railway Company. And it was presumably Mr Bagwell who secured the 47-year-old war veteran his fatal posting at the Meigh level crossing.

'My mother loved it at Marlfield and didn't want to go, but my father loved travelling. Working on the railway was a good job with a free house, free travel, free education for us, free everything. And so we went. Unfortunately, the country was at loggerheads at that time and we weren't long up there when the sadness struck.'

Mrs Fitzpatrick was forty-two years old and heavily pregnant at the time of her husband's death. 'The company wanted to keep her there and give her my father's job. But she said, "How could I? Look at the ground with all that blood from where my dear husband was killed." All she wanted to do was to get back home to Tipperary.'

The widow and her family returned home shortly before the birth of her youngest son Tommy. Nellie went to school in the Presentation Sisters Convent in Fethard where the nuns taught her the basics of 'domestic economy'. She became highly adept at baking, butter making, ironing and sewing. 'I made my own Child of Mary cloak and my own dresses.'

During this time, her youngest brother Jimmy died of typhoid fever aged just seventeen. He was taken away to hospital in an ambulance and his family was prohibited from visiting. The news of his death was given to them in a telegram. 'That was a very sad part of my life,' says Nellie. 'He was a very talented young boy, over 6 foot tall, great at sport. He could play the button accordion beautifully. My mother never got over his death.'

Meanwhile, Nellie started working as a cook in Rocklow, the Carroll family home outside Fethard, where she dazzled them with her culinary repertoire. During the war, she worked in Maynooth from where she would cycle into Dublin to buy tea from Findlaters, returning with the valuable commodity, then rationed, strapped to her bicycle. She also went to County Clare

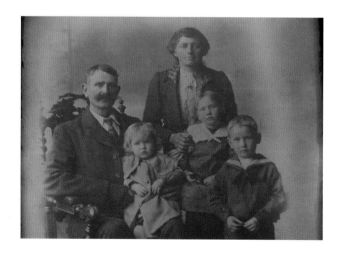

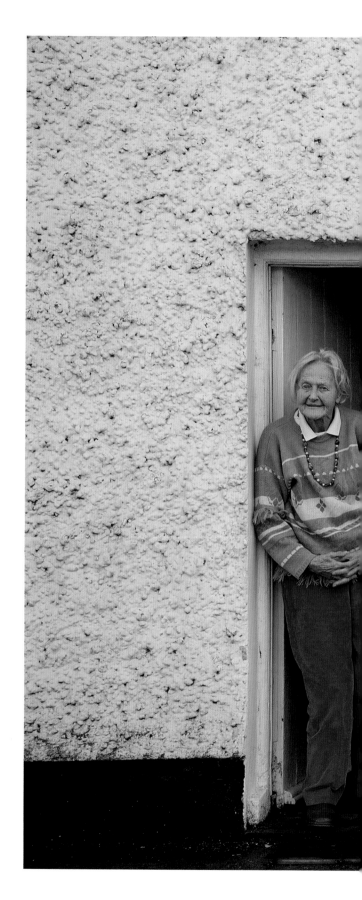

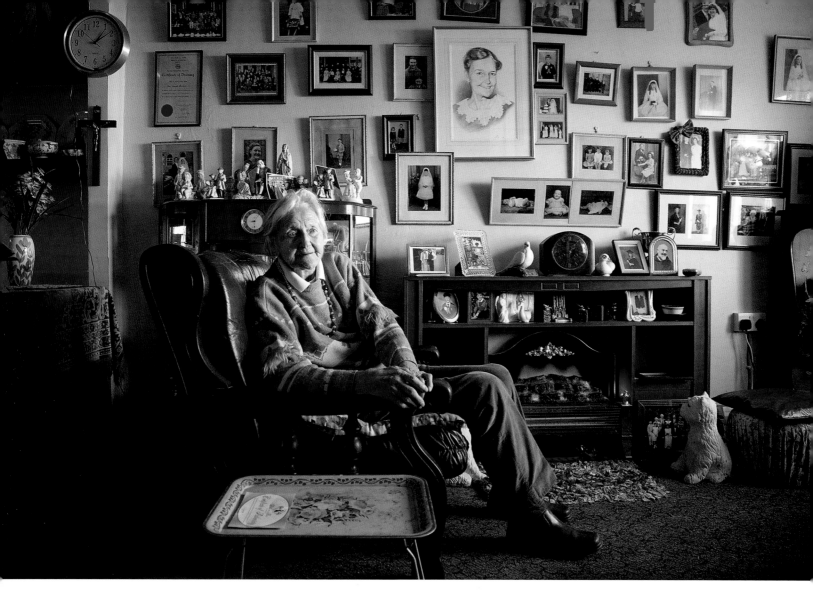

and worked in a guest house in Lisdoonvarna and a pub in Kilkee. 'I wanted to open my own guesthouse,' she explains. 'So I learned all about cooking and housekeeping and bar work and cleaning toilets and whatever else I could learn!'

However, by 1945, she was plagued with a debilitating illness. What she initially thought was a toothache transpired to be a serious thyroid problem. 'The operation I was advised to take would have left me with big raw stitch marks on my neck. I was a young woman and I didn't want that on my neck.' But then she learned of 'a new way in London where they could clip it instead of stitching it'. It occurred to Nellie that if she found work in England, she would be entitled to free health care, so she decided to go to London and began scanning the *Daily Mail* for jobs.

In early 1947, her intrepid pursuits paid off when she secured employment as a cook in St John's Wood. Her employer was the writer F. Tennyson Jesse, a great-niece of the poet Alfred, Lord Tennyson. Considered one of the more remarkable criminologists and journalists of her age, Tennyson Jesse was amongst the first to report on German atrocities in Belgium at the start of the First World War. Her husband Harold Marsh Harwood was a cotton merchant and manager of the Ambassador's Theatre in London's West End.

'My mother was very frightened about me going to London,' says Nellie. 'But Tennyson Jesse and Harold looked after me and they became great friends.' Tennyson Jesse later gifted Nellie a copy of her book *Sabi Pas or, I Don't Know*, inscribing the book, 'For Ellen Fitzpatrick whose name is like a lovely chord on an organ.

Mine is an old name and a good name but it does not sound so beautiful.' Nellie keeps the book in her sitting room as a reminder of her London years.

From St John's Wood, Nellie made her way to Newend Hospital in Hampstead where she had 'a most beautiful, successful operation', followed by four weeks' convalescence in Margate.

It was still Nellie's plan to move to New York, where her sister Jo lived, and open up a guesthouse. However, during a visit home in 1947, she met Larry Shortall, the son of a farmer from County Kilkenny who had lately set up a business distributing coal, timber and turf from premises on Fethard's Main Street. Nellie told Larry of her plans to open a guesthouse in America. 'If you marry me, you'll have America at home,' he replied. The offer was accepted and the Shortalls were married in 1949. Three children followed, John, Marie and Anne.

Larry and Nellie duly set up The Valley Stores on the outskirts of Fethard. 'People used to come from all over the country for our cabbages and carrots and potatoes.' These were grown in a long garden that Larry created behind the shop and which he regularly ploughed with a horse. Nellie also sold blackcurrants and other fruits, grown in the garden, as well as jams and home-baked bread and tarts.

Nellie kept the accounts for Larry's fuel and second-hand furniture business. 'He had the turf and the timber and he got coal in from England. It was hard work. He'd break up the coal and saw the timber, weigh it all up and put it into bags. Then they'd put it into lorries and bring it off. Our son John also worked with us over the years and helped develop the business.'

'We were always working,' she sighs. 'The only time I got out from the shop was when I went up to mass. But I always loved my holidays. We would go to Tramore with the children. And I regularly went up to Dublin, to Arnott's and Switzer's, so I could keep up with the fashion! I still go up whenever I can.'

The Shortalls continued to work together until Larry's sudden death in 1978 in his seventieth year. Nellie closed the shop soon afterwards, removing the counters and converting the space into the living room where she spends much of her time today. 'It was the right time to close,' she says. 'There were shops all over the town at that time. But by the late 1970s, the big supermarkets were coming, the VG shops and Five Star and Dunnes Stores.'

Nellie has never been inclined to rest her feet for long. Indeed, she still appears on the streets of Fethard on a motorised scooter. 'I kept myself busy all the time,' she says. 'My brain is always working.' Her desire to keep learning remains fundamental to her being. After Larry's death, she became actively involved with the Hogan Musical Society, singing with the cast in many of their shows. She took up the bodhrán at the age of eighty-five and played the violin up until recently. She has won endless cookery contests. She was also a regular at the Dublin Horse Show, winning a prize as Best Dressed Lady which earned her an appearance on the *Six O'Clock News*. In recent years, she also joined the Irish Countrywomen's Association and began painting and making pictures from scraps of tweed. Some of these works now hang on the wall of her living room, the former shop, alongside photographs of her extended family.

She is in the process of reorganising her photographs when we visit, preparing to write a caption on the back of each. 'The young people don't bother much about old things, but I kept everything! When I'm gone, they'll know nothing about who any of these people were unless I put the names on the back of the photos.'

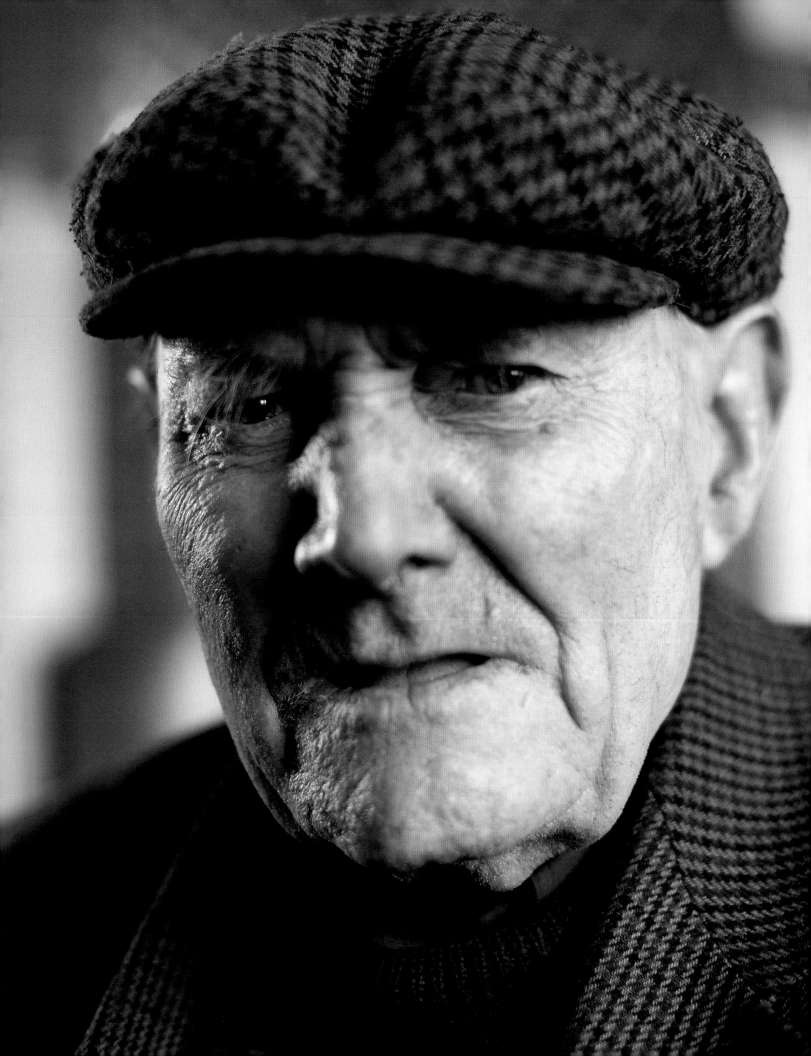

Tom 'Ned' McMahon

Kilfenora, County Clare

Builder & Actor

Born 1919

'Tis a bit of a wrong age for you to be turning dishonest, but you must do it now. On account of the depopulation, no shopkeeper can keep alive unless he waters the drink and sells short weight and robs both rich and poor.'

Thus spoke Tom 'Ned' McMahon a hundred times or more. They were not his words as such. They belonged to Paddy King, an 80-year-old farmer who reckoned himself to be 'an irresistible ladykiller' but who was, in point of fact, an innocuous numbskull.

Paddy King was one of the main characters in *The Wood of the Whispering*, a dark but poignant comedy about emigration and chastity written by M.J. Molloy for the Abbey Theatre in 1953.

In 1957, the play went nationwide with Tom Ned and the Inchovea Players, an impressive amateur theatre company from the tiny east Clare village of Inchovea. The eleven-strong company was founded by Tom Honan and his actress wife Carmel. Amongst other plays they staged were M.J. Molloy's 1963 comedy *Daughter From Over the Water* and Bryan MacMahon's powerful hunger-strike drama *The Bugle in the Blood*. But *The Wood of the Whispering* was their biggest hit and, having performed at Muintir na Tíre festivals and fleadh cheoils across the country, the Inchovea Players returned home with several medals including an All-Ireland title and the coveted Rural Cup from the Killarney Drama Festival.

Playing Paddy King was the highlight of Tom's acting career. 'I wore a big black moustache which I clipped with a pair of sheep-shearers,' says he. And as luck would have it, his brother Jack was playing the role of Paddy King's deranged brother Jimmy in the play. 'Oh, I gave him plenty of abuse all right,' smiles Tom.

'We were very brilliant at remembering our lines,' he explains, when asked why the Inchovea Players were a cut above. 'It's something within you and if there is a bit of it in you, then you can act. The same as playing music. I had a big script but I just learned it.'

It undoubtedly helped that the Honans ran a tight ship. 'I went into a pub before a play one night and I had the four whiskeys ordered for myself and three others. Tom Honan came in and clipped me around the head and said, "What the hell are you doing Ned?" He wouldn't let us touch them. But we were good. We were always well able for a play. And we partied very well afterwards.'

With so much travelling under his belt, Tom was a man to be admired. One neighbour remarked to him, 'You'd need to be hammered and galvanised to listen to you, you had it so well off!'

'And I did have it well off!' agrees Tom.

Tom's father was James McMahon, a farmer who fattened his cattle on the same 50-acre farm in Inchovea where Tom was raised. Tom's mother Mary McCarty grew up near a waterfall known as the Seven Streams of Teeskagh. In the legends, these streams were the milk of a sacred cow. 'When the big floods come down the mountain, the water tumbles through Teeskagh,' he says.

Born in November 1919, Tom – or 'Tomás', as he was christened – was one of six children. To distinguish them from other McMahons in the area, they were known as the 'Ned McMahons'.

He went to school in Inchovea where he excelled at Irish, which he also spoke at home. 'They say it is a hard language to learn, but it isn't,' he insists.

When Tom left school in 1934, emigration was considered the only option for many in Inchovea. 'I knew seven girls from the one house that all went to England,' he says. 'And six of my father's brothers were in America at one time.' He still chuckles about a friend who feared that the skyscrapers in New York were getting so tall that the moon wouldn't be able to get past them.

However, Tom struck lucky and found work with a building contractor who is 'dead since, the Lord have Mercy on him'. 'I was never tempted to emigrate then, because I always had work here on the buildings and that gave me a few bob to rattle.' He worked 'as a kind of superintendent', building a large number of houses around Corofin and as far south as Ennis.

Tom never married. 'I kept the women to one side,' says he. For him, life was about music and theatre and the occasional gamble on the gee gees. 'I was at the Galway races a thousand times,' he says, recalling a victorious £114 treble, followed by an £80 win on the Tote, on the very day he witnessed The Clancy Brothers perform. He also went to the Galway racecourse to meet the Pope. 'I was within the roar of an ass of him but I wasn't able to shake his hand.'

Some divine compensation came his way in 1997 when the veteran stage actor was recruited to play in the Annual, All-Priests, Five-a-Side, Over-75s Indoor Challenge Football Match for the third series of *Father Ted*.

In 1998, he moved from Inchovea to his present residence in Kilfenora, a practical move that placed him within walking distance of shops, pubs and the church. Already famed across east Clare, he became an icon of Kilfenora, singing songs and telling tales. He can hum and lilt like his cousin Robbie McMahon of 'Spancil Hill' fame. His brother Jack was also famed for his rendition of Martin Reidy's 'Tangaloni'. And while he doesn't play any instrument, Tom knows all the Kilfenora reels by ear. 'The Three Flowers' is a favourite song, he confides. And lo, as we sit and talk, he leans back in his chair and sings:

> 'She took a flower and kissed it once
> And softly said to me
> "This flower I found in Thomas Street
> In Dublin fair," said she.
> "Its name is Robert Emmet
> It's the youngest flower of all
> And I'll keep it fresh beside my breast
> Though all the world should fall."'

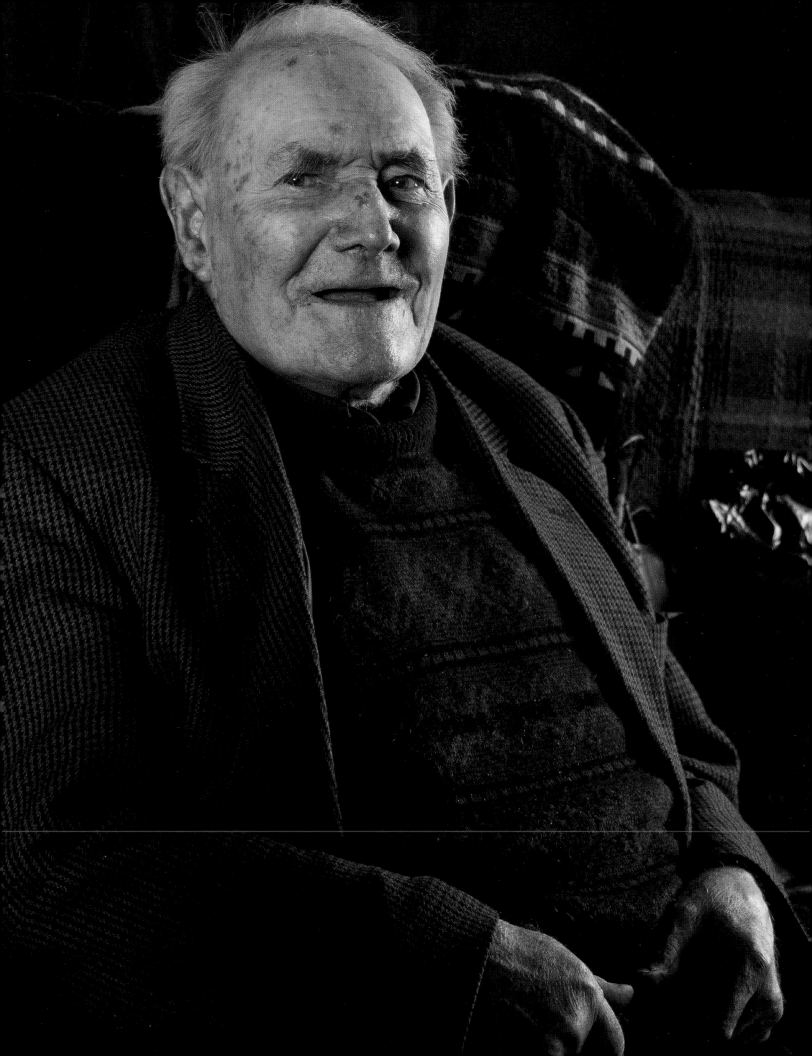

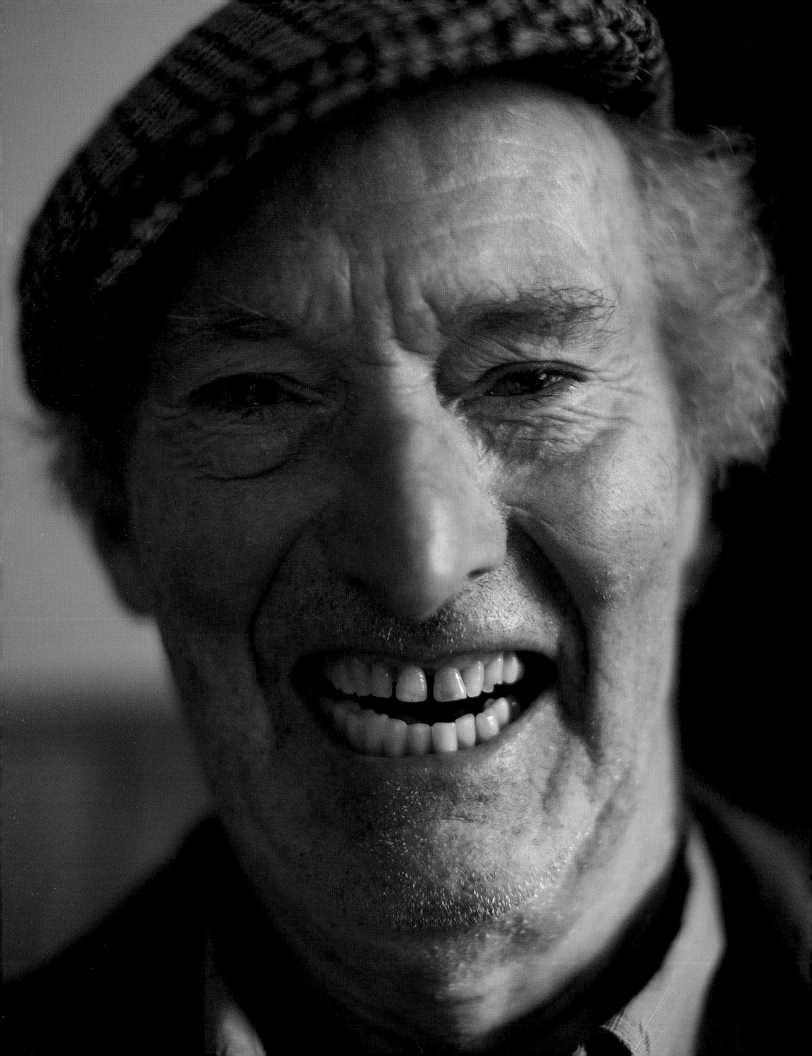

Tomás Ó Nialláin

Gort Inse Guaire, Chontae na Gaillimhe

Farmer, Policeman & Melodeon Player

Born 1932

If they had to choose their absolute favourite, the cows would probably opt for the Kilfenora Céilí Band. Certainly, when Tomás played the Kilfenora's reels to his cattle, they stood easy and the milk flowed pure and simple. But when he threw on a rock 'n' roll record, all hell broke loose. 'It had them cracked,' he recalls. 'They broke the machines and fences and everything.' To play it safe, Tomás generally just sang while he milked, and that did the job. 'Republican ballads,' he says. 'Some of the cows sang along.'

Tomás is a quick-thinking, inspirational and engaging soul. His farmyard is neat and intelligently planned. His cattle live in a field that rolls up a hill, open to a conifer plantation on one side. 'I have the conifers for shelter,' explains Tom. 'It protects the house from the wind and the animals can go in amongst the trees when they need to.'

At his peak, Tomás kept a hundred head of cattle, as well as a substantial flock of sheep. He used to ride out to inspect them on a horse. These days, he has a herd of eighteen Charolais and life is somewhat easier. In fact, he has lately renovated the old cow-house into a new residence for himself and his wife Maureen. The place where his cows once milked and mooed is now the Ó Nialláins' living room.

'I was bred, born and reared in the shade of Lady Gregory's Coole,' says Tomás. 'But to tell you the truth I wouldn't be sure when my birthday is.' He likes to think it was the same spring day that Lady Gregory died in May 1932. His father was a tenant on Lady Gregory's estate at Coole Park, just as his grandfather and great-grandfather had been. 'My father had hopes to introduce me to her ladyship.'

Tomás was one of ten children, five sons and five daughters, raised by Packie and Birdie Ó Nialláin. As children, they often played amid the abandoned house and gardens of Coole Park. That pastime came to an end in 1941 when the Board of Works made the dismal decision to demolish the house where Synge, Yeats, Shaw and so many others drew their literary inspiration. 'It was a national disgrace,' says Tomás. 'I have a very vivid memory of men throwing down the slates. There wasn't a stone left upon a stone when they finished. But then a priest come to Gort and he had an interest in Coole so he turned it into a national park with lovely walks and seven woods and forty-nine swans and all this. It's a very fine tourist attraction now.'

Talk of tourists leads to the tale of his neighbour Tommy Geraghty who was headed to the bog one

day to cut turf. 'At that time, the tourists were all on bicycles and didn't a Yank pull up to Tommy while he was walking and say, "Excuse me, is Spancil Hill far?" "Well now," says Tommy, "as the crow flies, tis about ten miles." "Okay," said the Yank, "but if the goddamn crow was on a bicycle, how far would it be?" "About twenty-five."'

Another of Tomás's neighbours was a basket-maker, the last of his kind, and it was he who taught Tomás how to make baskets from the branches of a willow tree. As Tomás rotates one such basket between his hands, he muses upon his motive for learning the craft. 'I felt that if I lived too long, then I wouldn't be able to walk or talk, but maybe I would still be able to knock up a basket.'

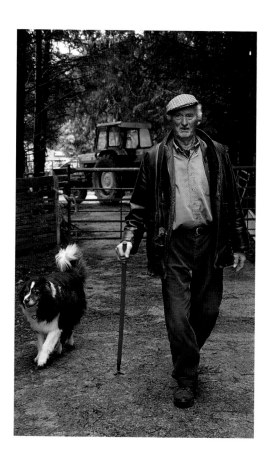

Tomás is all about contingency plans, improving situations, making life smoother, smarter and, wherever possible, more enjoyable. Keeping busy is part of his raison d'être. 'I couldn't be idle. I belong to the great outdoors. I never went for rest or anything like that. I always have things to do.' His desire to learn is lifelong; even at school he attended night classes for 'woodwork, languages and things'.

After school, he spent five years working for a local stonemason, building private houses between Tubber and Corofin. 'Construction was the only work going at the time,' he says.

At the age of twenty-three, Tomás successfully applied to join the Dublin Metropolitan Police and went east to be trained in the Phoenix Park. The young Galway man fetched up as a security man in Dublin Castle, with specific instructions to 'mind and protect' Taoiseach Éamon de Valera and any visiting foreign diplomats. 'I was a young buck who knew no fear,' he laughs. 'But I had a wonderful time in Dublin. I met the finest men and women ever known in the police. I rowed in the Liffey, swam in the Forty Foot, boxed in the National Stadium … It was a great experience.'

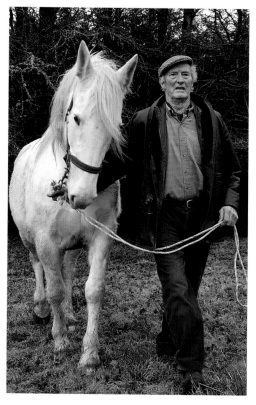

After five years as a policeman, Tomás decided to resign his post and return to his native county. One day in 1955, he went to a dance in the local ballroom and met Maureen Sheehan, a niece of the couple who owned the

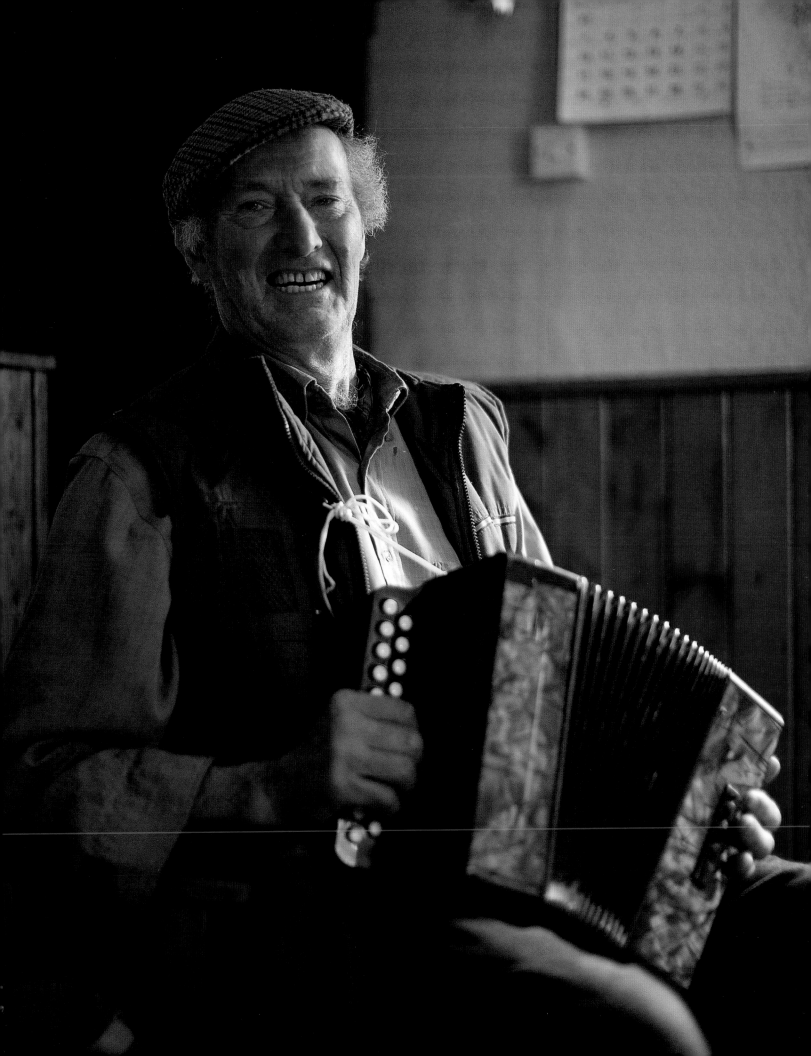

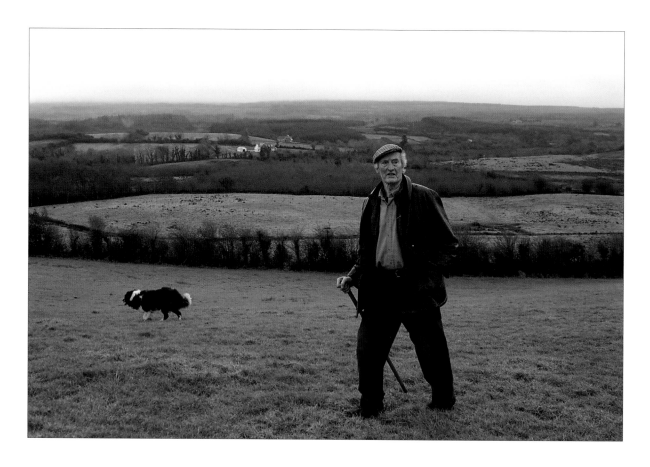

venue. 'That was where everyone went at that time,' says Maureen. 'We would come in on our bicycles from every direction, from Killanena in east Clare and Tulla and Spancil Hill and Corofin and all along Tubber. It's where we met and it's where every one of my friends met their husbands.'

'My own wedding was the first I had ever been to,' says Tomás. 'The morning we got married, everyone was talking at breakfast and they asked me to say something. I was so excited and privileged to have the lovely girl. I wanted to thank her father and mother for giving her to me. But what the Christ did I say only I thanked them for giving me the farm.'

The marriage did indeed give the newlyweds a farm close to Lough Cutra and just ten miles from Tomás's childhood home. This is where they raised their three sons and three daughters.

'I belong to the land', says Tomás who strides across his farm every day, humming and lilting, with a handsome stray called Skippy by his side. During the 1960s and 1970s, he planted large numbers of ash, oak and lichen-hued beech, as well as the conifers beneath which his cattle shelter. In an adjacent meadow, as round as the sun, a white draught mare ambles alongside a young filly who has been handled so much that she is soft as a Spaniel. 'If a man has a horse that doesn't work, it's the man that is wrong,' he says.

There are always challenges, the hard frosts, the falling prices, the wild deer that have been chewing his crops. He can view his entire farm from the summit of Sheehan's Hill, with Lough Cutra, the hills of County Clare and the Atlantic Ocean glittering darkly far away, beyond Kinvara.

Tomás produces a rickety Horner melodeon held together by masking tape. 'When I was doing stonemasonry, I had a very bad bicycle,' he says. 'There was a little shop in Gort with a Raleigh bicycle for sale in the window for £14. I was earning £1 and 10 pence a day. I decided to buy it but, when I went back, this melodeon was

right beside the bicycle for the same price. So I walked with a bad bicycle for the rest of the time after that.'

With his eyes closed, he plays three consecutive polkas that his granddaughter taught him. The polkas were 'smuggled up' from County Kerry into this proud land of jigs and reels. 'Did you like them?' he asks when he's done. 'If you didn't, I can play them again for you.'

Music has always been a major part of Tomás's life. In his youth, it seemed that everyone he met played some instrument or other. As a policeman in Dublin, he often slipped into the homes of 'the poor people' around the Coombe to take part in a session.

Tomás's mother was a genius with a single-row melodeon, or button accordion. 'She had one of the real old types, with four stoppers on the end. It had a most beautiful sound and she played it brilliantly, with great timing and great rhythm. She learned from an uncle a long, long time ago, and she knew the right amount of decoration to give a tune. That was the way we spent the long winter nights!'

A neighbour taught him how to use a double row melodeon, explaining how one row was for jigs and the other for reels. He is also a dab hand with the bodhrán. 'It is sixty years since that goat came down from the Burren Hills,' he says of his goatskin bodhrán. 'And Christy Moore was the last man to play it before me. If you put your face to it, you can get the smell of Christy's sweat.'

Maureen's family were also fine musicians; her mother was a noted concertina player. The musical blood ensures that Tomás and Maureen's grandchildren are passionate players. Tomás often duets with his granddaughter which is surely one of the happiest places a grandfather can find himself. In fact, the Ó Nialláins frequently host céilidhs in their kitchen and only three days before our visit, there were seventeen playing, young and old, from all over the county.

There was dancing too, sean nós and sets. 'We learned how to dance when we were children but we only learned the south Galway set,' says Tomás. 'We didn't even know there was any other set because we never left the village!' He got a considerable insight into alternative sets when a gang from County Clare stood up and performed the Caledonian on board a flight to Paris. As the dancers began reeling down the aisle with mounting excitement, the captain ordered them all to sit down 'or they'd break the bottom of the plane and we'd all be drown'ded'.

Tomás was headed for Paris for a short rambling tour of France and Germany with his old pal Charlie Piggott, the banjo player who co-founded De Dannan. The pair played together for over thirty years, mainly at the Royal Spa Hotel in Lisdoonvarna, and Tomás still sometimes performs the melodeon in the pubs of Gort.

The Ó Nialláin home is an Irish-speaking one and Tomás is a proud gaelgóir, or fluent Irish speaker. As his daughter Martina puts it, 'Is cáinteoir Gaeilge é a bhfuil an-mheas agus grá aige don teanga agus tugann sé tacaíocht don Ghaeilge agus d'fhoglaimeoirí Gaeilge.' (I am an Irish speaker with a great respect and love for the language and I support those who wish to learn it.)

'I'm hanging in by the toenails now,' Tomás says of his senior years. 'I'm stone deaf in one ear and I can hear nothing with the other one.' There's foggy cataracts, arthritic fingers and missing teeth too. But life moves on, and you must play the tune accordingly. The concrete ballroom where Tomás and Maureen's romance began was flattened in 2010 to make way for a supermarket. There have been other changes too, such as the local population. 'Cromwell sent all the poor people here and then Maggie Thatcher sent us all the hippies,' says Tomás. 'One of them came up and asked me what was the Irish for water. "Uisce", I told him, and that's what he named his child. It's a nice name, I suppose.'

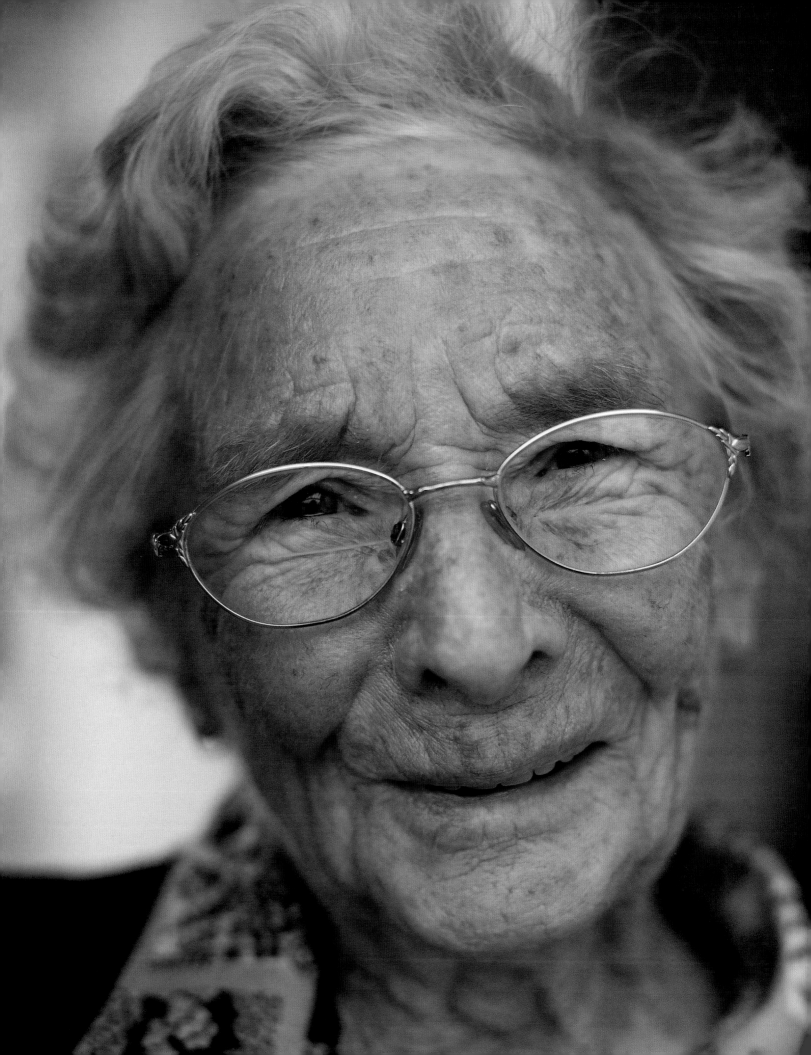

Maisie Grannell

Enniscorthy, County Wexford

Seamstress

Born 1925

'I could hear my two legs breaking the same as sticks. And I never lost consciousness but, to tell you the truth, I didn't think I could even be alive.'

Maisie Grannell was walking to mass in Enniscorthy when the car struck on that dreadful Sunday morning in January 2001. The vehicle lost control on the icy road and slammed her into a stone ditch. She lay on the road for nearly an hour before the ambulance came. In that time, a passing Traveller woman adopted the role of the Good Samaritan. 'She had a bottle of holy water and threw it on me,' chuckles Maisie. 'The poor lady thought she was doing right but all it did was make me colder.'

One of Maisie's legs was amputated which, given that she was in her seventy-seventh year, might have understandably driven her to an early grave. But Maisie is made of exceptionally sturdy stuff. She is hardwired to survive, no matter how glum things get.

It is probably a family thing. In the late 1890s, Maisie's grandfather, Gareth Sunderland, was employed making farm implements for a company called Bolger's of Milltown near Ferns, County Wexford. 'There was a grinding stone for putting edges on the sickles and scythes,' says Maisie. 'One morning, my grandfather was cleaning the grinding stone when someone switched it on and he was killed.'

After Gareth's death, his widow Ellen was apparently evicted from their home in order to make way for Gareth's replacement at Bolger's. Maisie says Ellen was literally put out on the road, along with her three sons and daughter. As she made her way south towards Enniscorthy, she was welcomed into a house at Scarawalsh by a family called Whelan. 'They were poor farmers,' says Maisie, 'but they brought them in and gave them tea and bread and butter.' William, the oldest boy, stayed with the Whelans while his mother and siblings headed on for Enniscorthy. William Sunderland was Maisie's father.

William left the Whelans after several years and went to work on a farm near Bree. He then joined the threshing gang of a farmer called Kavanagh and in time, he was given charge of his own steam-engine, travelling to farms all around Wexford and south Kilkenny on his bicycle. Always conscious of his father's tragic demise, William was wary of threshing machines, particularly when someone 'green with the drink' was operating it.

Shortly after the outbreak of the First World War, William married Mary Cahill, the daughter of a mountain

farmer from Kiltealy, County Wexford. In 1916, Mary gave birth to a little girl in Enniscorthy whom they named Ellen in a tribute to her grandmother. Three sons and another daughter followed, though one son perished from the whooping cough as a baby.

By the time Gareth, the oldest boy, was born in 1919, William and Mary Sunderland had moved to Clonhaston, near Vinegar Hill, where they lived for the next fifty years. It was a typical thatched, white-washed, two-room cottage with an open fire.

Maisie, the third of William and Mary's children, was born in Clonhaston in November 1925 and christened Mary Theresa. She was educated at the Sisters of Mercy Convent in Enniscorthy where she says she generally behaved although she does recall 'at least one slap'. She also had to be on best behaviour for her mother.

'My mother was a very good woman,' she says. 'She was also a very exact woman! My father wouldn't say boo to a fly but my mother would give us a slap all right. She taught me how to cook and bake and make butter and everything and anything.'

Maisie was nine years old when her mother gifted her a small lidded pan and taught her how to bake bread. By the time she was a teenager, Maisie was able to make a Christmas cake on the open fire at Clonhaston. 'You'd make the fire up with whatever bushes you got from the fields and then surround the pan with wood so it was like an oven.' In time, she would pass these skills on to her daughters and it is certainly no coincidence that one of Maisie's daughters now makes cakes and buns professionally in England.

Maisie left school in 1939, aged fourteen, to help out her parents. We were caretaking a farm for a man who lived a long way away in Gorey. He allowed us to keep a couple of cows in return for minding his cattle.'

Her brother Gareth also kept a pair of workhorses on some nearby land, which he used to draw stones from the quarry. At certain times of year, Gareth would bring the horse and cart to the Sunderlands' small farm. 'There was no manure spreaders like they have now,' says Maisie. 'The horse and cart would be brought to the field and we'd get the sprongs in and spread the manure all over the drills, for the potatoes or turnips or cabbage. I was a very young girl, about ten, but it never bothered me. I had to do it and that was that.'

Her mother taught her how to sew. She duly spent twenty-four years working part-time for the Springs of Ballynadara House in Bree, 'making horse rugs and suits and racing caps for all the fellows who were riding'.

In 1955, Maisie married Jack Grannell, a farm labourer who was twenty-five years her senior. They had a son, Dennis, and two daughters, Maureen and Betty. Maisie was determined her daughters would go into adulthood with as many domestic skills as possible. 'I taught my girls how to bake, how to cook, how to sew and knit, and everything like that. I used to say, "If you're out in the world and you don't want to do these things, you don't have to … but it's nice to be *able* to do them if you do want to."'

'I had to work very hard to educate the children,' she says. 'I got no free school books!' As well as making horse rugs for the Springs, she became one of the most prized housecleaners and childminders in Enniscorthy and spent thirty-one years working as a housecleaner for the Church of Ireland rector.

At the same time, she was looking after her aged parents. Tragically, her father became crippled with arthritis in the early 1950s and Maisie spent 'sixteen long years' putting him to bed and helping him get up. Although she is a lifelong pioneer, every morning and night she gave him a cup of whiskey with sugar to boost him along. William Sunderland had spent the last decades of his working life employed as a ganger, building and maintaining roads for Wexford County Council.

Ironically the Sunderlands' own house at Clonhaston was located on a poor stretch of road which was prone to flooding. Maisie recalls one dark, wet November night in 1966 when she was minding her parents. Awoken at 4 a.m. by the sound of gushing water, she rushed to her parents' bedroom and found them still fast

asleep with 'the water nearly up to the mattress'. Her father was bedridden and blind by that stage, so she had to run up the road to a neighbour's house and throw pebbles at his window to get help. The neighbour carried William out on his back and brought them to his house. Maisie took all the water out herself, with a bucket and sponge, but she was unable to save the dressers or the mattresses.

Mary Sunderland died shortly before Christmas 1969 and William passed away the following August. If Maisie thought that her days looking after debilitated souls had ended with the passing of her father, she was to be sorely disappointed when Jack was blinded during a botched eye operation in the late 1970s. The Grannells' daughters were still in their teens when Jack passed away shortly before Christmas 1985.

Not everything has been bleak. 'There was always dancing and music in my home,' she says. 'The night of the threshing, we'd have a dance that was the greatest fun. We'd go until maybe one o'clock in the morning.' She also taught set-dancing down in Ballyedmond on Friday evenings for over twenty years, until she 'met the accident'. 'But I sent my daughters to be taught by someone else because maybe they wouldn't do what I told them! And they are both All-Ireland champions.'

When Enniscorthy Cathedral was refurbished in 1994, Maisie was commissioned to make a patchwork quilt, along with all the bunting for the church railings. She continues to keep busy with her sewing machine, making wedding dresses and christening robes.

Maisie has endured considerable hardship in her life between her accident and the time she devoted to looking after her parents and husband. But by dint of her amazing determination and sheer work ethic, she has survived with her sense of humour intact. But politicians, be warned. Maisie has a catapult and a bag of road chippings set aside for door-to-door canvassers – and she knows how to use them.

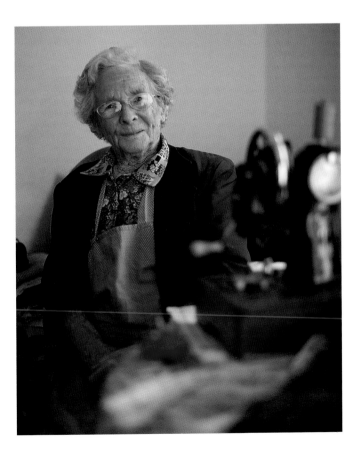

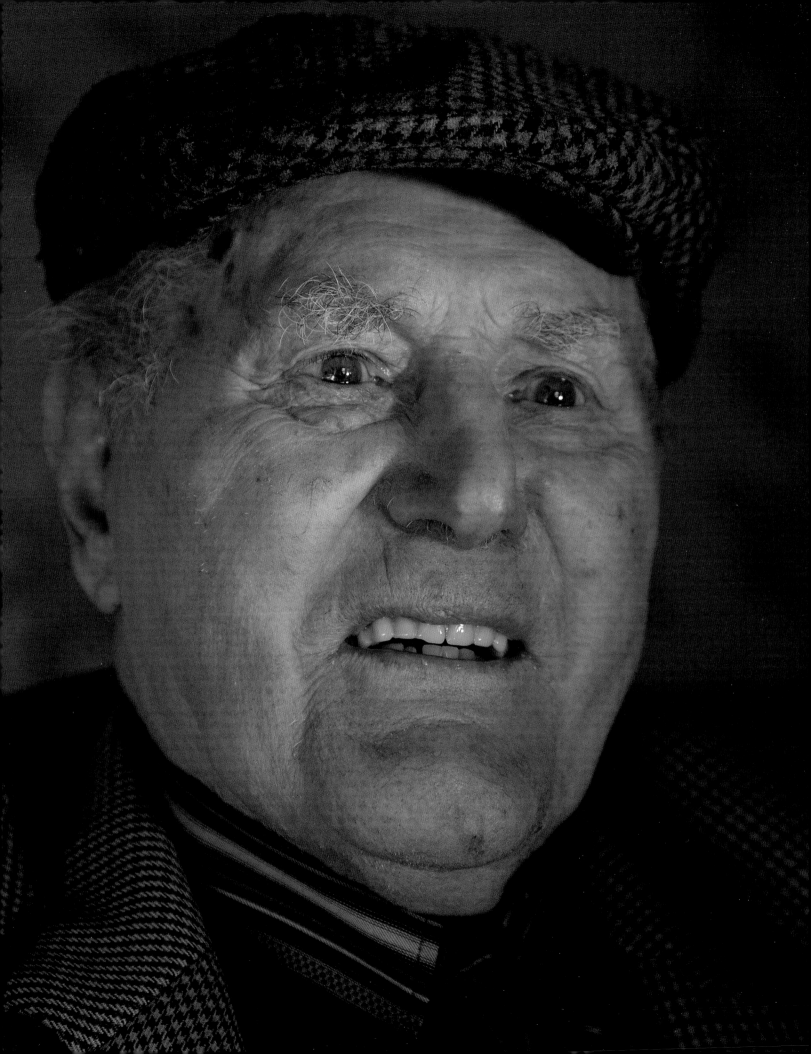

Paddy Faley

Glenbawn, Ballyhahill, County Limerick

Ganger, Farmer & Poet

Born 1919

'It has long legs and crooked thighs, a small head and no eyes.' Paddy Faley looks directly at me, his eyes luminous, as I scratch my head and look increasingly confounded.

'The tongs for the fire!' he says at length. 'Another one. It has a bow-legged father, a fat-bellied mother and three little children all the one colour.'

Riddles were a big part of Paddy's childhood. In general, the answer lay within view of the boys and girls gathered around the blazing turf fire. And the riddles they relayed were little different to those which had perplexed his father when he was a boy in the 1870s.

Paddy clearly enjoyed his childhood. In fact, he seems to have enjoyed all ninety-one of his years. However, that cannot be entirely true because he has experienced great sadness along the way. His beloved wife Nell died in 1962, less than ten years after they were married, leaving him with five small girls to raise. When Paddy mentions this, there is the briefest of shadows, but he is quickly on the up again.

The Faleys are a resilient tribe who originated in Kerry. His grandfather Mick Faley (or Fealey) was born in 1838, shortly after Queen Victoria ascended the British throne. In 1859, he married Ellen Sheehan, the daughter of a farming family from Kilbaha, County Kerry. 'The Sheehans were famed for tricks for meeting their future husbands,' says Paddy. 'She saw a young man sitting on the bridge in Athea and she seduced him.' Family lore holds that Ellen was twelve years older than Mick but on the 1901 census the age gap is kindly reduced to two.'

During the 1860s, Mick found work as a road labourer and joined the force of a private contractor called James Lynch, 'making the Kerry line' as the road from Shanagolden into County Kerry is known. In 1866, Mick acquired a remote 5-acre patch of bog from Mr Lynch where he and Ellen duly built a house and settled. The bog was in Glashapullagh, Kilmoylan, County Limerick. The family simply called it 'Glasha' and this was the house where Paddy was raised. 'We didn't have an avenue. We lived three quarters of a mile from the road, inside the mountains.'

Mick and Ellen had seven children, two boys and five girls, all of whom stayed in Ireland. Denis, their oldest son, was Paddy's father. He was born in 1868 and married at the age of forty-one to Bridget White, fifteen years his junior. Five sons and a daughter followed. Paddy, their fourth child, was born in Glasha on

what he describes as 'a dewy April's morn' in 1919.

Paddy has cheerful memories of Glasha.

Of his father twirling his moustache and telling tales of old.

Of scampering across the bog to the shop to fetch a half quarter of plug or Bendigo tobacco for his father, or maybe a half-ounce of Clarke's white cap snuff 'for my mother's pleasure'.

Of loading eight-gallon milk tanks onto his back and striding out across the bog to leave the milk out for the creamery truck – Denis kept a handful of cows in a small meadow beyond the turf.

Of ragging and bashing away at drums and cymbals with his brothers. Paddy topped 6 feet but his brother Mick had a couple of inches on him and was evidently a strapping fellow. 'I could lie down on the floor and Mick would catch a grip of me with his teeth and rise me up. He must have had awful teeth. When he went on to England after, they said he was the strongest man in the country and that he done the work of three men every day.'

From 1926 until 1931, Paddy was at school in nearby Ballyguiltenane where he remembers being cautioned against the pitfalls of alcohol. 'And I took heed of it,' says he firmly. 'I was never tempted to taste it since, and I only took one pull of a fag in my lifetime.' He then spent two years at Knocknagorna, just north of Athea, before leaving aged fourteen to work on the bogs.

He got a job with Limerick County Council, mending the roads his grandfather had built the previous century, and ascended the hierarchy to become a ganger. The men generally met in Glin or Ballyhahill at eight o'clock in the morning which meant an early start for Paddy. 'There was a time in the war that you couldn't get a bike so I had to walk to work. I would leave Glasha at quarter to six in the morning, come down the mountain and straight out from the bushes. In all kinds of weather! It used to be dark when I was leaving. But my eyes would get so accustomed to it that I wouldn't miss a step.'

He then worked until midday, an hour's break for lunch, back to the job until the Angelus rang out at six o'clock and home across the bog.

During the Second World War, the value of turf shot up and Paddy joined his father and brothers harvesting the bog. 'We had nine or ten employed at Glasha back in that time but bog was a great asset and we lived right in the middle of one.' In the 1950s, Limerick County Council built a new road across the bog and suddenly the Faleys' house was accessible to the world. 'I stayed on with the council but I also went into farming then.'

By 1959, Paddy had made enough money from the bog to purchase the Wolfes' farm three miles east from Glasha at Glenbawn, Ballyhahill, where he lives today. He moved there on 25 April 1959, his fortieth birthday. And that was the day he became a poet because he wrote his first poem that night, 'The Home I Left Behind'.

More poems followed and Paddy soon began appearing at Fleadh Cheoil competitions and féiles across west Limerick. Sometimes he told stories too. 'Recitations,' he says softly, making that one word alone sound like an ancient melody.

In 1977, he co-founded the *Ballyguiltenane Rural Journal*, an annual compendium of local lore, anecdotes and history, for which he has written over 250 articles. In 2003, he published a compilation called *The Life and Rhymes of Paddy Faley*. All 500 copies sold out within three weeks.

In 2000, aged eighty, Paddy Faley headed off to Britain as part of Joe Harrington's annual Irish Rambling House tour. He quickly established himself as 'the Grandad' of the group and he proved such a success that he returned again in 2001. Both tours were recorded as *The Tour of Britain* and *Live at the Galtymore*.

While he amassed medals and trophies galore, perhaps his greatest achievement was with the weekly 'Dear Sir or Madam' competition on RTÉ Radio 1 in the 1970s. He regularly won the 'one guinea' prize as his story

was broadcast to the nation. Paddy was still working on the roads at the time and his supervisor repeatedly marvelled, 'What education did you get with your spade and shovel, to be winning things like that?' Paddy duly converted his supervisor's remarks into another winning entry for 'Dear Sir or Madam'.

'I never wrote a thing until I came over here,' he says. 'Isn't that a strange thing?' Paddy's gift is all the more extraordinary because it is inherited, and yet neither of his parents could read or write. 'They were both illiterate,' he explains, 'but my father was a great storyteller. He could remember long stories, every word of them, like a seanchaí. And he'd pronounce every word correctly. He could compose, but he couldn't write. When I was young, he told us stories about fairies and ghosts and giants and leprechauns. And he could sing and play the Jew's harp. At night we'd say, "Tell us a story, Daddy" or "Sing us a song" and my mother would decide which he would do.'

Paddy's best-known poem is probably 'Minding the House', written in 1960, which describes a time when his wife Nell was ill and asked him to mind the house. 'And everything I did went wrong.'

On the day we visited, Paddy's granddaughter Lisa Daly gave birth to his first great grandson, Noah.

And, oh yes, the bow-legged riddle? Pot hooks and a three-legged pot stand, of course.

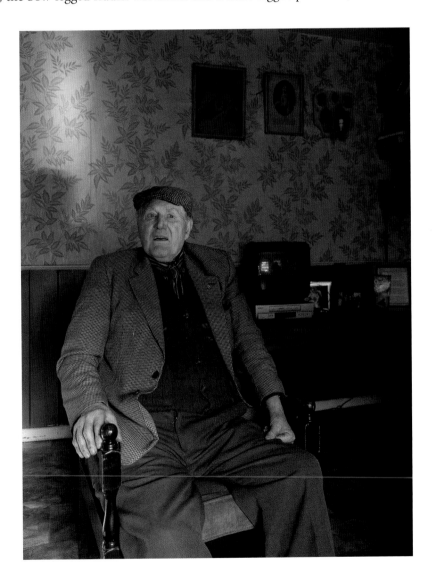

Minding the House

Thank God it is all over, 'tis a relief to my brain
My wife she is now better and is on her feet again
One day last week she got the flu and in bed she had to stay
She said to me, 'Paddy, I can't get up. Could you manage anyway?'

'Yerra, Nell,' says I, 'Why not I. What is there to be done
Only get the children out to school. To me 'twill be just fun.
But, now I know what fun it was and you'll know just as well
When you hear the muddle I got into – those days were just like hell.

I always thought that women had the finest time on earth
Just gossiping with the neighbours while sittting by the hearth
But now for them I've pity – they're wonderful no doubt
How they find time for gossip, I'll never figure out.

On the day I was housekeeping, my wife said from the bed
'Is there any chance now, Paddy, you'd throw down a cake of bread?'
'I will,' said I, 'just tell me the ingredients I want
I'll blend them together and I bet you 'twill be grand.'

Before I had it finished, I'd a path made to the bed
Asking where I'd find this and that to put in the cake of bread
And when I had it finished and ready for to bake
There was as much flour on my hands and clothes as there was inside the cake.

I put it in the oven over a fire of black ciaráns
And I said now while 'tis baking, I'll run for butter to Mullanes
I happened to be delayed there and alas when I returned
And looked into the oven my cake was black and burned.

I tried to scrape off the burned crusts to make it edible for the children and my wife
But I only broke the handle of a Sheffield stainless knife.
I cursed and prayed together – I was nearly off my head
I had to throw out the homemade loaf and go for bakery bread.

Then she informed me that she was longing for a fry
She told me how I'd cook it and so I said I'd have a try
My fry was going grand in top gear 'twould delight the heart of man
'Twas singing like a fiddle and dancing in the pan.
But when I poured in some water to make 'dip' out of the grease
The whole thing then exploded and the frying pan went ablaze.

I grabbed the burning frying pan and for the door did wheel
The dog he came before me and I was pitched head o'er heel
Hot grease was splashed all o'er me as my forehead hit the floor
The dog roaring with a scalded arse out through the window tore.

That evening the children from school came rushing in
I couldn't hear my ears with them, such a racket and a din
Quarrelling over this and that – I never heard such rows
Oh why did they wait to pick this day to go mad around the house?

They were calling for their dinner and with hunger they did shout
When I went to boil the kettle the fire it had gone out.

When at last the night came on and the children did retire
I sat down exhausted on my chair beside the fire
I took up the daily paper to read it for a while
But soon I was in darkness the lamp ran out of oil.

I caught the globe it was red hot and God forgive me I did fuck it
For at that very minute I was praying to God to kick the bucket
I shook my hand with the burning pain and from the wife there came a scream
As she heard her fireproof Pyrex globe landing on the floor in smithereens.

Now she was beseeching God and His Blessed and Holy Mother
To get her out of bed while there was something left together
She said, 'Go there to the dresser, behind the dishes and you'll find a candle there
There's one left over after Christmas and mind don't break the ware.'

Well I am one cursed man wherever there's another
For I broke a China vase – a wedding present from her mother!
Another lecture from the bed saying, 'Aren't you an awful curse
Instead of you improving you're going from bad to worse
No one in the world knows what I am going through
Or how did the good God ever splice me to an awkward hoor like you!'

Anyway I lit up my candle and the light was not so clear
To have it close by me I placed it on the range I was sitting near
I then read on my paper 'til the light grew dim and strange
When I looked there was my candle like a pancake on the range.

After mopping up I got into bed and was nice and warm there
When I heard a cry of anguish from a child in bed upstairs
Saying, 'Dad, come up quick. I think I'm going to puke!'
To comfort her I had to hop out from my warm nook.

Probing in the darkness up the stairway I did go
I struck my foot against the step and disjointed my big toe
When again I had got into bed under the warm clothes
With aching head and painful toe I had started off to dose

The dog he started barking and she woke me with a roar
Saying, 'As sure as God, Paddy, that's the fox. Did you close the fowlhouse door?'
To add to my misery there I was again
Running out to close it and I naked to the skin.

I returned from the henhouse, my backside as cold as clay
The frost had froze my thighs and toes and perished what I won't say.
I squeezed in beside her for the heat – I was like a walking corpse
She said, 'Keep out from me with your icicle or you'll give me the relapse!'

But I won't be caught again for I know what I'll do
The very first sneeze I hear out of her – I'll start sneezing too.

Paddy Faley

77

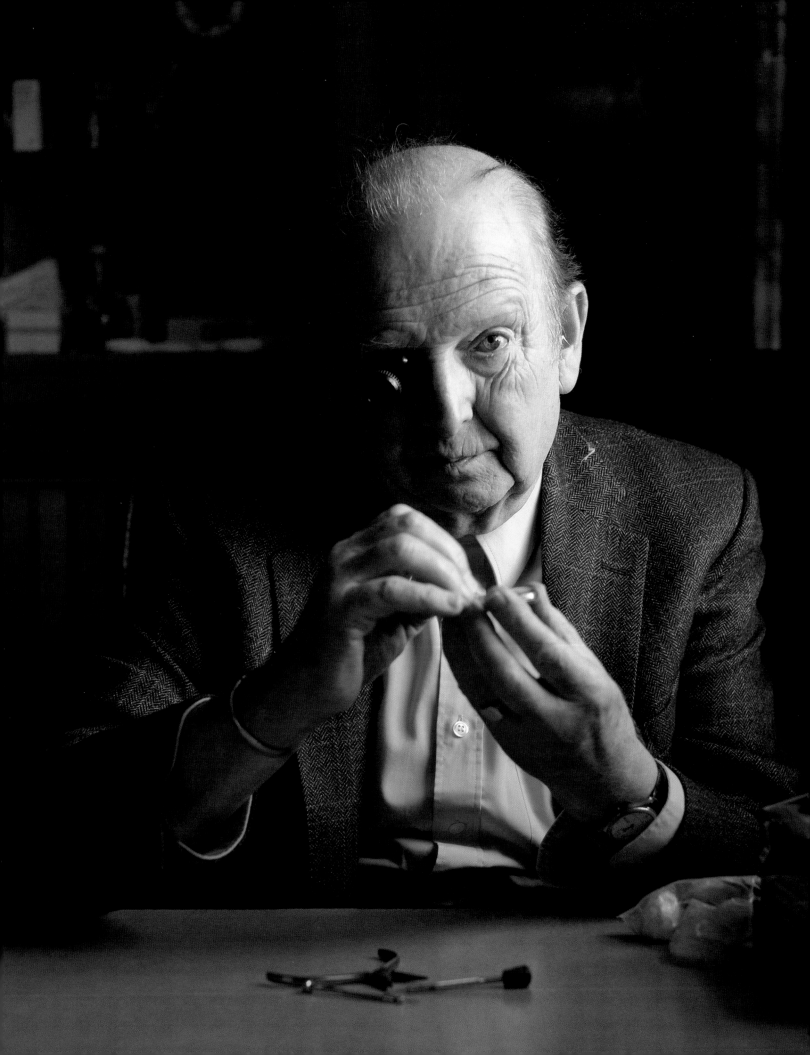

Christy Waldron

Cloghanover, County Galway

Clock & Watch Repairman

Born 1932

'Did you never hear of the Wag of the Wall?' asks Christy, somewhat incredulously. 'It was the first clock to come along after the sun dial. It had a big, long pendulum with chains and two weights. A man brought one into me once that hadn't come down from the wall for 160 years. "You'll never get that going!" he said. But it was in good shape. I got it going beautiful for him and he was delighted.'

Christy's earliest memory of clocks harks back to a travelling man who 'used to go around the roads of Ireland with a bag full of New Havens on his back'. New Haven clocks were produced in the USA and shipped over to Europe en masse. 'They had a big round face on them and the man would go from door to door selling them for seven and sixpence in the old money. Or you could buy it on a sort of hire-purchase arrangement for sixpence a year.'

Christy's first love was not clocks but speedometers. 'When I was a young lad, I loved getting speedometers and putting them all back to nought again.' He was a schoolboy in Cloghanover at the time, sitting on the same rickety chairs in the same timber classroom where his mother had sat thirty-five years earlier. She was Ellen Bane and her family farmed the land at Rafwee, just across the road from the school. Shortly after the First World War, she met and married Christy's father, Pat Waldron, who hailed from Cross East, near Cong, County Mayo. Pat subsequently took on the Bane family farm and raised seven children, of whom Christy was the fifth.

'We'd be shaking afraid of him,' says Christy of the Cloghanover schoolmaster whose four-room house he later bought. 'And in all the days I passed his house going to school, I never thought I'd one day be living in it.'

Christy was a bright kid. He excelled at maths and science. However, a serious leg injury at the age of twelve put paid to school and he was thereafter educated by his mother. 'You could learn nearly as much at home as you did at school,' he holds. 'If you had an interest in books and things, you could keep on reading.'

In 1935, the Irish government shut the Galway to Clifden railway. Seventy-six years later, Christy is still cross about the decision. 'That was the biggest scandalism that was ever done in this country. It was a beautiful journey from Galway city, through the middle of Lough Corrib and on into Connemara. The lovely pillars of the viaduct out in the Corrib were cut stone! But they closed it down and sold the scrap to England so they could make bombs to kill Hitler, and that's a fact.'

Christy was still in school when the Second World War broke out. 'Money got so scarce, it was beyond belief,' he recalls. 'There wasn't an orange or a banana to be seen, even if you offered a million pound for one.'

Christy left school in 1944 and, when his leg had recovered, went to help his widowed mother run the farm at Rafwee. He often fished and shot in a place called the Rafwee Turlough. 'It's a hundred acres big and it used to flood in the winter which was great for wildlife. My grandfather told me the Galway Races were held there before they moved to Ballybrit. They'd watch the horses from a timber stand.'

He also made a few quid shooting rabbits and pigeons for which the butcher in Headford paid half a crown per head. In 1954, the Irish government introduced myxomatosis into Ireland to reduce the rabbit population. The effects of this miserable man-made disease were not only catastrophic for rabbits, but also deprived people like Christy from a useful income as the demand for rabbit meat nose-dived.

All six of Christy's siblings emigrated; his brother Éamon is the only one still living, far away in Canberra, Australia. 'And when I got my chance I went to Dublin,' says Christy. 'I served my time with a watchmaker on the quays called Rovada. After that, I worked alongside fourteen other men with an Australian company on O'Connell Street. And then I moved to Benson's Jewellers on Mary Street.'

'We used to spend twelve hours a day repairing watches. Nine in the morning until nine at night. But that was what people did back in the '50s and '60s. I'd have the lens on my eye all day and when I was walking home up Henry Street after the work, I'd be seeing stars. I'd almost be dreaming through the lens.

'When I got home, there were always other watches to repair. I fixed all the watches for the nurses in Baggot Street Hospital. I'd get all the diamond rings for them too. I shared an apartment in Ranelagh with a Kerryman and we had two friends who taught at St Patrick's Teacher Training College, so I used to fix all their watches too! But there were some beautiful watches. If you'd seen the way Hunter pocket watches were finished! Christ, but they were works of arts. Ah, I had nimble fingers at that time, but they're failing on me now. I used to make leather wallets too. But it was mainly watches when I started and they were coming in by the bucket. They were all mechanical then. There were ten or twelve spare-part specialists in Dublin alone. But there's no need for watchmakers or spare parts these days. All the movement is done by computer now, and the rest of it is vulcanised. You can't even take them apart anymore. Most people use their mobile phone to tell the time. If your watch stops, you just stick in a new battery and off you go. And if it doesn't work – the dustbin.'

In 1969, Christy went to visit his brothers in Boston and was offered a full-time job with a Jewish jeweller. 'I was working for a Jewish jeweller in Dublin at the time and you could have sworn this was his twin brother!' he marvels. However, the proffered wage was insufficient. 'I was getting better money in Dublin!' Moreover, he wasn't crazy about the cold Massachusetts winters. 'They have awful frost over there. I still had the bad leg and the snow wasn't good for it and so I said, "Bloody hell, I won't," and I came back.'

'And if he'd stayed, he'd have missed me,' observes Siobhán who grew up outside Spiddal. The couple met in Dublin where she was working as a telephonist and switchboard operator in the post office.

The Waldrons were married in Rome in 1974. 'One of my best friends from when I was growing up became head of the Carmelites in Rome,' explains Christy. 'Whenever he was back visiting the Carmelites in Donnybrook, he'd always come into the city and see me. "Christy," he'd say, "if ever you're getting married, let me know." We were married in St Patrick's Church and he brought us to meet the Pope afterwards. We were in the right place for the honeymoon anyway.'

Christy was longing to return to the west and, in 1977, the Waldrons moved back to Cloghanover and raised their two daughters in the old schoolmaster's house. They still have the original school roll books in which the handwriting of the children, Christy's mother included, is often astonishingly beautiful.

'When we were at school, good writing was completely drummed into us,' says Siobhán. 'That's all gone. Now the children learn how to write and that's about it. And they write in text language. "Gr8 2 C U last nite!" I know we can't stand in the place of progress but you have to have the basics as well.'

Christy's innumerable clients have included Éamon de Valera and a 90-year-old woman from Partry who 'spoke the very same as Margaret Thatcher' whom Christy thrilled when he repaired a mantel clock for her that had lain idle for sixty-seven years. There have been some massive jobs along the way, such as an eight-foot antique grandfather clock that was all but destroyed when a container crashed down on it during a voyage home from North America. 'It was an incredible clock,' exhales Christy. 'It had a moon dial on the side which could tell you when there was a full moon in the sky. So I rebuilt it and I got the whole lot going again.'

And although Christy is now officially retired, with reading, writing and playing the melodeon on his list of daily pursuits, he clearly still relishes the challenge of being presented with a broken clock and told it's a hopeless case. 'It's a jigsaw,' he says. 'You just have to piece it all back together again.'

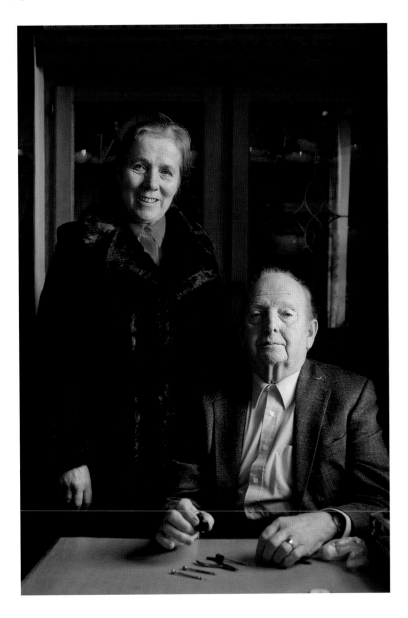

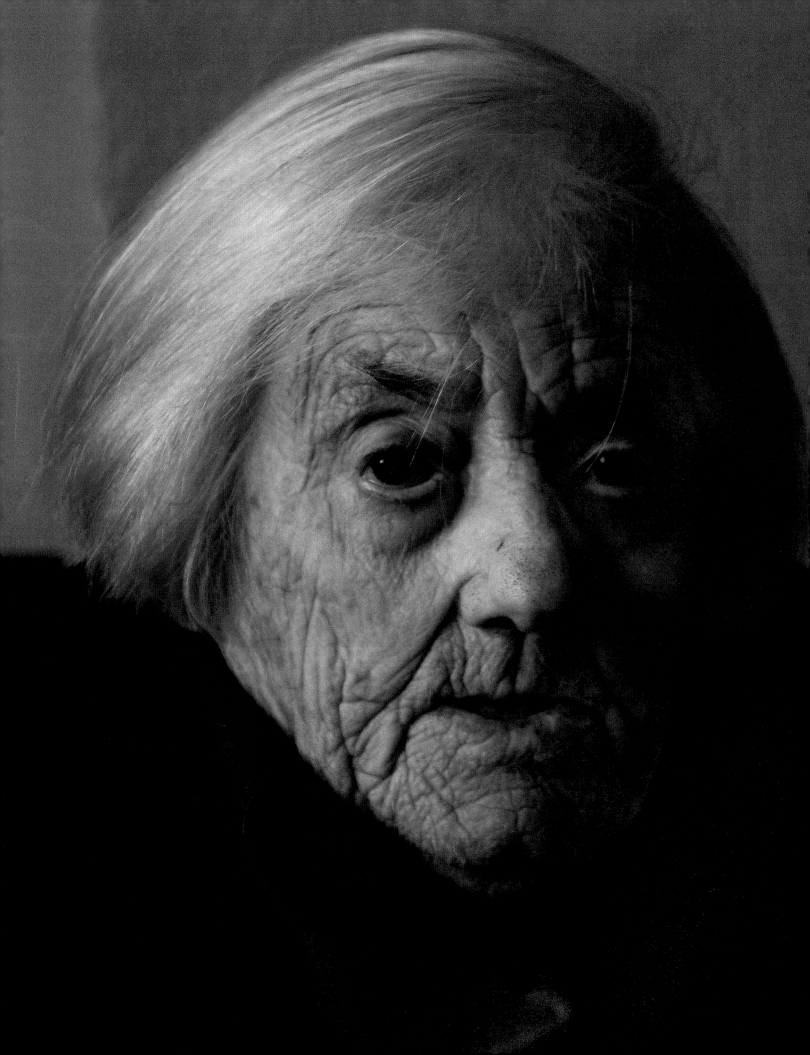

Annie Conneely

Cloonisle, County Galway

Housemaid

Born 1919

'My mother sometimes smoked a pipe,' recalls Annie Conneely. 'She would light it off the kitchen fire with a piece of paper. All my people smoked a pipe at that time. Luckily, I didn't like smoking at all.'

Annie's people were the Conneelys of Cloonisle Bay near Roundstone. Her father Pat Conneely was born in 1877 and grew up in the village of Aill na Caillí on the bay's western shore. Traditionally, the families of Aill na Caillí sustained themselves through a combination of farming and wily currach trips to Galway where they bought flour and other provisions to sell to the townsfolk of Roundstone and Clifden. However, the arrival of the railway link between Clifden and Galway in 1895 put many such currachs out of business and gradually the people abandoned Aill na Caillí. Today, it is one of many deserted villages on that windswept Atlantic shore.

Pat was in his twenties when he left the village – though he did not stray far, acquiring a cottage and 14 acres from the Land Commission which directly overlooked Cloonisle Bay. The cottage, built in 1914, is where Annie and her sister Mary were born and remains Annie's home today.

Her childhood memories are happy ones. She and Mary often accompanied their father on trips in his small boat out on Cloonisle Bay. He taught them how to fish and she gleefully clucks at the memory of a particularly good haul of white-bellied pollock. Sometimes, Pat took the girls back into Aill na Caillí where they talked with the 'good, kind, ordinary country people' who still lived there.

At certain times of year, the girls cut and gathered driftweed along the shore at Cloonisle, and it was then loaded onto Pat's boat and taken to the factory in Kilkieran from where it would sail to Scotland. The girls also dragged some of the seaweed back home. 'We'd put it on the land as manure when we were making new ridges for the potatoes and turnips and carrots and oats we sowed.'

There was always work to be done, tending to the cattle and sheep, feeding the chickens and turkey, preparing the land for the upcoming season, knitting clothes and preparing meals. Fish was a big part of the daily diet. 'Mutton was a rare treat but my mother didn't like any meat except chicken, wild geese and sometimes turkey.' Annie's mother Bridget hailed from Mweenish, an Irish-speaking island near Carna. Under Bridget's guiding eye, Annie and Mary spent many contented hours in the kitchen, converting their home-grown potatoes, flour, buttermilk and egg into pan-fried boxty.

Everything was cooked on an open fire using water from a nearby spring well. There was no running water, electricity or gas in the house and at night they talked in the glow of paraffin lamps.

The house smelled of tobacco. Annie's mother may have enjoyed puffing on a pipe but no woman was ever seen smoking in public. The last person to bed raked the fire and threw fresh turf on top, before covering the turf in ash and leaving it to smoulder overnight. The fire was never allowed to go out, even in summertime. The moment the last chimney stopped smoking in Aill na Caillí was the moment that Pat Conneely's home village became abandoned.

In 1925, when Annie was six, an unusual neighbour moved into the area. Prince Ranjitsinhji, the Maharajah

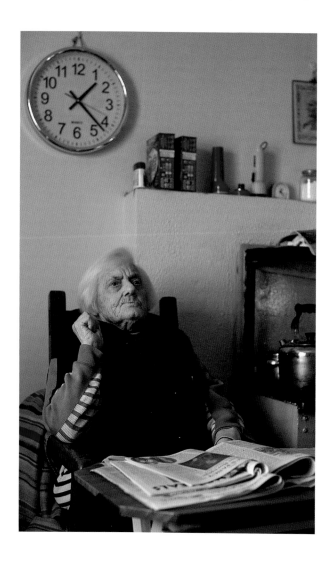

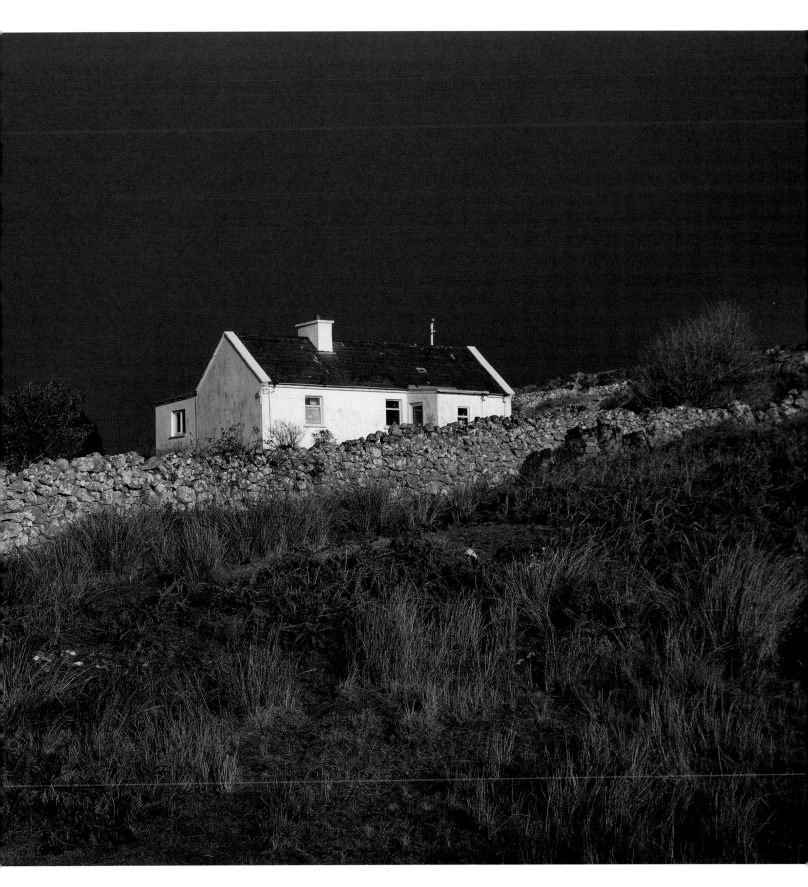

of Nawanagar, was one of the world's greatest cricketers and had stood as the Indian representative at the meeting of the League of Nations in 1923. He befriended the Irish delegation and was invited by President W. T. Cosgrave to enjoy some Irish sport at the Tailteann Games at Croke Park. Impressed by Ireland, the Maharajah – better known as Ranji – bought Ballynahinch Castle in Connemara, with 50,000 acres, from the Berridge family.

Ranji's move to Ireland placed Connemara squarely on the map for well-to-do tourists from all over the world. Mary Conneely was one of those employed to work at Ballynahinch in Ranji's day, but Annie is too discreet to speak of any of the high society gossip that her sister might have let slip. Suffice it to say that in Connemara, it is believed Ranji, a lifelong bachelor, kept at least seven wives back home in India.

In 1933, the Cloonisle milkman told Annie that the Berridges were looking for a housemaid at their home on beautiful Lough Inagh. Richard Berridge's father was a wealthy Catholic brewing magnate from Middlesex in England. In 1883, the tycoon had bought over 170,000 acres of counties Galway and Mayo, becoming, at a stroke of the quill, the biggest landowner in Ireland.

Annie was not long finished her schooling at Toombeola when, aged sixteen, she walked ten miles to Lough Inagh Lodge and secured a full-time job as the Berridges' housemaid with a bedroom at the house. She had every second Sunday and one afternoon a week off, and three weeks holiday annually. There was a gardener but, for a long time, Annie was the only house help. 'I was cooking, washing up, laying the table, making the beds, any kind of work they'd have me do.'

Annie could not climb between the sheets until every pot, dish and wine glass was scrubbed and dried, and the table set for breakfast. 'But I liked it good enough,' she maintains. 'I was near home and that satisfied me.'

During the Second World War Colonel Richard Berridge was captured by the Germans. When he returned to

Galway after the war, Annie reckons his body weight had fallen to six stone. 'He had a hard time,' she says quietly. 'He was a nice man and he always seemed to get on with the people.' In 1951, the Berridge family relocated to Screebe Lodge near Maam Cross but for Annie the distance was too far from home.

When her mother took ill, Annie returned to help her father. She continued to work part time at various country houses in the area, notably at Cashel House when it was a private house belonging to the Browne-Clayton family. She also worked two summers at Ballynahinch Castle which was sold after Ranji's death in 1933 and converted into a hotel by the affable Noel Huggard, the owner of Ashford Castle.

Annie is a quiet, unassuming woman, at ease with a copy of *Ireland's Own* and her memories. When she looks out across Blackhaven Bay, she can visualise the Galway hookers setting out from Achill Island. When she closes her eyes, she can see the twirl of the house parties that took place in her home when she was young. 'There'd be a round from here to Glinsk and Carna,' she recalls. 'And maybe they would head on from here, around by boat to Inishnee Island, all in one night!'

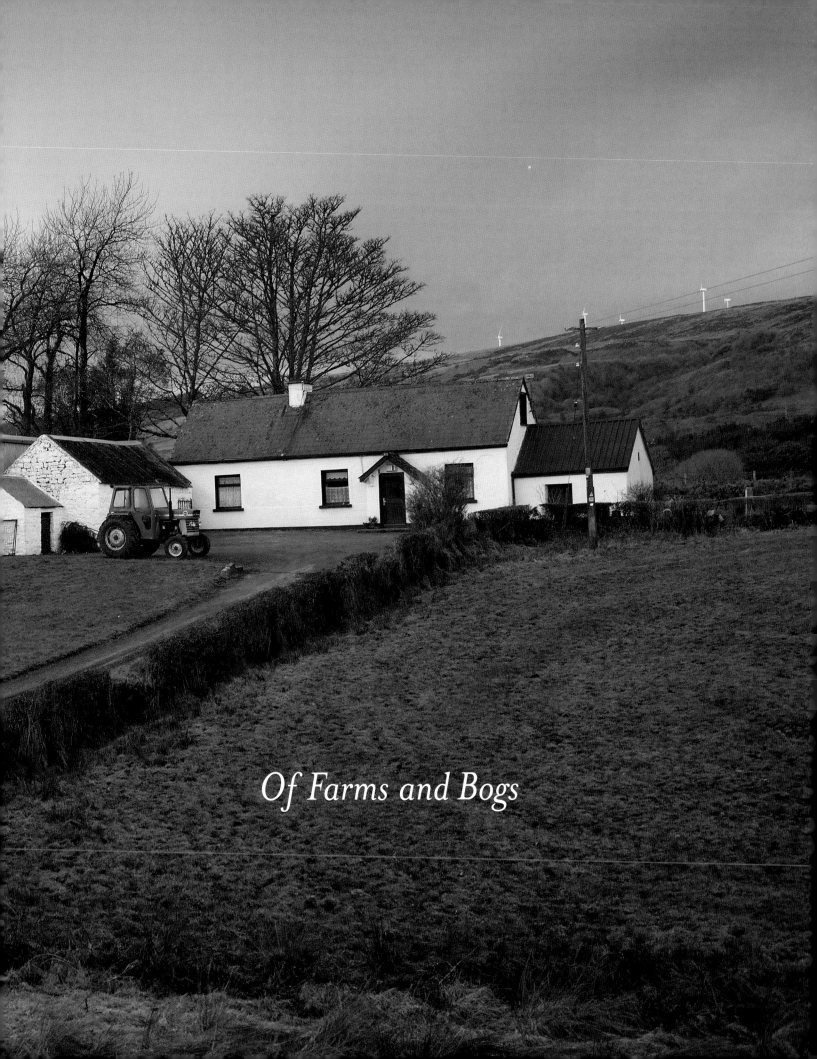

Of Farms and Bogs

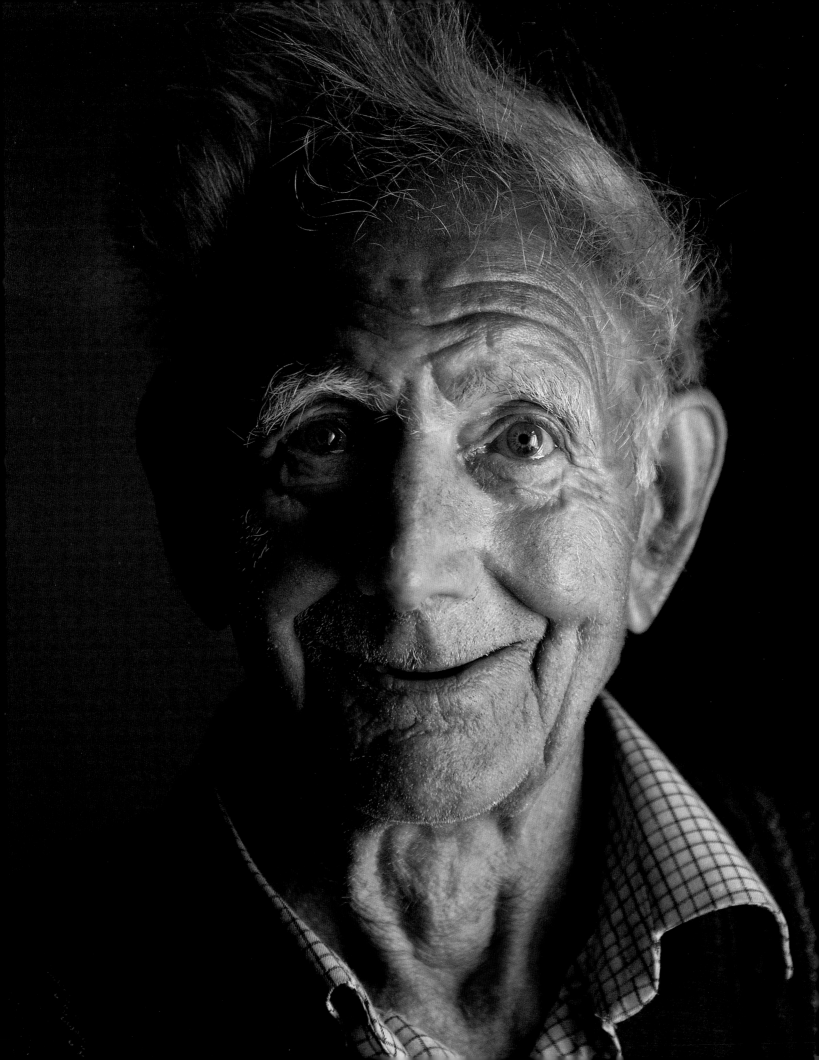

Joseph Hanrahan

Kilsheelan, County Tipperary

Farm Labourer & Trap Driver

Born 1930

When Joseph Hanrahan left school at the age of twelve, the world was three years into the Second World War. Across the Irish Sea, Britain was practically the only other part of Western Europe that had not fallen to Fascists of one form or another. Churchill's people needed a lot of things to survive. Faith, courage, fortune, resilience – and rabbits.

The rabbit trade between Ireland and Britain was massive in the early 1940s. And life for the bunnies who lived alongside the banks of the River Suir in County Tipperary became singularly less promising when Mrs Prendergast, the Kilsheelan postmistress, began her conquest of the area.

'She used to get loads of maybe four or five hundred rabbits at a time,' recalls Joseph. 'She had a pony and cart and I was her driver. We went all around County Waterford, gathering rabbits up from all the farmers. The rabbits were caught in traps beforehand. We'd put the carcasses onto crates and then she'd ship them all across to England. They lived on rabbits in England during the war.'

Mrs Prendergast paid Joseph half a crown a week to drive her around the county, as well as her twice-weekly trips into Clonmel town. 'Things were poor enough around here that time,' he says. Jobs were 'scarce', so he was thankful for the work.

Besides which, anything was better than school. 'Oh, Christ, stop,' he says. 'I didn't like school. Oh, God, I didn't. The teacher was fine but he was very hard. He knew how to work the cane.'

Joseph's father Thomas was a ploughman who harrowed fields all around the area with a pair of workhorses. Joseph was the seventh of eight children, who all grew up in the same house where he lives today. Also living there were his parents and his grandfather Thomas Hanrahan who died in his seventy-fifth year. 'We got kind of squashed all right,' he chuckles. 'But I lived here from when I was very small until I was grown up.'

He strikes a match with his fingers and lights up a Sweet Afton. He casts the match into the open fire around which his living room is focused. Timber from the woods of the nearby Gurteen estate is piled optimistically either side of the fireplace, an axe gleaming in the nearby darkness. But, despite the cold day, he has not lit the fire yet. Along the mantelpiece above the fireplace is an impressive collection of cigarette lighters, gathered since he smoked his first cigarette at the age of twelve. Cigarettes and black pints, the source of enjoyment for

so many of Ireland's twentieth-century bachelors.

In the summers of his youth, Joseph's once-nimble fingers explored the surrounding woodlands for fleshy vitamin-rich bilberries, known in these parts as 'hurts' or 'fraochán'. 'We used to go any place and pick them and sell them for a couple of pence to the old postmistress. She'd send them off to England, with the rabbits!' The bilberries were traditionally gathered on the last Sunday in July, known as Fraochán Sunday. They were also collected in August for Lughnasa, the first traditional harvest festival of the year, and the quality of the bilberries was considered a good way of predicting the quality of the other crops come the harvest. 'But there's no demand for hurts now,' says Joseph, 'and the bushes have all been smothered.'

All of Joseph's brothers and sisters married and emigrated to England. 'So I was left alone,' he says. 'But I was never tempted to emigrate. I never got the idea into my head.'

In 1948, six years after he first started with Mrs Prendergast, Joseph took on a job as a labourer for a neighbouring farmer with a wage of a crown a week. 'I was too young to be drinking at that time, so the money lasted well,' he laughs. 'But then I got bigger and I started having a pint and the money became valuable!'

For the next half a century, Joseph worked all around the Kilsheelan area, 'a bit here, a bit there, anywhere I could get a few bob'. For nearly twenty years he was employed at the nearby Gurteen estate to look after their cattle and poultry.

Joseph never learned to drive a car but rode a bicycle with confidence and reckons he could ride a horse too 'but badly'. The farthest he has travelled is Dublin, to which he once journeyed by train to watch Tipperary win the All-Ireland. He also used to frequent Thurles for the Munster final, particularly savouring those occasions when Tipperary beat Cork. 'We used to say Cork beat and the hay saved,' he says wistfully.

As a youth, Joseph hurled 'for the craic', although he dismisses the notion that he was ever a sporty type. He also used to be something of a card shark, flipping out winning hands of 25s in Sullivan's pub in Kilsheelan. 'But the money got bigger and then you're gambling so I got out of it,' says he sagely.

Whilst he has occasionally been to the coursing competitions at nearby Ballyglasheen, Joseph was never one to wager his money foolishly, 'not on man, dog or horse'. Instead, he derives considerable pleasure from ceilidh music. 'I don't play and I can't sing, but I love it,' says he. 'I wouldn't give tuppence for anything else I hear on the wireless except ceilidh.'

Joseph has always lived a quiet life, at ease with a newspaper, a cigarette and, so long as it's ceilidh time, a radio. He often sits on the bench by the crossroads in Kilsheelan, peaky hat over his eyes, watching the world whizz by. His dog Blacky is by his side and Joseph endeavours to walk him every day, irrespective of weather.

'I've seen a lot of changes,' he says. 'But for the good or the bad I don't know which. People say they are happier now than they were but I don't believe they are. Money is not all. In the old days, you could go out in the morning and pick up an odd job. But now you won't get work like that anywhere. It's a very different world.'

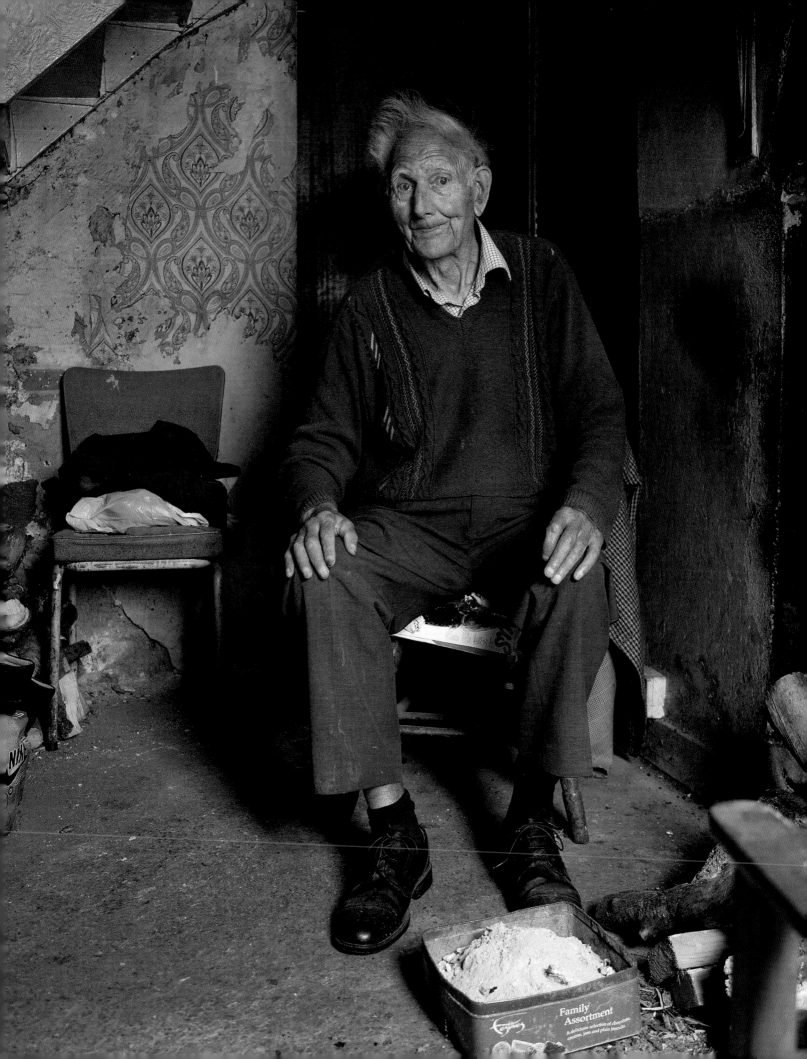

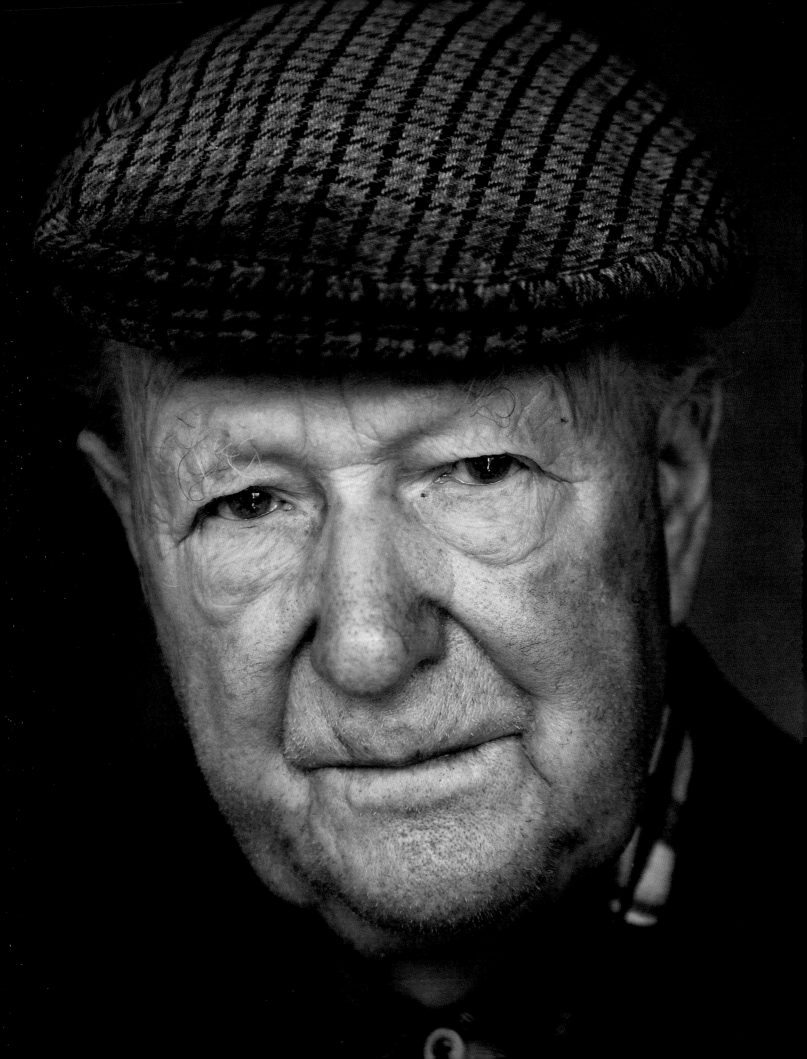

Willie Sheehan

Clonwalsh, County Tipperary

Cattle Breeder & Bootmaker

Born 1917

The bricks were still hot when Willie Sheehan and his father arrived up at Castle Anner in October 1926 – or what was left of the castle. Considered one of the finest mansions in Tipperary, it had burned down overnight. The cause of the fire became apparent when Edmund Burke, the caretaker, was found dead in the nearby coach house. He was dressed in his Sunday best with a fowling gun lying across his chest and the top of his head blown off.

Mr Burke had always been considered eccentric. The coroner's inquest later determined that he had become 'unhinged'. Precisely why he set fire to the castle and shot himself is unknown, but, five days earlier, John Parnell Mandeville, the owner, had handed the castle and its 120 acres over to his younger brother, Lieutenant Geoffrey Mandeville of the Royal Navy.

'It was a strange business,' says Willie. 'There was a rumour that the de Mandevilles were going to sell the castle. So maybe that went to his head.'

Willie's forbears were small farmers from 'Killusty country', the fertile lands between the medieval town of Fethard and the northwestern slopes of Slievenamon. During the late nineteenth century, Daniel Sheehan, Willie's grandfather, journeyed around the mountain to the northern banks of the River Suir and began working with another farmer near Mullinarinka.

In 1885, Daniel secured a cottage from Tipperary County Council in Ballinvoher, close to where Willie lives today. Although he never met his grandfather, Willie remembers the gate to the cottage, branded with Daniel's initials and the date he moved into the house.

Dan Sheehan, Willie's father, was one of six children. He was also the only one who remained in Ireland. By the time of the 1911 census, all five of his brothers and sisters had emigrated to the USA, mostly settling in and around Chicago. Dan was 'all his life' working on the railways. He started as a plate-layer and was one of a gang of four entrusted with maintaining the track between Clonmel and Kilsheelan. That was no small feat during the War of Independence when the line was repeatedly sabotaged by Republicans.

Willie was born in November 1917, the same month Lenin's Communists seized control of Russia. He attended the parish school in Powerstown during the 1920s. 'We walked there and back every day. It wasn't a case of enjoyment or disenjoyment. We just went there and that was it.'

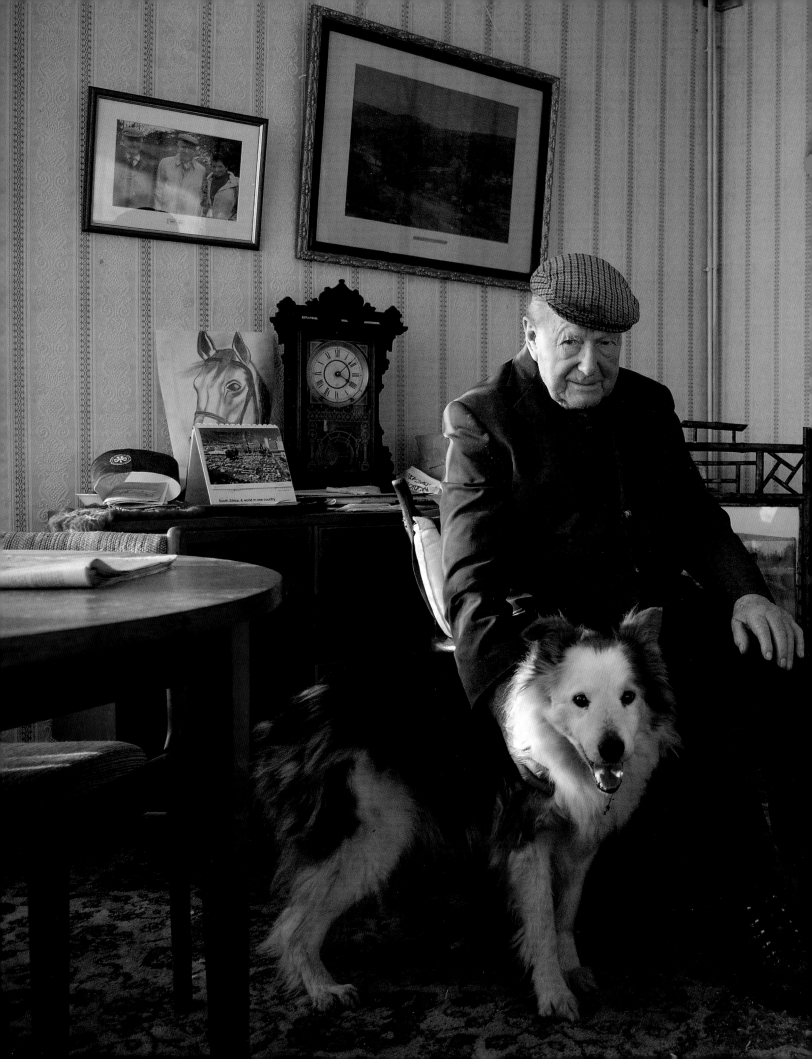

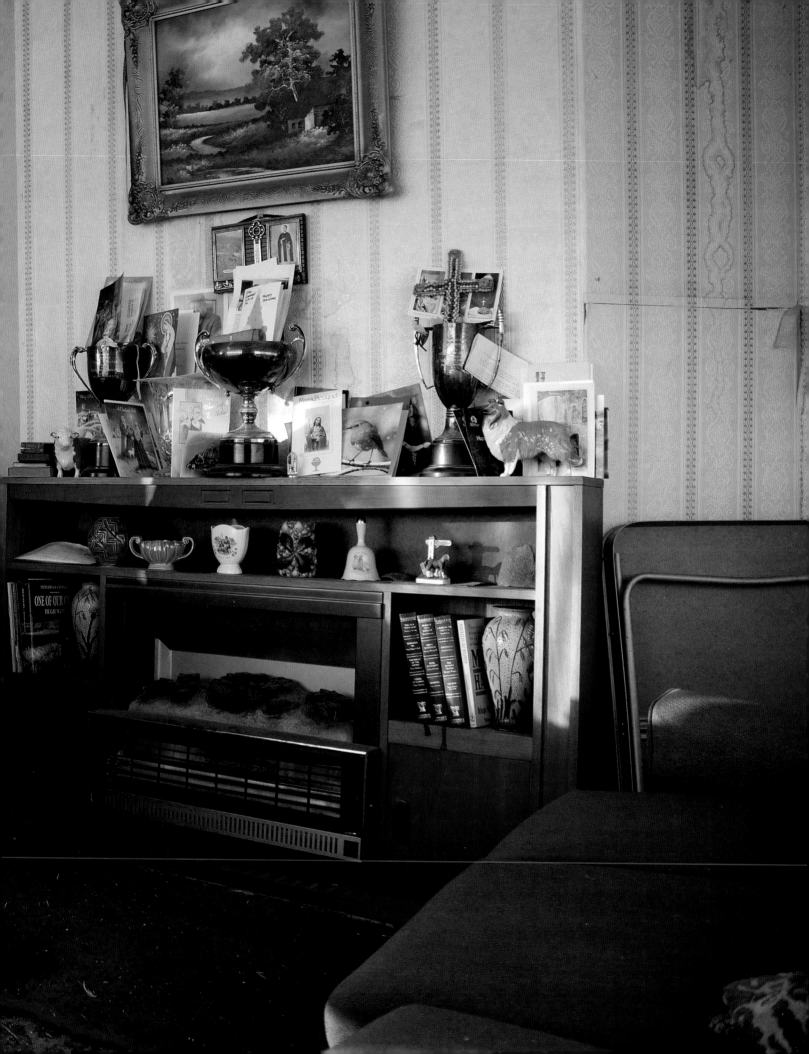

He left Powerstown aged fourteen and then spent four years studying administration and accounting at the technical institute on Anglesea Street in Clonmel. He trained as a motor mechanic and was all set to start in the local garage when the boot and shoe factory opened in Clonmel. Now occupied by the Social Welfare office, the factory stood on the corner of New Quay and Wellington Street. This is where Willie worked for seven years, putting heels on boots and ladies' shoes, then edging them up.

'It was nice work,' says Willie. However, in 1947, the Irish government relaxed control of the Irish shoe industry and an estimated two million pairs of imported shoes flooded into the country. The Clonmel factory spiralled into decline and the first employees to be given the heave-ho were the bachelors, including Willie.

Not that Willie stayed a bachelor for long. His wife, Josephine Dillon, was the daughter and co-heiress of an influential famer named John Dillon from Powerstown, County Tipperary.

Willie and Josie Sheehan proved to be an inspired partnership, not least in cattle-breeding circles where they enjoyed considerable success until Josie's death in 1994. Although they never kept more than five cows, the Sheehans bred a superior breed of Hereford. During the 1960s and 1970s, they exhibited at shows all over Ireland and frequently won their classes. In 1976, one of their yearlings was declared Champion Hereford at the Tipperary-Laois-Offaly Pedigree Breeders Show in Thurles. Another yearling that Willie and Josie bred took top prize at the Royal Dublin Society's Spring Show in Ballsbridge the following year. The owner of this champion was so thrilled that he presented Willie with the winning cup by way of congratulations.

The Spring Show was the number one event on the calendar for cattle breeders and Willie's bulls often came home with rosettes. 'Brackford Valley, Brackford Knight, Brackford Goldie … they all did us proud.' Their most successful prize bull was Brackford Champion who won Bull of the Year at the Limerick Show and was chosen to represent the Hereford Society at the Spring Show the following February. 'I looked after him every day, morning and evening,' says Willie. 'Good breeding is crucial. If you have a well-bred heifer, bring her to a well-bred bull and the results will be good.'

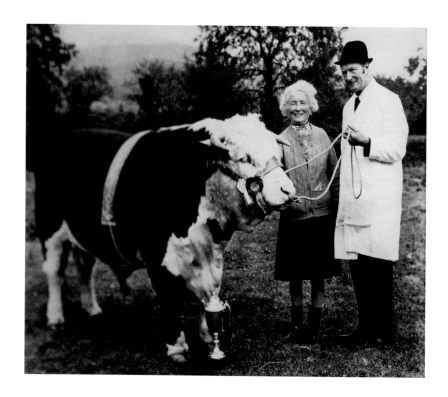

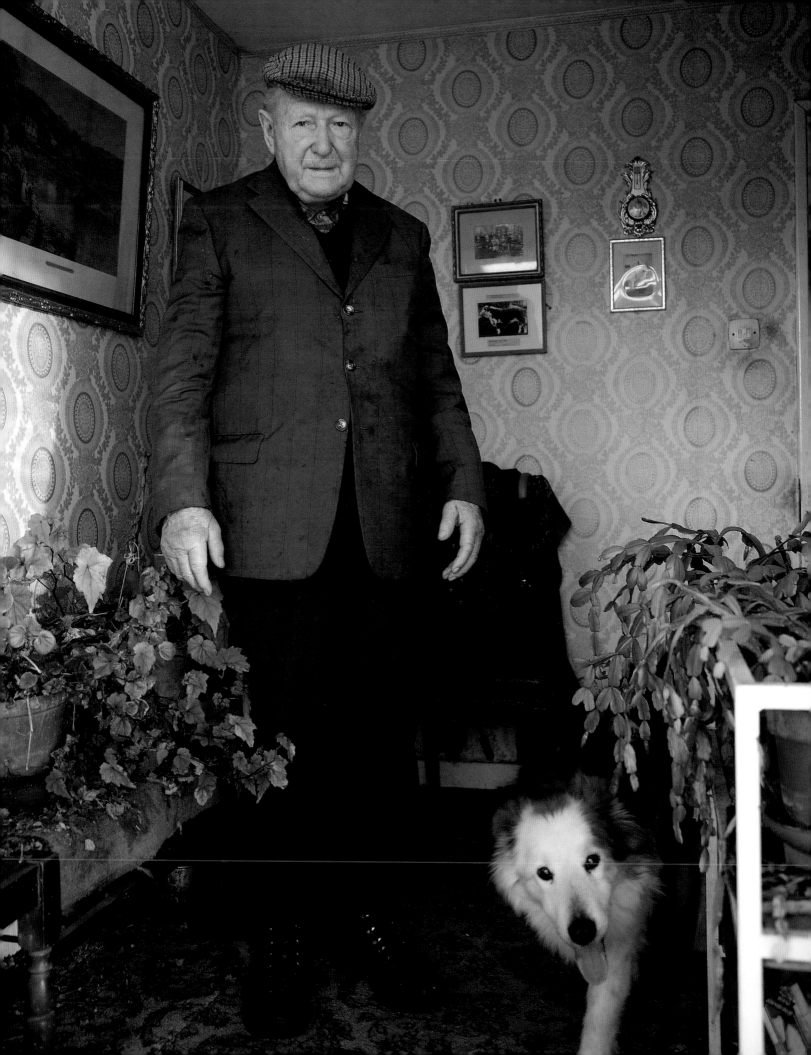

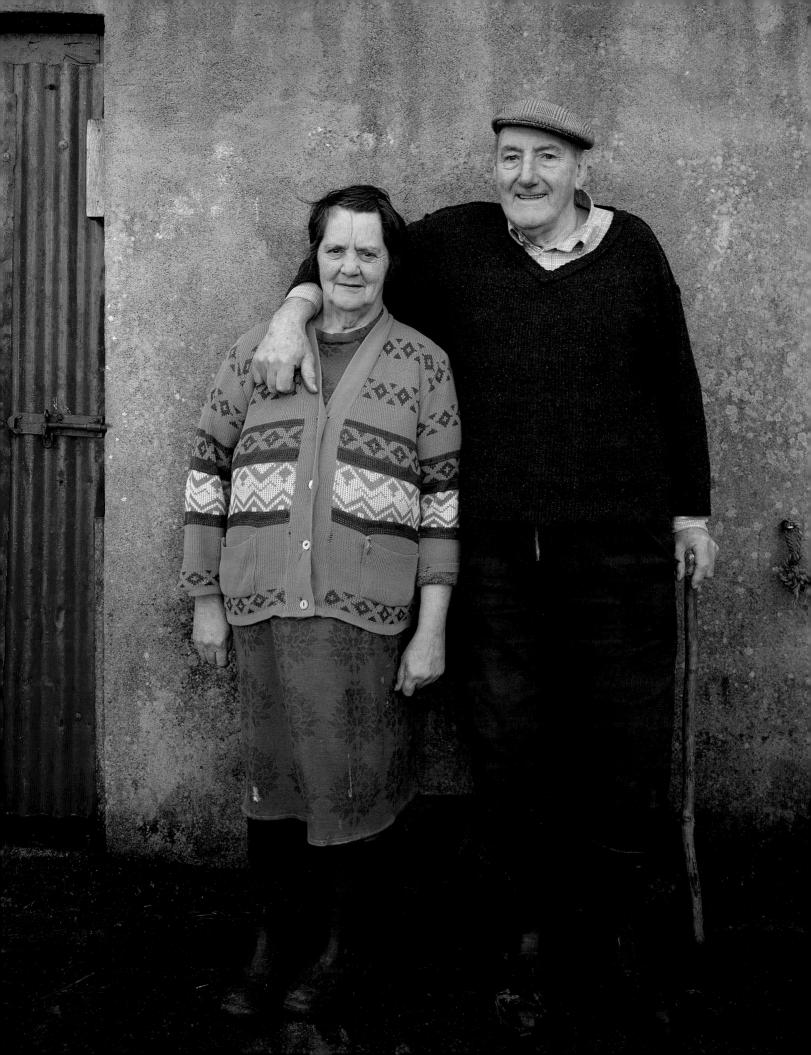

Moiky Kinnane

Glenagragara, County Limerick

Farmer

Born 1932

During the 1960s, Moiky Kinnane developed an ingenious and cost-effective system for transporting his family around. He removed the front wheels from an old Volkswagen Beetle and attached its undercarriage to a tractor hitch. His wife Annie and their children would then get into the car, along with any neighbours whom they might meet along the way, and bumble on up the bog roads, perhaps bound for the shop in Glin or to attend Sunday mass. It worked perfectly, not least on days when the sky was filled with wind and rain. When Moiky enquired about insuring his system, he was advised that there was no need for insurance, so long as he did not put a football team in it.

Probably the most important bog road in Moiky's life was the one built in 1836 which linked Athea and Glin, traversing hundreds of acres of blanket bog on the Limerick side of the Shannon estuary. The road was constructed by Sir Richard Griffith, the Dublin-born engineer who gave his name to 'Griffith's Valuations', an immensely helpful record of the names of nearly every landowner and householder in Ireland during and after the Great Famine.

Griffith's new line of road completely changed the economic outlook for people in west Limerick. A massive swathe of bogland was now accessible in an age when turf was the foremost energy fuel. People used turf to warm their homes, cook their meals, burn limestone in their limekilns, boil the water in which they mixed the meal for their cattle and horses. Turf was also the number one cash crop for the area. After Griffith's long, straight and inevitably bumpy road opened, smaller roads and lanes quickly began to radiate off it as more and more people rushed in to stake their claim to the bog and the barren hills which surrounded it. By the mid-nineteenth century, the people in towns as far away as Adare, Croom, Newcastle West and Rathkeale were supplied with turf from this district.

Moiky's grandfather William Kinnane was born in Ardagh in 1845, when Griffith's road was so young that it had barely had time to grow a pothole. By his marriage to Johanna Riordan, he came into the Riordan family farm at Glenagragara, near Glin. The Riordans' original house was probably a mud-walled cabin, typical of these parts, with a roof made of crooked beams of bog deal. The roof was insulated with sods dug from the top layer of bog, to which rushes were then fixed. Windows and doors were literally cut out of the walls

with a trench spade after the house had been built. Their son Jack sunk a well beside the house which, just 2 feet deep, still provides clear spring water for Moiky and his wife Annie. They maintain that it makes a superior cup of tea.

In 1903, William and Johanna built a new stone house. This was undoubtedly completed with the aid of a limekiln on the property. Limekilns were valuable assets in those days. Rocks of limestone were thrown into the kiln and heated to such a temperature (900 degrees centigrade) that only the lime remained. This white powder was not just useful as a mortar and stabiliser for building walls, but also acted as a fertiliser for the fields in which the Kinnanes grazed their cattle and the lazy beds where their potatoes grew. In order to get the limestone, they would journey by horse and cart twelve miles to Askeaton where, according to Samuel Lewis in 1837, 'limestone of good quality is obtained in great abundance'.

The Kinnanes' lifestyle was one of subsistence, growing enough potatoes and vegetables to feed the family and a sufficient amount of turnips and barley oats for their cows and horses. It was also very much about the turf and Moiky's chest heaves with passion when he starts exhibiting his treasure trove of turf-cutting tools. Some of the more beautiful implements were made in County Wexford, including a stainless steel breast-sleán for cutting the peat blocks that he is particularly proud of. 'It will never rust and it will go through anything.'

Some were tailor made down at Jack Adams' forge in Glin, such as the ash-handled right-footed wing-sleán his father used for cutting turf. And others were bought in a hardware shop, like the hay-knife, or scraitheog, he used for cutting the heathery 'scraw' off the top of the bog. 'Would you like a sod to take home with you?' he asks, producing a rather beautiful sod of sleán-carved turf. 'Not this one, though, I'm leaving that for my grandchildren!'

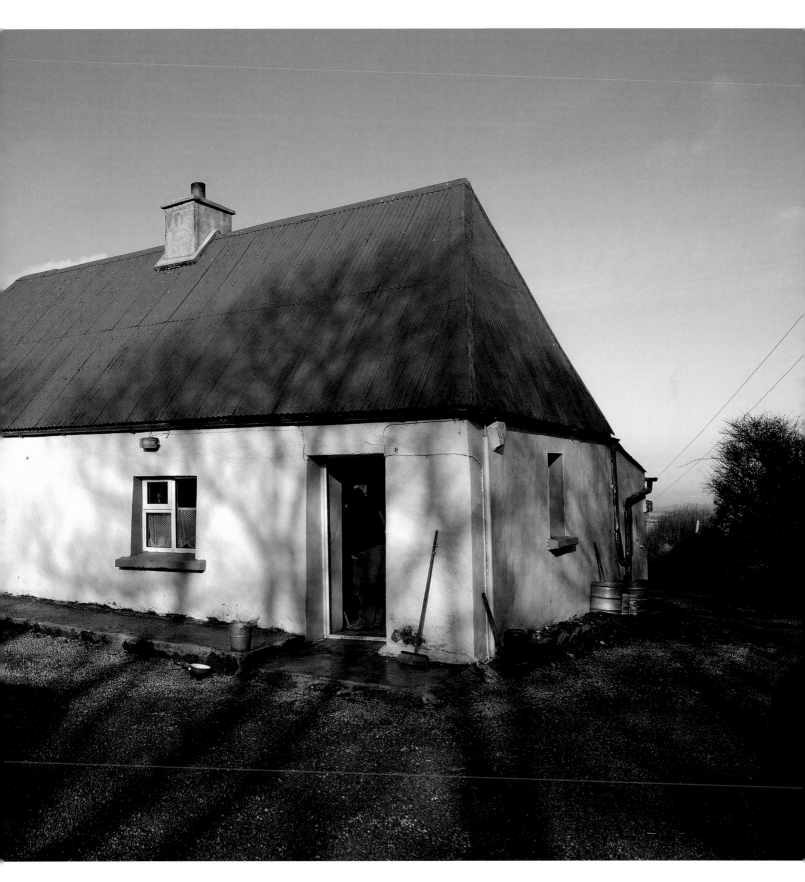

In one corner of his tool shed is a grand collection of ropes including super strong tow ropes made on Aughinish Island. 'The very best,' he says solemnly. Nearby is the quin to which he tacked plough horses in autumns past. And elsewhere there are other gadgets designed to keep the livestock from straying off-piste – a spancil for hobbling their legs and a fetter he made for a restless donkey. 'If you didn't fetter him, he'd be gone off and you wouldn't have him in the morning,' says Moiky. The donkey-cart stands nearby, its timber wheels bound by an iron rim. 'The common car as we call it,' chuckles Moiky, giving it a tap. It was made by Danny McGrath of Turraree and shod by Glin blacksmith Tim McGrath. That said, there hasn't been a donkey at Glenagragara for over forty years; the banded wheels vanished quick when the 'rubber wheels' came in.

Born in 1932 Moiky was the second of three children born to William and Catherine Kinnane. At the age of six he went to school in Ballyguiltenane. 'Any sooner than that and you would not be able for the long walk. I walked there and back again every day, barefoot as was the custom in those times, and there was no road there then. My sister Josie took me the first day. I still remember that morning. Micky Normile had a mud-walled house with a mound of subsoil piled nearby. He had his cows walking in a circle on it. This was to temper the mud for the construction of the walls. I often heard that the women did the same job in their bare feet. The women of today would have better legs if they could do the same job.'

The school principal in Ballyguiltenane was Master Casey. 'He was a very learned man and made great scholars.' He was strict but did not indulge in the savage canings of many of his contemporaries. He also taught gardening and sometimes kept the boys in after school to tend and water his flowerbeds. As with many schools, the pupils were obliged to bring a sod of turf in with them every morning but Moiky developed a neat ruse for getting around the rule. 'If you brought a donkey load in one time, then you didn't have to bring a sod with you every time! That was the trick.'

Moiky left school at the age of fifteen to help his father on the farm. His older brother John emigrated to England where he worked as a painter and decorator in Essex. His sister Josie spent much of her life working as a housekeeper for Catholic priests in Limerick city, including twenty years with Canon O'Brien.

When William Kinnane died in the summer of 1957, Moiky took on the running of the farm. Like his father, Moiky kept the farm modest – a couple of horses, a scattering of chickens and duck, and never more than seven cows. He also added an extension to the house his grandfather built. He has never left Ireland and has rarely left the county in which he was born. He and Annie live at ease with a cheerful sheepdog called Tony. Their two sons live locally.

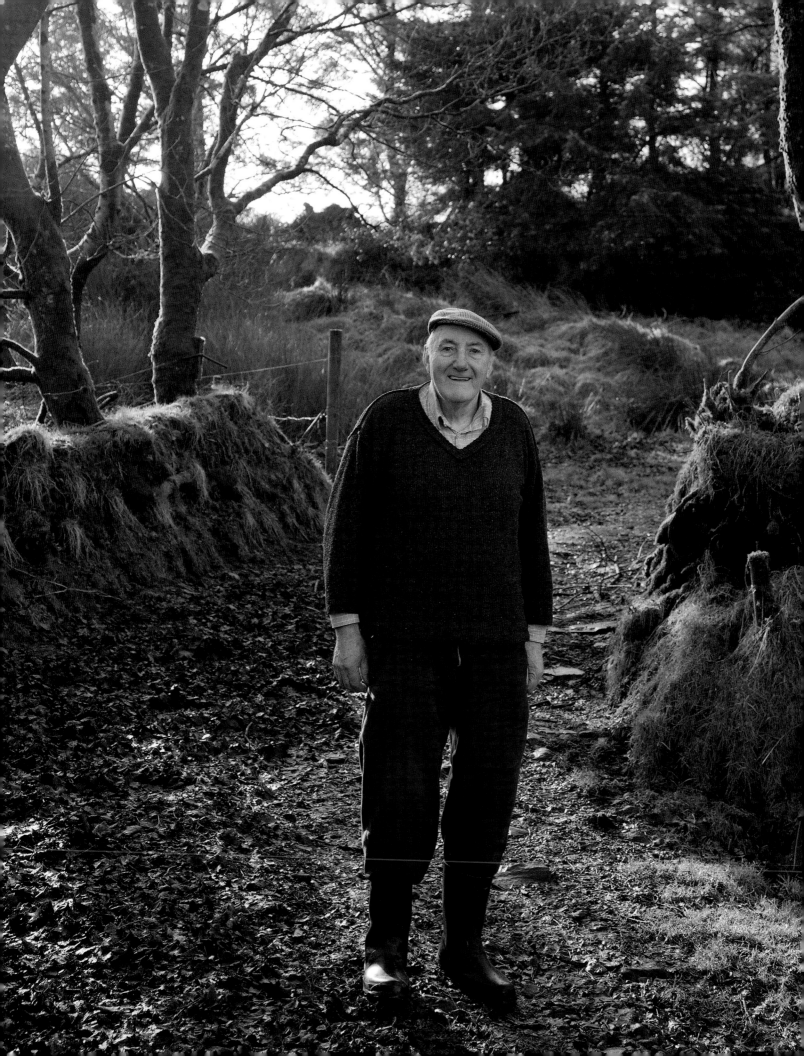

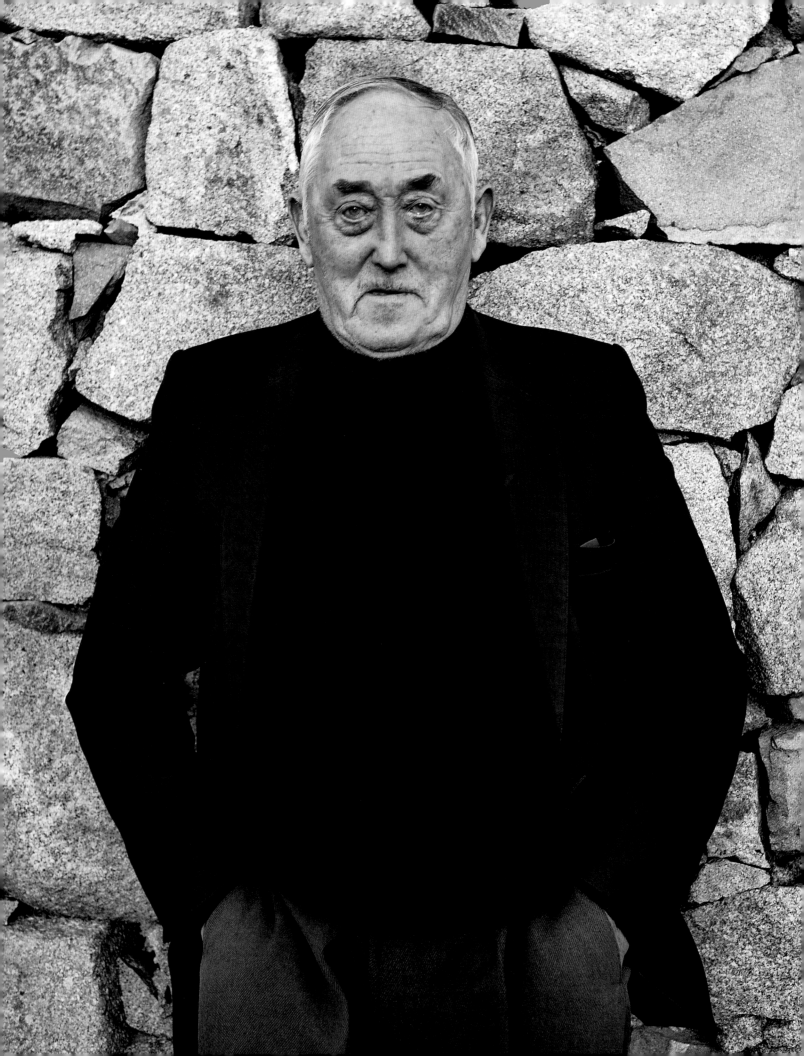

Pat Green

Damhros, Letterard, County Galway

Farmer & Fisherman

Born 1926

'Farming never paid around here,' says Pat Green, as the evening sun spreads over the barren rocks beneath his Connemara home. 'Just look at the colour of that land! It is not great by any means. There are more rocks than soil. Even if you had a thousand acres, you wouldn't survive farming around here!'

He has a point. The Greens' 22-acre holding is certainly rocky pasture for the handful of cattle and sheep they farm. On account of all the rocks, there is no chance of using a tractor. Hence all the tilling and mowing is still done with spades and scythes. 'It's slow, hard labour,' says Pat. 'But still, it kept the people going. At least everyone was independent and had their own little place. Without a few acres, we'd be nowhere.'

The Greens' homestead sprawls upon the western shore of Damhros Bay, a small inlet on Connemara's Atlantic coast, some four miles from the village of Carna. Pat's ancestors have been living in this Gaelic-speaking area for 'surely four generations, whatever about the fifth'.

The air is rich in maritime aromas. Dull, orange buoys and tattered ropes, rickety ladders and seaweed-strewn rocks, driftwood surging on the olive-green tide. An ash-grey donkey hee-haws like a dinosaur somewhere yonder. A grey gander and a white goose waltz around a boulder. A youthful sheepdog bounds out from a corrugated shed and pounces upon a currach. A smoky cat hides behind a lobster pot, glowering at the dog.

Pat never met his grandfather who was 'driven across the Shannon by Cromwell'. He never met his grandfather who was 'a part-time farmer, part-time fisherman, like myself', but he has hazy memories of his grandmother Kate Green. She was born at the time of the Great Famine of the 1840s. Her family survived by grace of their location on the Atlantic coastline. 'There was always fish and shellfish to be got from the sea,' explains Pat. 'But those who lived inland with small farms were all starving. And when they flocked towards the sea, it became very overcrowded around this area.'

The landlord of Damhros was Thomas Martin, the son of 'Humanity Dick' Martin, founder of the Royal Society for the Prevention of Cruelty to Animals. Pat points to an isolated hulk of land on the near horizon. Originally known as Croaghnakeela, this has been called Deer Island since Humanity Dick converted it into a deer sanctuary.

Through starvation, fever and emigration, Connemara's population tumbled from 33,465 in 1841 to 21,349

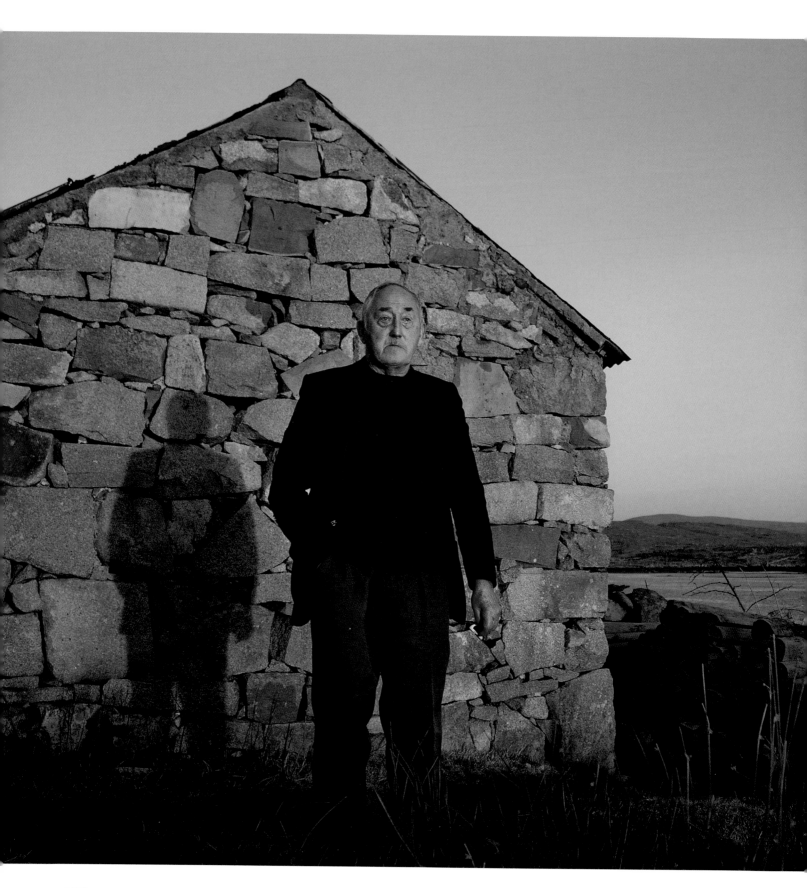

by 1851. Amongst those who died was Thomas Martin, a victim of famine fever in 1847, whose family were declared bankrupt two years later. By the time Coleman Green, Pat's father, was born in 1881, the Martin estate belonged to the Berridge family. And, as Pat says, shortly before his own birth in 1926, 'the land was divided and everyone got their own piece'.

'I was born at Christmas,' says Pat. 'And I heard there was plenty of poitín to celebrate my arrival.' His mother passed away in 1930 when Pat was only four and his younger brother just ten months old.

Coleman and his bachelor brother Pádraig then reared the two boys on the small farm. 'Musha, it was hard times for them,' says Pat. 'There was no soft money going, no social welfare or anything.'

Every farmer was also a fisherman. 'Fishing was the mainstay when my parents were growing up,' says

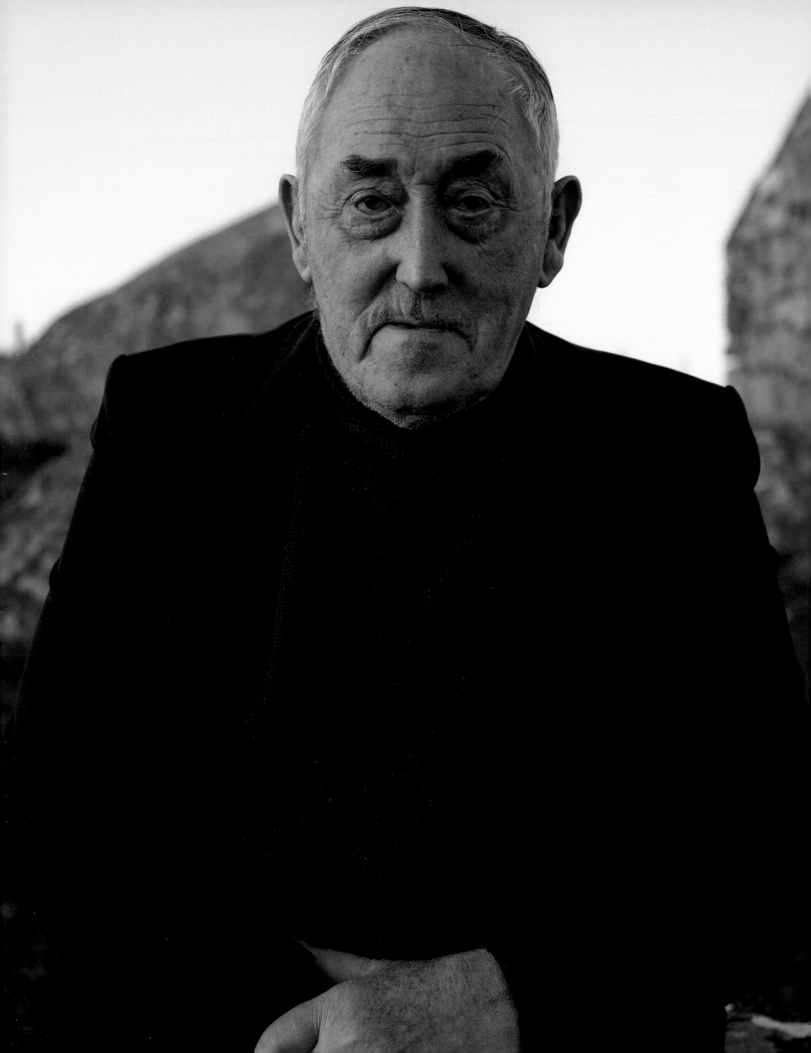

Pat. 'Only for the sea you wouldn't survive around here.' When Arthur Balfour, Chief Secretary for Ireland, travelled through the west of Ireland in 1890, he was shocked by the poverty he witnessed. Pioneering a new British policy of 'killing [the desire for] Home Rule with kindness', Balfour established the Congested Districts Board (CDB) to tackle the problem. Tenants were given loans to buy their own economically viable holdings.

And, as Pat says, the CDB also 'got boats for the poorest coastal counties of Ireland, to give them a chance to earn a living'. Advancing out on their currachs, families like the Greens fished for lobster, crayfish, scallops, periwinkles, mackerel and herring, depending on the time of year. The policy worked and the fishing industry thrived in Connemara until the outbreak of the First World War which obliterated the vital French and Russian markets.

Having a boat was also exceptionally useful for getting to Roundstone – 'our main trading town' – which is twenty-three miles away by road, but only three by sea. The Greens still shop by boat when opportunity knocks and if they return on a high tide, 'you'd nearly land your bag of flour on the kitchen window sill'.

Being of fisherman stock, Pat became a champion rower and frequently contested the competitions that took place in bays all along the Galway and Clare coastline during summer months. 'We used to have great rivalry between ourselves and Roundstone,' he recalls. 'We'd lose and win equally but there was no spite once the race was over.'

Pat's childhood memories are a blur where it 'was not much different from one year to the next' and it was 'probably the very same' for his father and grandfather. 'We were brought up speaking Irish at home, with the odd English word in between. My parents were better English speakers than we are. In their time, English was the only language allowed in local schools. But they had the Irish from the cradle. And all three of our sons are fluent Irish speakers too.'

Pat went to school in Carna, a fine granite structure, since demolished, with two teachers for forty pupils. After they left, the majority of his classmates emigrated. 'Most went to England first,' he says. 'It was very easy to go to England. There was no expense and if you got fed up, you could come home the following day. After the war, there were more Irish lads and lassies in England than there were in Ireland. They were all emigrating! And when they had their eyes opened in England, a lot went farther on to Australia and America.'

While Pat was helping his father on the farm from the age of fourteen, he also became a part-time emigrant. For three Septembers in a row, he caught a bus from Carna to Galway, then took a train to Dublin. At the North Wall he boarded the *Princess Maud*, sailed across the Irish Sea and made his way to the English Midlands.

'We don't forget what the English did in this country,' says Pat. 'But, still and all, England is a great country and they were very nice to the Irish.' Like 'every young person around here', Pat worked in the sugar beet factories of Nottingham and Newark. He slept in a large hut beside the factory; each hut accommodated up to fifty men at once. 'We'd stay until January and if you completed the campaign, you'd be paid your ticket home.'

'I might have stayed longer,' he muses, 'but there was nobody at home except my father and he was getting old.' With his younger brother by then an established resident of Liverpool, Pat returned to look after his father, as well as his cattle and sheep.

Shortly after Coleman Green passed away in 1968, Pat married Annie Kane, a farmer's daughter from Tiernakill in the Maam Valley. Three fine sons followed – Aidan, Donal and Declan – all of whom live at Damhros today.

Pat maintains that the changes in his lifetime are for the better. 'There is no point denying that. If you had £1 long ago, you were considered a rich man. But now, with radios and televisions and washing machines, life is far better.'

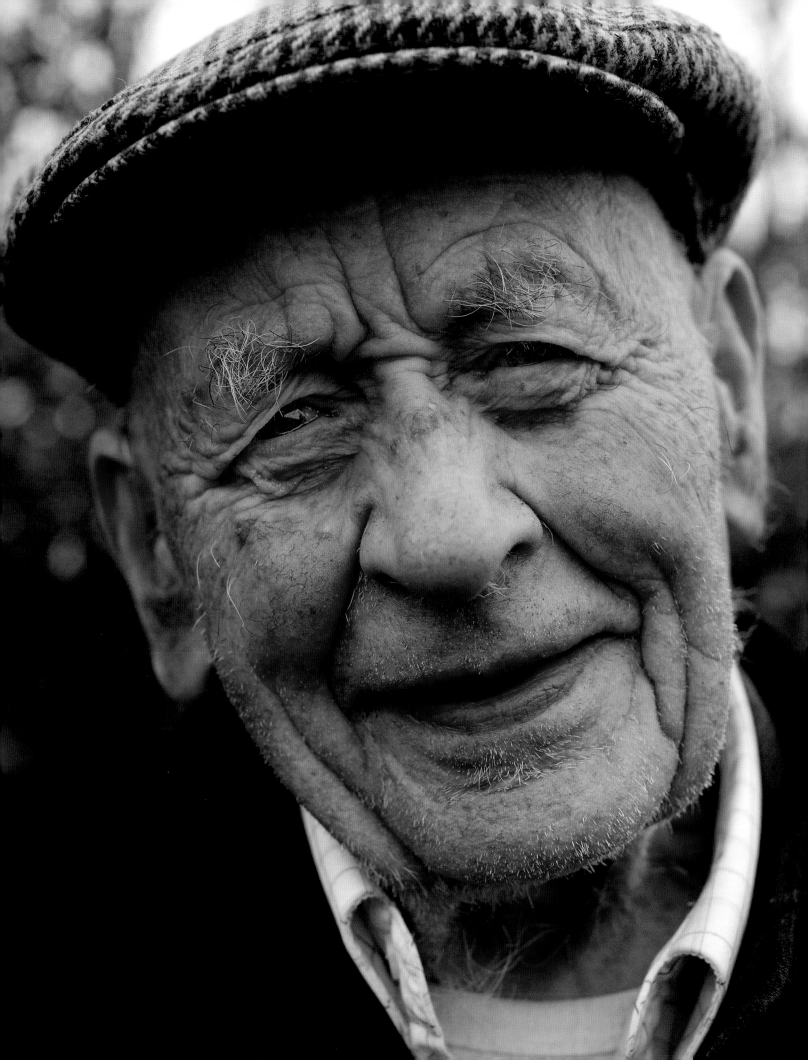

George Hawkins

Ballyhackett, County Carlow

Farmer

Born 1914

'When you got a blow from Master Henry, you wouldn't get up for three days.'

'Master Henry' was Henry Curran, a powerfully built, curly-haired Republican employed for protection during the Irish War of Independence by German Hawkins, a Protestant farmer from County Wicklow. Curran was ostensibly employed as a shepherd. His lodging were in the loft at the Hawkins farmstead in Tourboy, County Wicklow.

'He was a burster all right', recalls German's son George. 'But we never had any trouble at Tourboy because we had him sleeping in a loft near the front door. He was one of their men. They wouldn't touch you.'

In 1920, one of the Hawkins' Protestant neighbours was burned out of his farm. His cattle were due to go under the hammer at the Carlow Fair and German resolved to buy them. At five o'clock that dark, wintry morning, German set off with horse, trap and Master Henry by his side – both men were wrapped in blankets to ward off the chill. Shortly after they passed Killerig Cross, a voice hollered out from the blackness.

'Halt! Who are you?'

'I'm German Hawkins from Tourboy over Rathdangan.'

'Where are you going?'

'I'm going for the fair of Carlow to get out cattle from Mr Salter's place.'

There was a flare of a match as Master Henry lit a cigarette.

'Oh, Jesus, it's you Henry!' said the voice. 'Go on about your business.'

As chance would have it, Henry had been out the night before with the very same Republicans.

'They were tough times,' says George. 'But, anyway, they went on to the fair and got the cattle and everything was grand.'

When George tells stories of the old days, he becomes the characters about whom he talks. As such, he has entire role-plays in his head complete with soliloquies and the rat-a-tat-tat exchange of dialogue. For instance, he recalls a 'Free Stater' called Jimmy Harman who worked with his father after the war.

'Mr Hawkins, you're lucky I'm alive,' says George, metamorphosing into how Jimmy might have sounded at the Hawkins breakfast table eight decades ago. 'I met the IRA, the Fianna Fáils. They had four guns and

put me up against the ditch. But for God's sake Mrs Hawkins, didn't Séamus O'Toole come forward and say, "Hold on till I get a look at what you have." And he looked at me, Mrs Hawkins, and he knew me. "Put down your guns. I went to school with him." "Get the hell out of here as fast as you can, Jimmy," he said to me. Poor O'Toole. He was a decent nice fellow.

'I remember hearing O'Toole's body was on the side of the road,' says George, becoming George again. 'The Free Staters got him and Myley Carroll at Straduff. They named the dance hall in Rathdangan after him. Henry Curran helped draw the sand and stone for it. He went off to America then, poor Henry. He lived to be ninety-two by some accounts.'

It is thought the Hawkins family originally hailed from County Laois, perhaps descended from the gutsy Englishmen who settled in that county during the reign of Mary Tudor (Laois was originally named 'Queen's County' in her honour). By the eighteenth century, a branch of the family were tenants of Earl Fitzwilliam at the Coolattin estate in south Wicklow.

'The Fitzwilliams were the best landlords in the world,' says George. 'They took three Hawkins boys and two girls out of Coolattin and put them into the old farmstead at Tourboy. That was the last farm I had and I owned it for ten years.'

Tourboy lies at the foot of the snow-capped Lugnaquilla. The land belonged to 'a rich crowd' called Freeman who divided it between three farming families – Driver, Eager and Hawkins. George recalls the Freemans living a merry life, 'swallowing whiskey' at point-to-points and driving around in Bentleys long before anyone else had a motor car.

George's great-grandfather, Richard Hawkins, was the first to settle in Tourboy. His son, George, was born in 1838 and married 23-year-old Louisa Finlay in 1874. Her people owned a large farm in Knockanarrigan, close to the present-day army camp at Coolmoney. Louisa was petite and George was tall so they made something of an odd couple. But they enjoyed thirty-five years of married life together, during which time they had three sons and four daughters.

George's father was born in 1880 and christened German Hawkins, which was a common first name for the families of Tourboy, although some spelled it Jermyn or Jerman. 'He didn't like it much,' says his son. 'When he met his cousin German Finlay, he addressed him as "Namesake".'

On the death of old George on St Patrick's Day 1909, German succeeded to the farm. Four years later, he married Katherine Drought, with whom he had two sons, George and Fred, and two daughters, Kathleen and Louisa. 1913 was an extraordinary year for the Hawkins family as five of the seven children were married. Each service was followed by a party back at Tourboy, which took place in the loft, the same place where Master Henry would later sleep. 'It was a powerful loft with a double floor over eight cows,' explains George. 'You wouldn't even know the cows were below you.'

George junior was born at Tourboy on 3 October 1914, two months after the outbreak of the First World War. His arrival coincided with the globalisation of the conflict. That same day, 33,000 Canadian troops sailed for Europe, the largest force to ever cross the Atlantic.

On his second birthday, his grandmother gifted him a Cheviot sheep. 'It had a bluish face that I can still see to this day. I have owned a sheep ever since which is ninety-four years … isn't that a long time to have owned sheep?'

George was at school in Rathdangan where his father had 700 acres of mountain on which he farmed sheep. While George enjoyed the outdoor life, his brother Fred was fascinated by the internal workings of a transistor radio. At the age of fifteen, Fred built his own radio. It was designed for home use but soon became

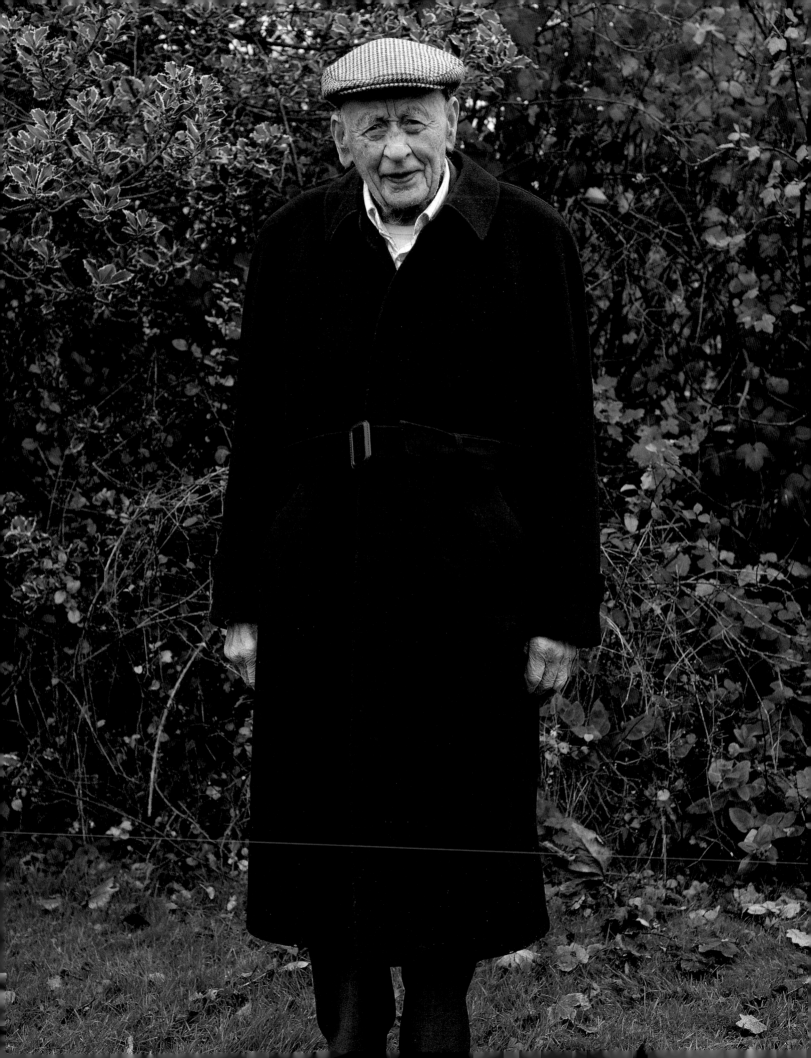

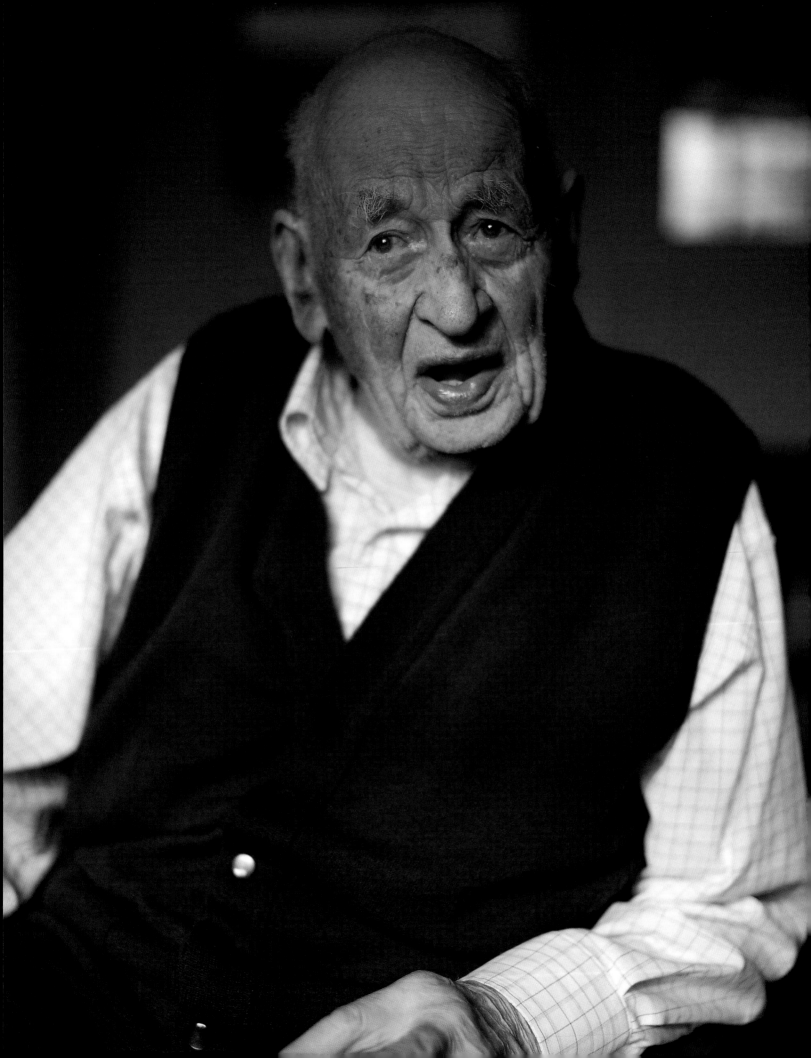

a focal point for the parish. Every Sunday, the local community piled into the kitchen at Tourboy, grabbed whatever long stool, chairs or floor space they could find, and awaited the news. Fred's radio was considered such a marvel that when the parish priest encountered two men whispering on a roadside near Tourboy, they gingerly explained, 'No, we haven't lost our voices, Father. It's just that Hawkins over there has a new machine and it's able to hear every bit of news in the country. We're afraid it can hear us too.'

German Hawkins rented some good fields near Naas where his cattle and sheep could savour the short grasses during the winter months. Throughout his late teens and twenties, George herded the livestock down from his father's lands at Tourboy and Rathdangan and across to these fresh pastures. Katie Bollard, one of German's sisters, lived at Bluebell beside Naas and George would stay there for weeks on end. These were carefree days when he rambled from house to house, listening to stories and telling more. When opportunity knocked, he attended point-to-points, the Punchestown races and sheepdog trials.

In 1950, George married 25-year-old Betty Boyd with whom he enjoyed fifty-nine years before her passing in 2009, four days after his ninety-fifth birthday. 'She was the most generous wife anyone could have,' says George. 'She was my master. She always won.'

George and Betty experienced considerable personal tragedy, although you would never get that impression from talking with George. In May 1951, their baby daughter Pamela was stricken with spina bifida and died. Seven years later, their 6-year-old son Richard succumbed to cystic fibrosis. The same disease accounted for a third child Beryl, aged fifteen, in the summer of 1976.

In 1954, while his parents were still at Tourboy, George bought a farm at Ballyhackett near Tullow, County Carlow. He was now making his mark as a cattle dealer and was frequently on tour across Ireland, exhibiting his prize-winning cattle. In later years, he ran the farms at Tourboy and Rathdangan. He was also a leading member of the Sheepdog Association of Ireland.

His son Spencer has run the farm since 1987 and keeps thoroughbred horses, suckler cows and sheep. Spencer's wife Fiona ensures the old fellow gets his daily nutrition. George's daughter Norah is married to another farmer, Edwin Burgess, whose father Bill appeared in the first volume of *Vanishing Ireland*.

Undoubtedly the most remarkable thing about George is his memory. He remembers the precise size and topography of every field through which he has trodden, the breed of sheep that were watching him, the length of every potato drill, the weight of every sack of potatoes he has handled, as well as the type and quality of the potatoes within, the number and names of all men, horses and machines who were in the field with him and why so-and-so wasn't there. He recalls, or at least has a glorious stab at recalling, the exact chain of events, including dialogue, between cause and effect, the movement of limbs, the colour of walls, the quantity of money exchanged, George lets none of it go unnoticed.

'Ah I could tell you stories forever,' he says when our conversation must come to a halt. 'There's a lot more to be said.' Undoubtedly there is, but as I watch the 96-year-old zoom off down the farm avenue in his Volkswagen, I reckon we have plenty more years to go yet.

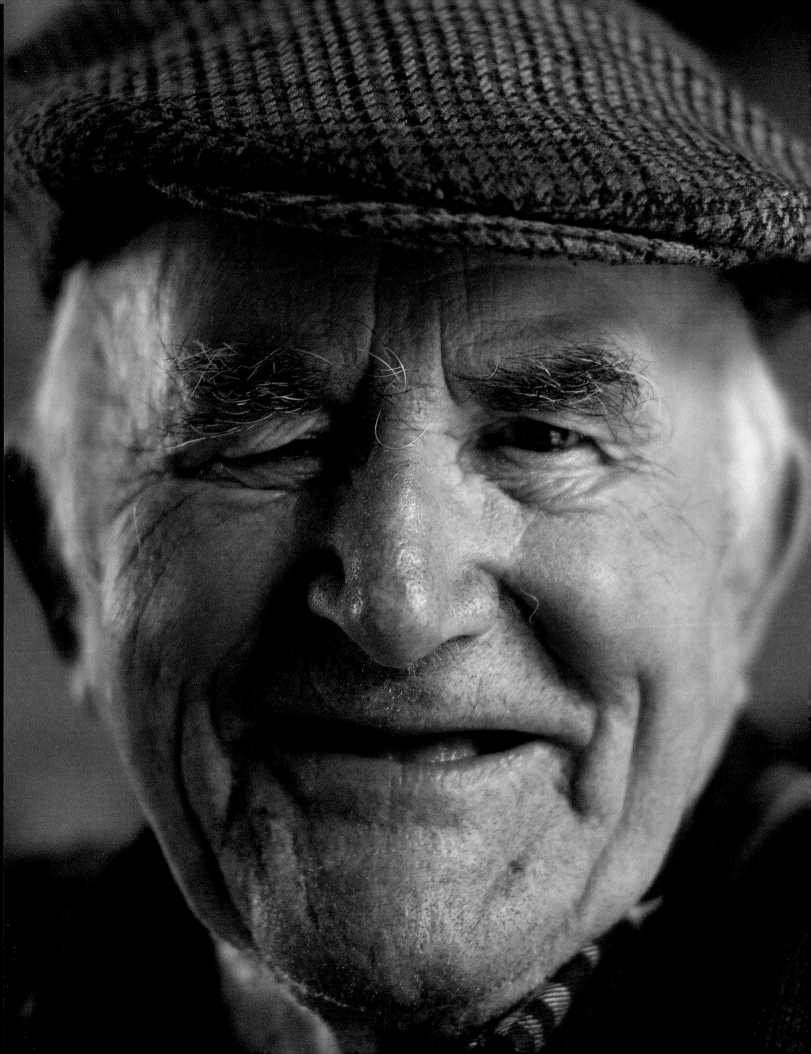

Terry Reilly

Corracar, County Leitrim

Farmer

Born 1927

Some hold that the Reillys have been stomping about these parts at least since the short-legged Fir Bolg were sent packing umpteen thousand years ago. Certainly, there was a tribe of that name who ruled a principality called Breifne O'Reilly in present-day County Cavan before the Normans came. However, there was also an English family called Ridley who arrived here with the Normans and who later Gaelicised themselves as Reilly. In any case, by the time Queen Elizabeth Tudor's soldiers came marching in, the O'Reillys were one of the most warlike septs in Ireland, skilled cavalry men who lived in a series of castles scattered across the drumlins and valleys of Cavan and Leitrim. The Elizabethans played their 'divide and conquer' game to perfection, partitioning County Cavan into seven baronies which they then assigned to different family members. Within a hundred years, the O'Reillys had been divided and conquered.

One of the most memorable family members was Myles Reilly who was so highly regarded for his sword-weaving skills in battle that he became known as Myles the Slasher. During a skirmish at the Bridge of Finea in 1644, a particularly large Scots officer plunged his sword into the Slasher's cheek. To the astonishment of the enemy, Myles gripped his attacker's blade in his teeth 'as firmly as if held in a smith's vice' and chopped the Scotsman's head in two with his own sword.

Terry Reilly believes his forbears have been sitting 'right where you're sitting now' since about the time the Slasher was flailing his sword. His farmstead lies at Corracar, County Leitrim, just west of the border between Ulster and Connaught.

In 1823, Patrick Reilly, Terry's great-great-grandfather, was listed as paying tithes on 10 acres of land at Corracar. Tithes were the most hated tax of that era. In essence, it meant that one tenth of the produce of every farm had to be handed over to the local Protestant clergyman. Opposition to the tax led to the Tithe Wars, a campaign of mostly non-violent civil disobedience that ran alongside Daniel O'Connell's emancipation campaign, both of which would later inspire Mahatma Gandhi's *satyagraha* movement in India during the 1930s.

By the time Richard Griffith conducted his valuations of County Leitrim in 1856, Patrick Reilly was noted as the lessee of a house, office and over 30 acres of land from John Godley who owned the nearby Kilbracken estate. This was the same John Godley who founded Christchurch in New Zealand in 1848, and whose bronze

statue was shattered in the devastating 2011 earthquake, revealing two mysterious time capsules sealed within.

During the 1830s, Patrick Reilly married Mary Shannon, a neighbour's daughter, with whom he had a large family. In 1860, their 22-year-old son Terence sailed for New York and was immediately thrust into the American Civil War. Serving in the 4th Artillery Regiment of the Union Army.

Meanwhile, Terence's younger brother Patrick remained in Ireland, succeeded to the farm at Corracar and raised thirteen children. Three generations later, Patrick's farm passed onto Terry.

Terry was born in 1927, the youngest of four. His childhood was spent on the farm where his parents kept a couple of cows and planted oats, vegetables and potatoes. He went to school in nearby Drumeela until he was 'near fourteen' years old. 'It was a good school,' he says, 'but there was a lot of discipline in it.' Their teacher had a passion for pulling their hair until the boys outsmarted him by giving one another crew-cuts with a kitchen scissors.

Many of those Terry was at school with emigrated to England during the 1940s, including his older brother who settled in St Alban's. Terry was never tempted to leave Ireland. 'I was in Dublin a few times but, to be honest, I didn't get much farther than where you are now.'

Instead, he stayed in and around Corracar, looking after his farm and working as an agricultural labourer in the locality. 'There was a lot of us who would do seasonal work at that time, going around to work with other farmers, maybe with a horse and plough, doing whatever had to be done.'

You might have thought the Big Freeze which brought Ireland to a halt in the closing weeks of 2010 would have impressed Terry. But he holds that the Big Freeze had nothing on the Big Snow which struck Ireland in 1947, leaving livestock dead across the country. He was twenty years old at the time and still remembers how self-sufficient his family had to be during those weeks. There was no such thing as a local shop. But one canny solution they hit upon for sick calves during those ice-cold days was to give them a drop of poitín.

In 1962, Terry purchased a hydraulic mowing arm for cutting hay and so moved into the world of mechanisation. 'That was a breakthrough,' he recalls with a whistle. 'Between the mow arm and the Ferguson 20 tractor, that took a lot of hardship out of the farmer's life.'

When he wasn't toiling upon the land, Terry was kicking footballs about. There were five teams operating in the locality back then – at Drumeela, Tully, Carrigallen, Doogary and Newtown Gore. Contests were plentiful although Terry recalls that some of the teams were 'rough enough' and the occasional leg was broken. Nonetheless, Terry remained devoted to the sport. 'Football was my religion,' he says.

Alternatively, there were dances every couple of weeks at the John Dillon Nugent Hall across the border in Dooagh, County Cavan. The galvanised hall was built by the Ancient Order of Hibernians, a Catholic fraternal organisation which had taken the pro-Treaty side during the Irish Civil War. Terry often attended dances here although the bachelor confesses he never had a great ear for music. 'I might have sung the odd time when I was out on a horse and cart because I couldn't hear myself then.' However, someone put a match to the hall and that was the end of dancing. 'The burning wasn't political,' says Terry. 'It might have been an insurance job or it may have been pure blaggardism. There was a song about it afterwards, "it bore the name of Dillon the Brave".'

Terry was never a man for the beer so once the dance hall was gone, he entertained himself with visits to the picture house in Ballyconnell. 'I was mad on cowboys – and detectives – anything in that line.'

Terry views the changing times with a healthy degree of detached amusement. At one end of his farm stands Aghaboy chapel where his forbears worshipped before the larger church at Drumeela was built. The chapel has now become the annual meeting point for upwards of 150 motor-bikers from all corners of Ireland. When Terry first encountered them, he genially invited them all in for a mug of tea.

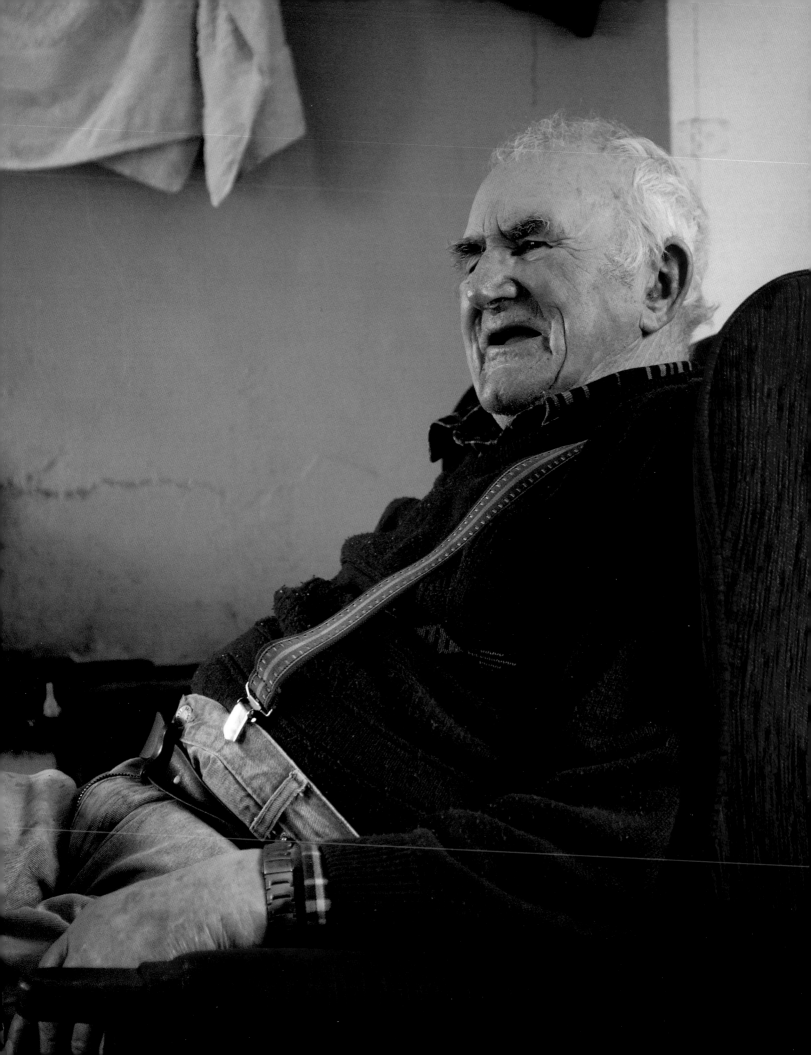

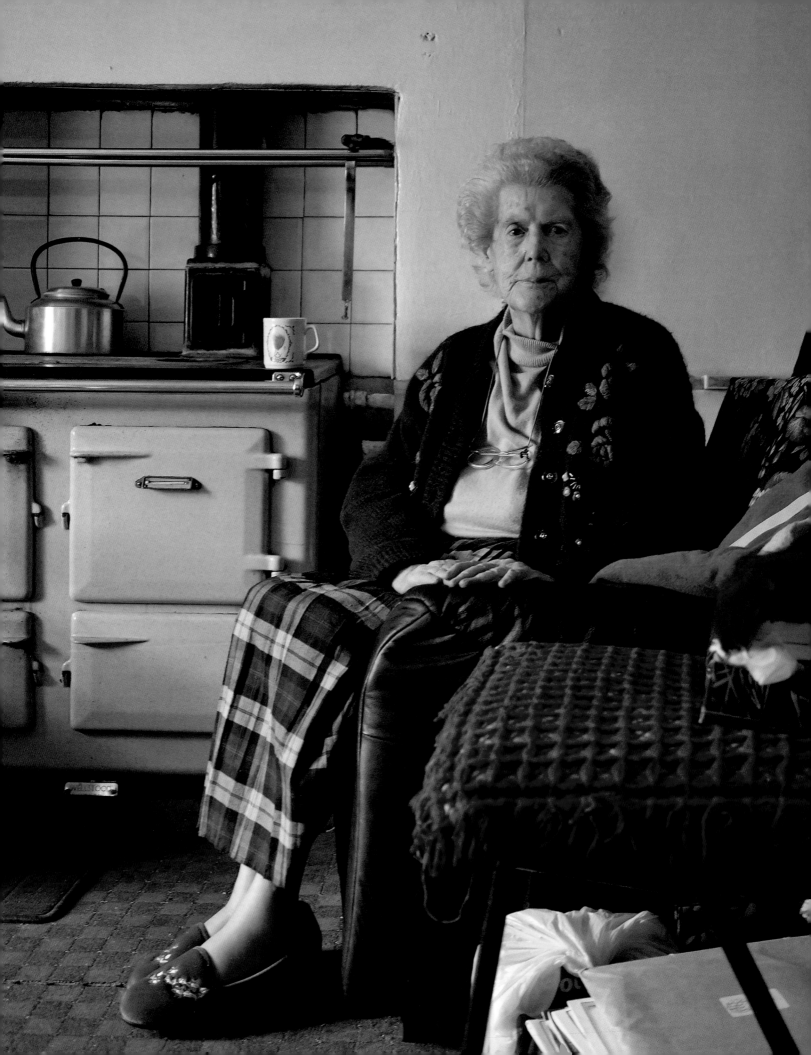

Liza Mulvihill

Moyvane, County Kerry

Dairymaid & Cook

Born 1915

'I didn't like to break the hearts of all of them, for the sake of one.' Liza Mulvihill blinks her playful eyes twice as she offers this explanation as to why she never married. And then she breaks into a laugh that knocks about ninety years off her age.

That is the thing about Liza. It is completely possible to forget she was born nearly a hundred years ago. Listening to her tales, you would reasonably conclude that she is still a rather beautiful young woman gearing up for a bit of craic and the next dance night.

Such as the Sunday night when her friend Kitty Walshe persuaded a young fellow called Dick Mahony to drive them to the Tarbert Regatta on his donkey and cart. 'We sat down in it very proud, riding down the road to Tarbert with our donkey.' While the girls had just enough money to get in, they did not have enough for Dick. So they tied the donkey up in a nearby farmhouse and the two pretty girls strolled up to the man on the door. They explained that they would love to attend the dance, but that 'our driver does not like dancing' and would not enter unless his admission was free. Hearing the word 'driver', the ticket man assumed this pair of damsels came by motor car and were thus persons of wealth. 'So he said all right and we went and got Dick in as quick as we could. We enjoyed ourselves to perfection, but we had two dates, with two boys, and we didn't want them to see us going home in our ass and cart. So we stole out before the dance was over. At two o'clock in the morning, we came on up the road in the donkey cart as happy as if we were inside of a plane.'

Nearly seven decades have passed since, but close your eyes when Liza tells these tales and you can quickly envision her twirling around and coyly stomping her feet at likely lads. As well as the Tarbert Regatta, there were the open-air platform dances in her home village of Moyvane which took place on Wednesday and Sunday evenings.

By and large, they danced to accordions – 'You couldn't have anything else out in the open in case it rained.' But she recalls one St Stephen's Day when fifteen flute players arrived on a tractor and trailer and performed blissfully in the rain.

'I was born on 19 August 1915,' says she. 'I remember it well.' She was the fifth of ten children born to Paddy Mulvihill, a thatcher, who lived 'in the heart of a mountain' near Moyvane, 'with a lot of turf all around us'.

'There was an awful lot of Mulvihills in that townland and they're all Paddys and Mikes, so we used to have quite a job with the post. We had to put "Thatcher" on my father's letters.' As it happens, Paddy was 'a very good thatcher' who 'got more work than he could cope with'. 'I'd see houses looking so bad and a day after my father was there, you wouldn't know it was the same house at all, it'd all be looking so straight.'

One of Liza's earliest memories is of standing with her mother Mary Anne Kiely at the cottage door when a troop of Black and Tans began coming down the mountain. 'I got afraid seeing all the men and I ran. One of them put up the gun to shoot me. They thought I was running to tell the IRA they were coming. My mother was in a panic until another one of them said, "Stop, don't shoot the child."'

She was more fortunate than the three unarmed local men who were gunned down by some drunken Tans in the nearby valley of Knockanure.

At the age of six, Liza went to the national school in Ballyguiltenane, across the border in County Limerick. 'It was a long walk through the mountain, no road, and we'd be barefoot from the first of April until November. We had sore feet from hitting off the stones and my father would have to pick the thorns out of my legs after. We'd wear strong boots at other times, with nails and tips. On frosty mornings, we'd have a couple of sods of turf under our arms and that would be our heating, although we wouldn't get near the fire … for fear that we would fall into it!'

'I liked my first teacher, Miss Fahey. She was from Tipperary, very nice and I was able to learn from her. But then I went to a new teacher who was all slaps and she scattered the brains altogether on me. She had a stick and, I tell you, your hand would be sore.'

Liza left school aged fourteen and went to work 'out with the farmers'. It was 1929, the year of the Wall Street Crash. Her brother Mike was already in New York but another brother Ger arrived just as the economic downturn was becoming serious. 'We were expecting money of course,' she recalls, 'but he didn't get work until November. He sold his own coat to buy food. It was terrible. But when he got a job, he did mind it. He didn't go from job to job. He kept on there until he retired. He had a lot of people to pay back for his digs.'

Back in Ireland, Liza's day sometimes began as early as five in the morning, 'You'd have to go through the fields and stir the cows up and bring them in for milking. And maybe you'd have to feed the little suckler cows before you'd have breakfast.' A boy would then take the milk to the creamery although, in summertime, the boys would be 'doing the harder work', so Liza brought the milk in on a cart driven by 'a big old horse that'd bite you'. She worked every day, including Sundays, when she also walked four miles to mass.

At other times, she stayed up all night while sows produced their litters. 'And sometimes you'd work all the next day, without a minute's rest, having been up all the night,' she says. 'But it was the same with everyone that time. We all worked hard.'

Liza worked on a number of different farms and houses. 'Some of them were very nice, like your own home, where you ate at the table with them and were treated the very same.' Others were less welcoming, and her mind wanders back to a rather snooty lady whom she worked for in Foynes for a number of years. One day, Liza opened the door to find another fellow who worked there looking for his bicycle which one of the houseboys had borrowed. The man had 'drink on board' and made his way to the dining room where the lady of the house was seated with guests. As he stood in the door, the lady admonished him for his impudence, to which he spookily replied, 'God blast your dirty rotten stinking pride, the crows of this parish will be flying through your dining room yet.' Liza shivers deliciously when she recalls passing the same house many years later. It was a ruin and crows were flying in and out of its windows.

The reason Liza did not marry is because her younger sister died during a botched gallstone operation,

124

leaving a 2-year-old boy and a baby girl. Liza recognised her destiny as she and her mother basically took on the two children and raised them until they were old enough to go out in the world and marry. The house in Glin, where Liza now lives, belongs to one of these children. Before she moved there, she was helping with another niece who had multiple sclerosis.

Liza has always had a sense of adventure. In 1975, that came to the fore when the 60-year-old flew to New York to watch the St Patrick's Day parade. While in the Bronx, she made the acquaintance of Mayo-man Jim Gavin and his wife, Nellie, who employed two of her nephews at their Golden Hill House resort up in the Catskill Mountains northwest of the city. They offered her a job as a cook at the resort. Liza declined as she had not come to America to work, 'but I was tormented and finally I gave in and I stayed'. She headed up shortly after St Patrick's Day and remained there until September. 'It was so mountainy that when I would be going up from the city, I'd think I was going back into Kerry.' Irish dancing was the highlight, with musicians like Paddy Noonan and her own cousin Martin Mulvihill. 'I danced more there than I did here in Ireland,' she marvels. Although she returned to Ireland after six months, Liza enjoyed her time in the Catskills so much that she did it all again the following year.

Still perfectly switched on about current affairs, Liza has her theories as to why Ireland has changed. 'Much wants more,' she says. 'They got too well off, and now they're feeling it hard because the work isn't there. People ask me now if I'd go back to the olden times or do I like the present day. I'd go back to the olden times. You had no cares. You didn't try to keep up with the Joneses. You were quite pleased with what you had and that was it! Now, they have everything and they don't know what happiness means.'

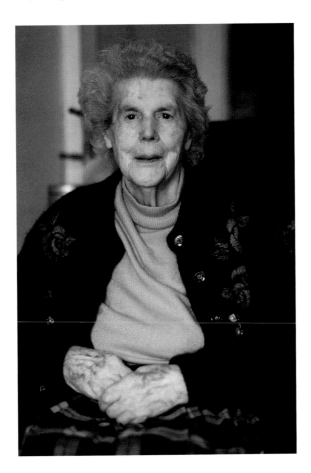

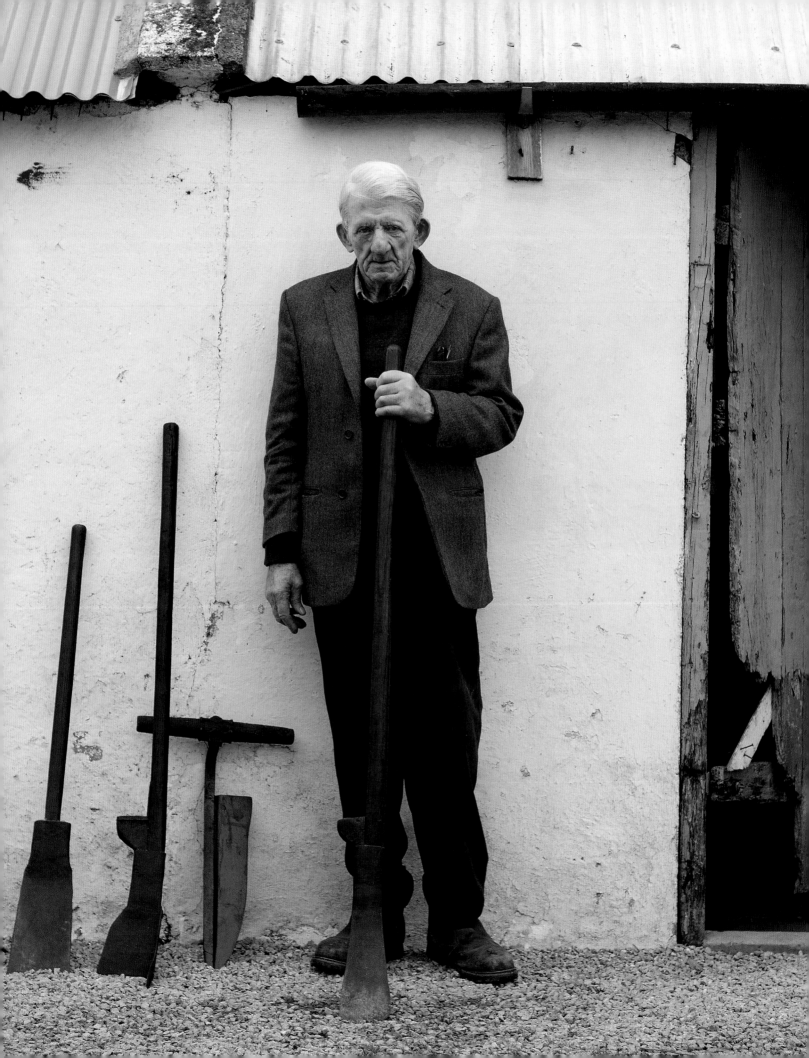

Din Lane

Glin, County Limerick

Turf Dealer

Born 1923

'Twas only the country children would go to school barefoot. You'd never see a town child go barefoot. On 1 October, we'd put the boots on again, but our feet were so hard by then that we could nearly walk on glass or thorns. And now I couldn't even go out to the doorstep barefoot!'

Din's school was in Glin, one and a half miles away from the small farm where he grew up. He wasn't crazy about school. 'It was just like *A Song for a Raggy Boy*, if you ever saw that film,' he says, his fists inadvertently clenching. 'We had two teachers the very same and if you made any complaint, the priest was as bad as either of them. None of us reported when we'd be beat at school because our mothers and fathers would hardly believe us. One of the teachers had a bamboo cane and was always looking for an excuse to give you a few slaps of it with a full, living belt.' Din is one of those who believes that the exposure of abusive teachers can only be a good thing, that surely such cruelty is now at an end.

Din stayed at national school until he was fifteen. 'Everyone was counting the days before they were fourteen because then you could leave and the teacher couldn't touch you. But even though Monday to Friday was like a month, I wanted to learn. And I was kind of lonesome to be leaving school. So I kept going as long as I could and when I was sixteen, I went to secondary school for a year. That one year was better than all the ones I spent at the national school.'

Denis Lane, known as Din, was the second youngest of seven children. His mother Elizabeth Faley was a farmer's daughter from Killeaney just south of Glin. As a young woman she emigrated to Pittsburgh where four of her siblings were living. She found work in a hotel but when word arrived from Ireland that her mother had taken ill, she took the momentous decision to return to her homeland.

In 1909, she married Paddy Lane, a farm labourer and Limerick County Council worker who lived at Carrigkerry in Glensharrold, west Limerick. Glensharrold experienced one of the darkest episodes of the Land War when, during Paddy's childhood, mounted troopers cleared over twenty-five tenants out of the townland. Paddy and Elizabeth settled in the townland of Clonoughter outside Glin where they raised six boys and a girl.

Din was a baby when his 12-year-old sister Betty contracted pneumonia in January 1924. When he recounts her sad tale, he adopts the role of narrator as well as the guise of the two key characters – his father and 'old Dr

Barrett'. The latter had only just arrived in the area so that 'every house was strange to him'. When he learned one of his neighbours had a girl sick with pneumonia, the doctor cycled over to their house as fast as he could. Hope was in his heart because he believed he had a cure for her. He arrived at the house in the mid-morning and asked, 'Is this Lanes?'

'It is.'

'You've a little girl who is sick. What way is she?'

'She's dead, Doctor.'

'Oh, Jesus. And I have the serum here with me.'

Paddy Lane and Dr Barrett remained friends for life. Unfortunately the doctor was to perform autopsies on two more of Paddy's children.

Din's brother Mick was thirty-five-years old when he drowned in Foynes. He had been walking by the boat slip on a grim winter's night and slipped into the water. 'His trousers were torn at the knees from trying to get back up the wall,' says Din. 'He wasn't got until the following day.'

Another brother Jack died young following an epileptic fit. Din found him just as he was breathing his last, lying in a sandpit near his house. The wind was wild that evening and, as Dr Barrett later explained to Din, the fatal attack was brought on when Jack accidentally inhaled some of the blowing sand grains.

Din's house sits on a hill above Glin, surrounded by corrugated sheds full of old peat tools and Honda 50s, and large bales of silage wrapped in shimmering black plastic. Across his carefully tended garden beds, the view rolls down to the Shannon estuary and Labasheeda, the bed of silk. His older brother Paddy built the house with his bare hands. 'He had no cement mixer, no electricity and all the stuff was tossed with a shovel. He even built his own blocks, but he had the whole thing finished nearly as quick as four or five men would build it now. He started on 13 May and he had it finished in November.'

After he left school in 1941, Din began working in the locality, helping farmers with their dairying and hauling cattle. In 1948, he and his brother Morgan acquired a Fordson lorry and put it on the road.

'Turf was our main business,' he explains. 'We'd sell it then around east Limerick, to all the farmers, Rathkeale and places.'

'It was hard work. We were on Joe White's bog by eight o'clock every morning from the end of March. We often used to make our dinner with a fire out in the bog. If we were out of butter, we'd go into Glin on our way, but we'd be there a half an hour before anyone else would get up!'

The brothers would stook the turf and leave it to dry for a fortnight. At length, they would draw it up to the roadside, load up the Fordson and head off to sell it. 'But the changes that are there now!' he says, shaking his head. 'A good big lorry would get you £12 at that time. Now they're getting €300 for a small cart-box load! We had five times that amount in our lorry. Nobody else had a tractor, so we used to be very busy drawing. Most of the famers only had a horse and creel which was too slow for getting turf.'

When he wasn't harvesting turf, Din and his wife Mary were raising their five children. Two of their daughters are married in America, meaning that the 88-year-old turf-cutter, who never once left Ireland in the twentieth century, has visited the USA five times in the past decade. As a younger man, he loved to play the accordion and take his Honda 50 for a spin. In latter years, he has tended to his garden. 'I do a lot of gardening all the time,' he says. 'In fact, I have two gardens now. I'm only waiting for April so I can start planting potatoes and turnips and cabbages.'

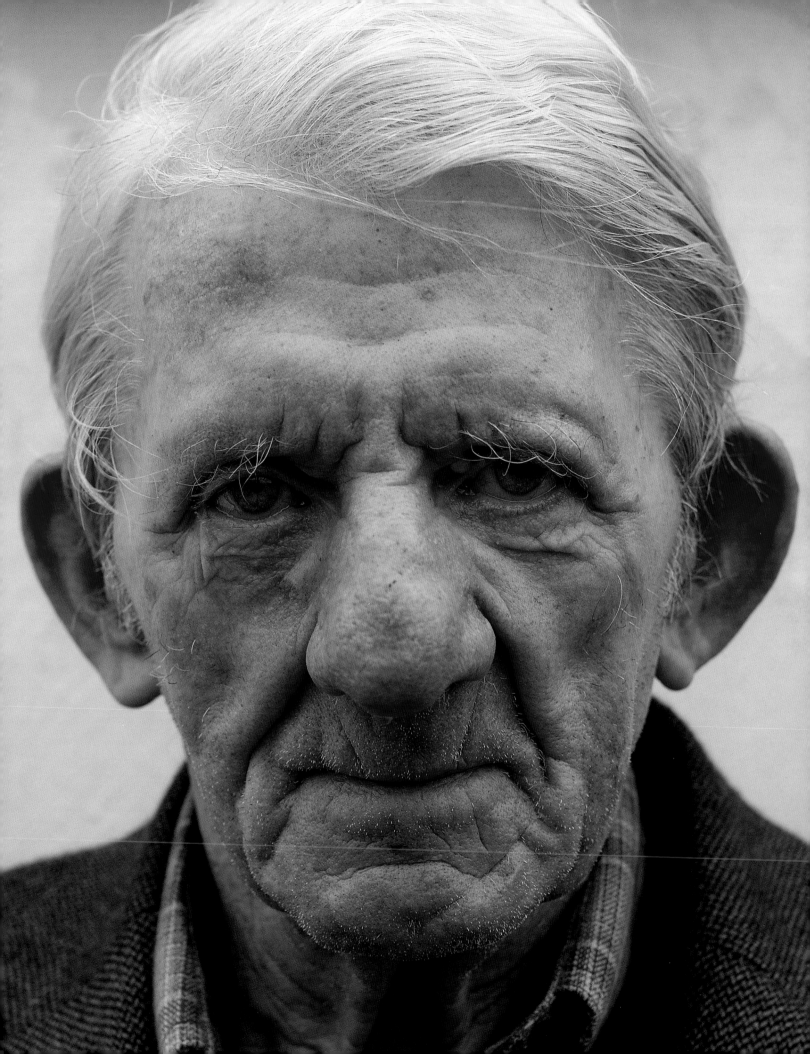

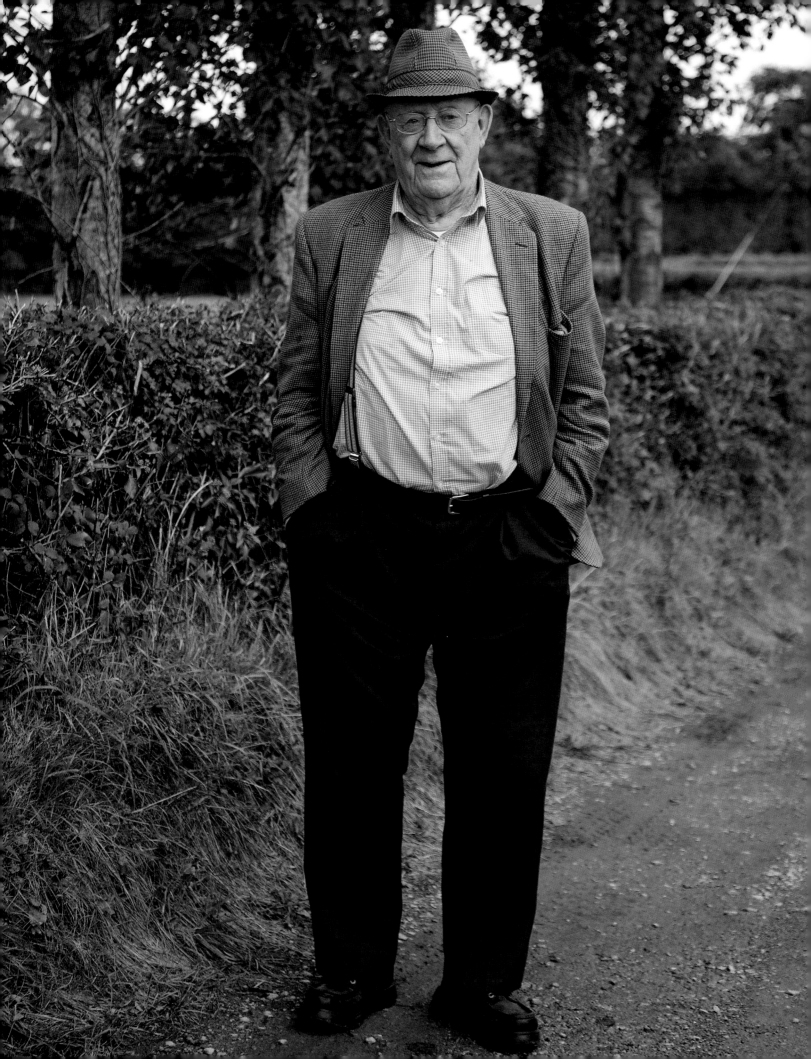

Mike Harte

Daingean, County Offaly

Farmer

Born 1919

Over 35,000 Irishmen were killed while serving with the British Army during the First World War, but for more than 315,000 Irish veterans who returned home with missing limbs and shell-shocked memories, there was to be no let up. As Ireland advanced towards independence, those who had fought for Britain were castigated as traitors. At least 200 war veterans were killed in Ireland during the ensuing Troubles.

However, Mike Harte disputes the concept that all Irish war veterans were treated badly, at least 'not in these parts'. 'People understood that the army was a good job with great pay,' he says. 'When they came out of it, they got a pension. Most of them sold the pension for a lump sum, which was half the value. But when they got the money, they drank it and never stopped. I knew a lot of men who fought in the war and, I can tell you, it affected every one of them.'

Mike grew up on a farm in the townland of Ballymullen on the northern banks of the Royal Canal in County Offaly. 'The road is that crooked you'd nearly see the back of your own head going around the corners,' a neighbour warned as we sought directions from Daingean, a couple of miles to the east.

Daingean was once the seat of the O'Connor Faly clan, chieftains of this eastern part of Offaly for a thousand years before the English ousted them. In 1556, Offaly was shired as 'King's County' by Queen Mary I, eldest daughter of Henry VIII. Daingean was simultaneously renamed 'Philipstown' in honour of her husband, King Philip II of Spain. It was not until 1922, when Mike was a 3-year-old boy, that the county and town were renamed 'Offaly' and 'Daingean' respectively.

Mike's mother descended from the O'Connors of Offaly and while he is proud of the association, he is still angry at the manner in which this once-noble clan were stripped of their lands and reduced to living in mud-wall cabins. 'Cromwell tried to drive them all to Hell or to Connaught but they didn't all go,' he growls. 'Some stayed behind and built their houses in the bog and somehow they survived.'

Amongst those who stayed and survived were the O'Connors, his mother's family, who owned the farm where he lives today. His grandfather John O'Connor was born in 1842 and died in 1913. And for the first thirteen years of his life, Mike shared a house with John's widow 'Granny Tess' who was born during the Great Famine. A part of the house where John and Tess originally lived still exists today as a shed. However, much

of the structure was so riddled with woodworm that Mike was obliged to take it down. To his considerable surprise, he found several Jacobite muskets hidden within the 3-foot-wide mud walls. 'The ramrods and the leather pouches for carrying gunpowder were there too but unfortunately they were all rotten.'

Mike's mother was Mary Kate O'Connor, the eldest daughter of John and Tess. Born in 1883, she married Michael Harte from Rahugh, a few miles from Tyrellspass in County Westmeath. Ten children followed with Mike 'somewhere in the middle'.

Mike was only a toddler when his two oldest sisters sailed for New York. 'They were both cleaning houses over there. I remember the letters coming back with a few dollars in them. One time there was five dollars. That was a lot of money. When I retired I went out to visit them and their children. One had ten children, the other had four and whatever way America works, they were able to educate them all. My nephews and nieces all got good jobs as electricians, foremen, nurses, teachers and things like that. And my sisters' accents never changed from the day they left Offaly.'

Mike's memories of school are bleak. 'It's hard to be bitter on someone who is dead but what they did to children at local schools in Ireland was unbelievable. It happened to me and they got away with it. But I knew of children brought out from my school bleeding. They were brought to the doctor and the doctor kept his mouth shut. It was terrible. Children were only second-class citizens. Even a priest saying mass might hit a child if he was in bad humour. Imagine doing that to a child!'

Mike feels it important that children of the present day, his own grandchildren included, understand how lucky they are 'now that the kicking and the abusing has stopped'. His school days were made no less miserable with the premature death of his father, as well as Granny Tess.

'I remember my father going to mass one Sunday and my mother giving him a ha'penny for the collection. Ah, they were tough times. Some of his children were very small when he died. There were lots of things I'd like to have known, but I wasn't old enough to ask him.'

The Second World War broke out when Mike was twenty years old. 'The war was a bad time. The wages were bad. Everything was bad. I was working with a farmer and there was an awful scarcity of tea and tobacco. There were plenty of house parties that time but there was no food. You wouldn't even get bread or tea.'

When a Local Defence Force was formed, Mike joined 'in case the Germans came'. His eyes turn skywards as he recalls how some of his neighbours heard the German planes going over 'the night they bombed the north of Ireland'.

In time, Mike took on the family farm, which his only son Michael and grandson Declan run today. In Mike's day, dairying was not lucrative enough and so, for much of his working life, he earned a supplementary income collecting peat from the surrounding bogs for Bord na Móna. 'I was out there nearly every day, especially in the good weather. A young fellow would milk the cows for me in the morning. I'd milk them myself in the evening. And I'd work the bogs in between.'

In 1954, Mike married Teresa Larkin, the daughter of an ambitious farmer from Cappincur near Tullamore who grew tobacco and sugar beet during the 1930s. Mike and Teresa had a son and two daughters. 'And when they got older, they'd milk the cows for me while I was on the bog. They'd put the milk into a churn which had our number on it. A tractor and trailer would come then and take it off to Tullamore. That's the way it worked back then but, of course, the whole system has changed since.'

Mike Harte's memoir *From the Cradle to Ninety* was published in 2010 and is available from the Offaly Historical and Archaeological Society.

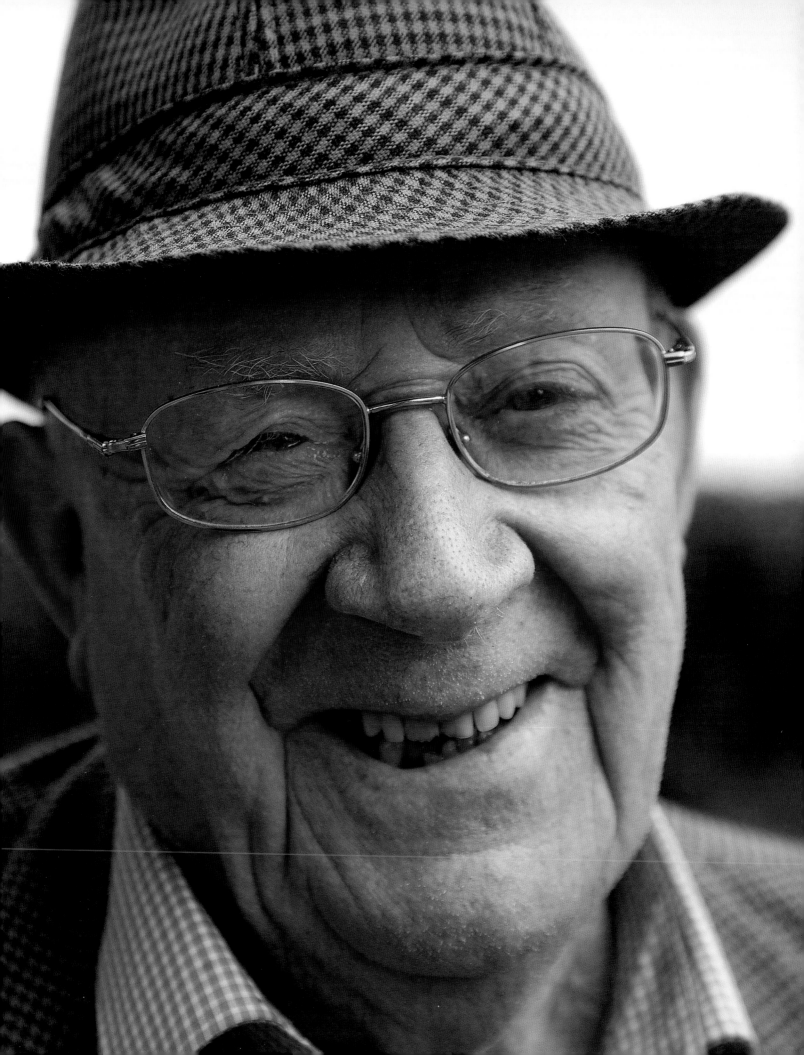

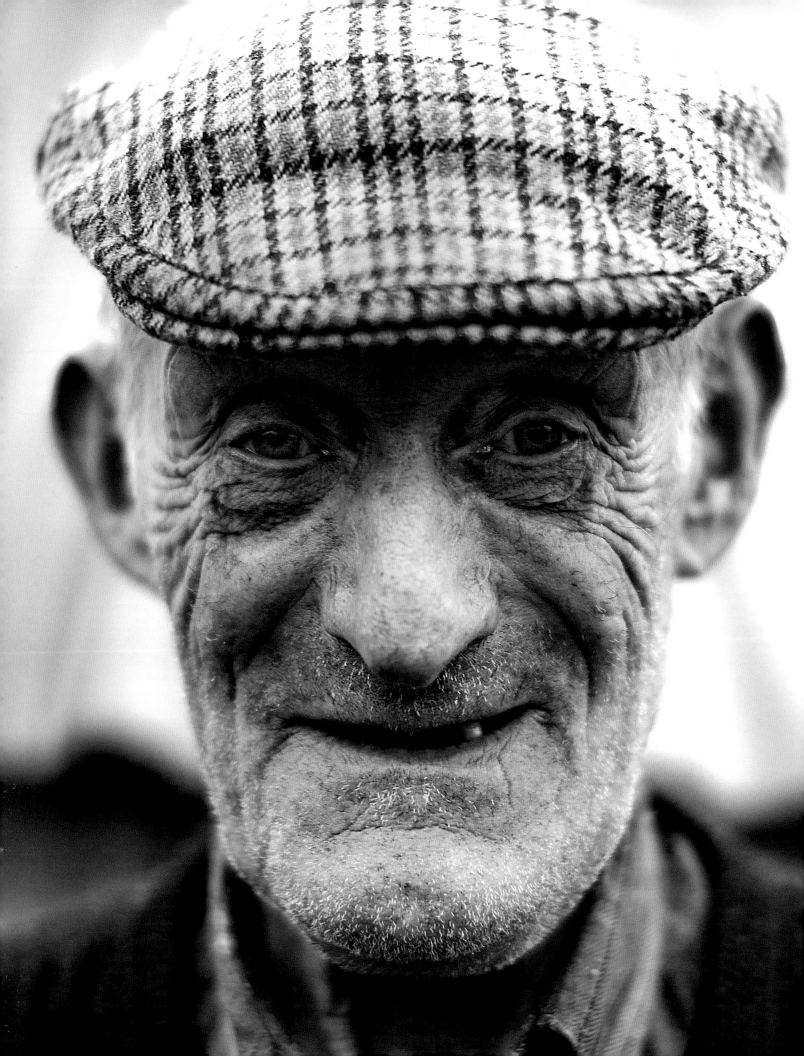

John Abbott

Carrigallen, County Leitrim

Farmer

Born 1931

'Every second man you'd meet in Walsall that time was from Ireland. But there was no work here then. And what work there was didn't pay. You might get £6 a fortnight working for the council over here, but if you went to England you could earn £11 or £12 a week.'

John Abbott was just a few weeks short of his twenty-third birthday when he first crossed the Irish Sea and made his way to the West Midlands town of Walsall. It was the spring of 1955 and the town was undergoing a massive facelift. Before the Second World War, Walsall's nineteenth-century streets had been one of Britain's most notorious slums. By the time John arrived, scaffolding and concrete blocks rose from the ground in place of the Victorian tenements.

For the next seven years, John was amongst thousands of labourers employed to build a series of housing estates around the town. He was specifically involved in the construction of a ring of eleven-storey tower blocks around the town centre. The men worked six days a week, starting at seven o'clock on a Monday morning, 'and maybe before it', and knocking off at six in the evening. On Saturdays they finished at midday and that evening all the boys would meet up for a few pints. 'You'd want the drink horrid badly after the week that was in it,' he grimaces.

John wasn't in Walsall all year round. In fact, he was constantly 'hopping and crossing' the sea. 'I used to come back to gather the hay every year,' he says. His father ran a small cattle farm in Drumderg, just north of the village of Ballinalee in County Longford. The Abbotts had been in that part of Ireland for a long time; Sir Richard Griffith noted several of that ilk living locally when he made his Valuations in the mid-nineteenth century.

John has hazy memories of his grandfather, another John Abbott, who was born in 1845, the year the Great Famine began, and died aged ninety-one when John was a small boy. According to the 1911 census, the older John Abbott was a Church of Ireland farmer who could neither read nor write. He rented his land at Drumderg off the well-to-do Bickerstaff family of Liscormack and Lislea.

In 1871, John married Mary Jane with whom he had eleven children. 'All eleven were reared in the same house where I was born,' says John. 'The oldest was a girl who went to America in 1901. Now, that's a few weeks ago.' By the outbreak of the First World War, another two siblings had emigrated, both settling in New York, while a third brother had sailed south for New Zealand.

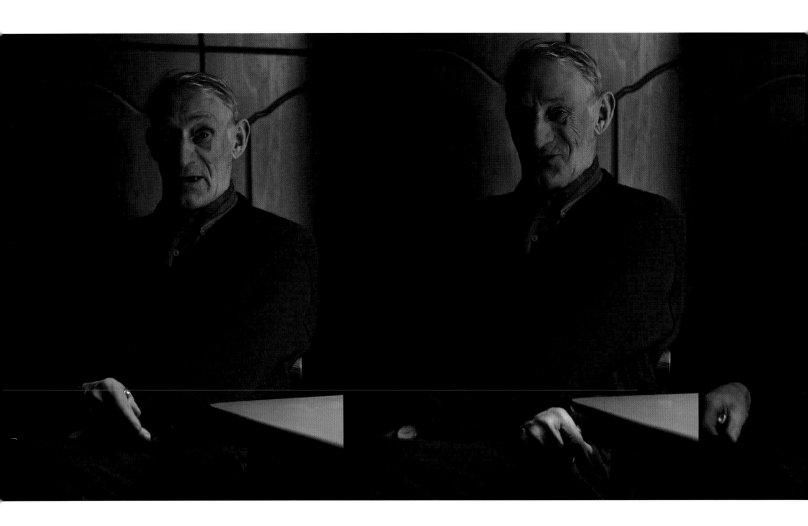

'Two of my uncles stayed behind and worked in Guinnesses in Dublin,' says John. Arthur Abbott worked as a motor driver, distributing porter all over the country, until his premature death aged fifty-two in June 1945. His younger brother Billy Abbott joined the brewery in 1911 and worked as a Stillager in the Traffic Department, helping to unload casks from the drays and horse-drawn lorries as they went on the delivery rounds.

When Billy retired from Guinness in 1943, John's father purchased a farm for him in Ballinalee. The land sale was orchestrated by Michael MacEoin, the local auctioneer, whose brother was General Sean MacEoin, famed across Ireland as 'The Blacksmith of Ballinalee'.

'The Troubles?' smiles John. 'Jesus, there'd be n'er a word of them until there was an election and then, sitting by the fireside at night, you'd hear the whole lot!'

John's father had been active during the War of Independence. He was an important figure within the County Longford branch of the Cumann na nGaedheal party which, with two other groups, was reborn as Fine Gael in 1933. 'It was all Fine Gael around that part of the country where we lived. I think there were only two or three families that were Fianna Fáil.'

General MacEoin was one of the new party's political icons. He was a hero of the War of Independence in which he led a ruthless but extremely efficient IRA flying column in Longford. He subsequently commanded the Free State Army in the northwest of Ireland during the Civil War. In 1932, he was elected to the Dáil for

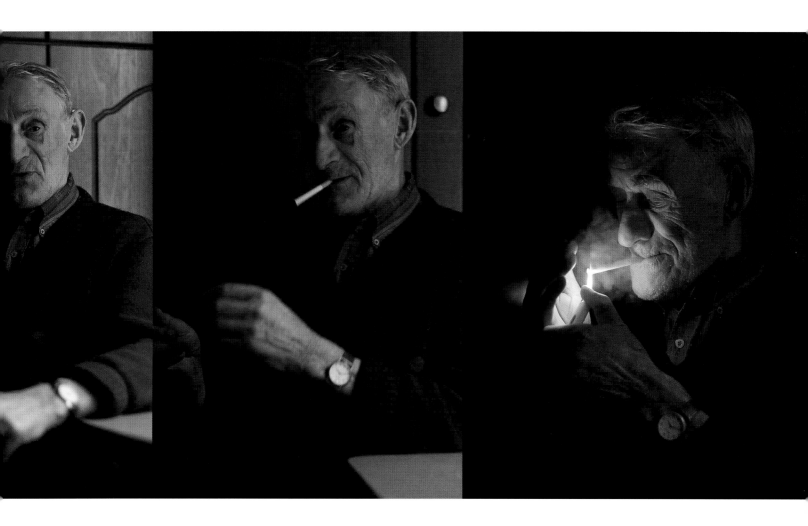

the Longford–Westmeath seat and he represented Longford continuously until his eventual defeat in 1965.

John Abbott was one of General MacEoin's most committed supporters. He campaigned for him at both the 1938 and 1943 national elections. Although he was only a teenager, the tall young Longford farmer was a useful addition to the general's canvassing team, standing outside the polling centre, paying his respects to voters as they went in. 'I call it babysitting,' says he with a wry smile.

MacEoin was the victorious candidate in both elections, although Fine Gael had to kowtow to de Valera's Fianna Fáil party until 1948 when an inter-party government was formed with MacEoin as Minister for Justice. He subsequently served as Minister for Defence under two Fine Gael-led governments.

When we met John to take the photographs for this book, Enda Kenny's Fine Gael party were but days away from the most successful election result in the party's history. Anticipating this outcome, John had a spring in his stride and talked politics with sparkling eyes, regaling us with anecdotes of phone tapping and political suicides, of electoral high jinx and being on the campaign trail. When John looks at a map of County Longford, you sense that he knows exactly which townland, and possibly which house, opted for Fine Gael, which went Sinn Féin and so on.

By 1961, he had moved back to Ireland permanently and was helping his father on the farm, mowing the fields with a reaper and binder that required 'three good horses to pull it'. In 1963, he met Ruby Patterson, the daughter of a farmer from Carrigallen, County Leitrim. Ruby had spent the previous six months working at the

Marlborough Court Hotel, next to the Pro-Cathedral in Dublin. Before that, she had worked six months in the workers' canteen at Luton Airport.

The winter of 1963 was colder than that of 1947. Bitter Siberian easterly winds pummelled the country, creating snowdrifts up to 15 feet in height. Villages were cut off, roads and railways blocked, telephone wires collapsed, food stocks ran low and livestock froze to death in the fields. This was a time for those living in thatched houses with just a turf fire to keep them warm, to brace themselves. However, as Ruby points out, few houses had running water in those days and so, without the fear of burst pipes, the 1963 winter was much easier to enjoy than the unprecedented ice age which struck Ireland in December 2010 and January 2011. 'You had to break the ice on the ponds for the cattle but when that was done, you could really enjoy a freeze up back then,' she says. 'Now it's all pipes freezing up and bursting!'

Boosted by the cold weather, John and Ruby quickly hit it off. His mother was also from County Leitrim, one of five sisters raised in Aughavas. And it no doubt helped that Ruby's family farm was only sixteen miles from Ballinalee. John had frequently walked his father's cattle along these very roads in the springtimes of his youth.

John and Ruby were married on 3 September 1964 and went on to have two daughters, Holly and Anna. The couple live now in the Pattersons' immaculate farmstead which was built in 1950, complete with steel windows. Beside them stand the rough stone gables of a much older thatched cottage that was already gone when they moved here.

In the past fifty years, John Abbott has not travelled far from his east Leitrim–north Longford stronghold. The quick-witted Fine Gael elder has greatly enjoyed a visit to Baltinglass in west Wicklow where the inappropriate appointment of a new postmaster nearly brought down the government in 1950. He has also ventured as far south as Oak Park outside Carlow for the annual ploughing championships. But by and large, he is happy at home. He certainly has no desire to return to Walsall where the tower blocks he once built have long since been demolished.

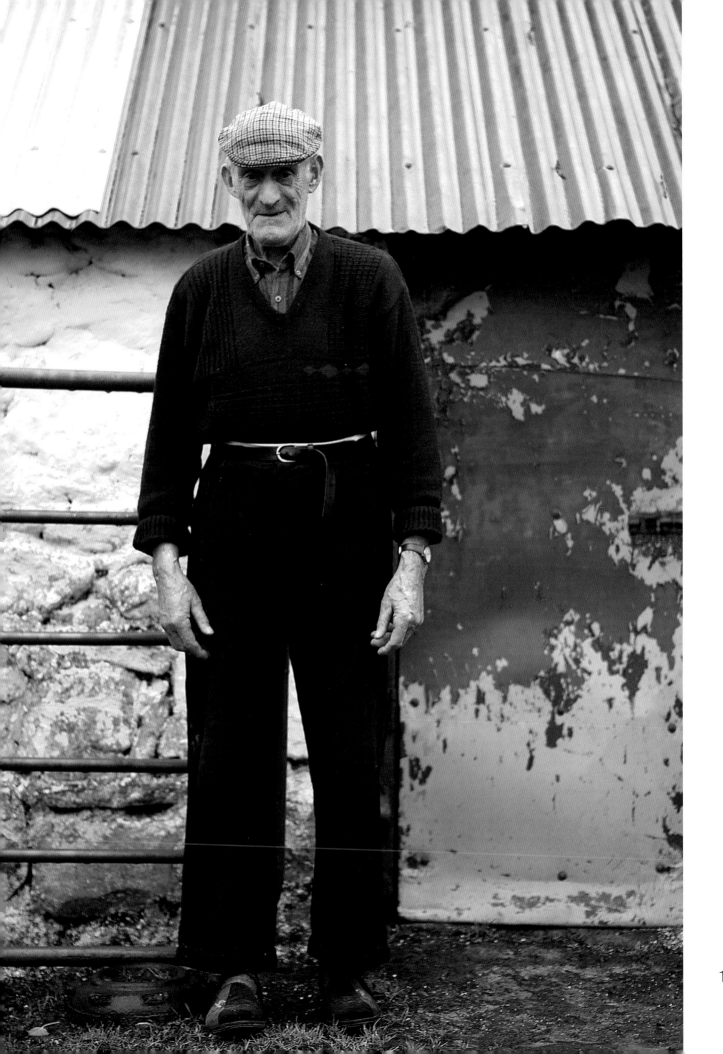

Of Industry and Trade

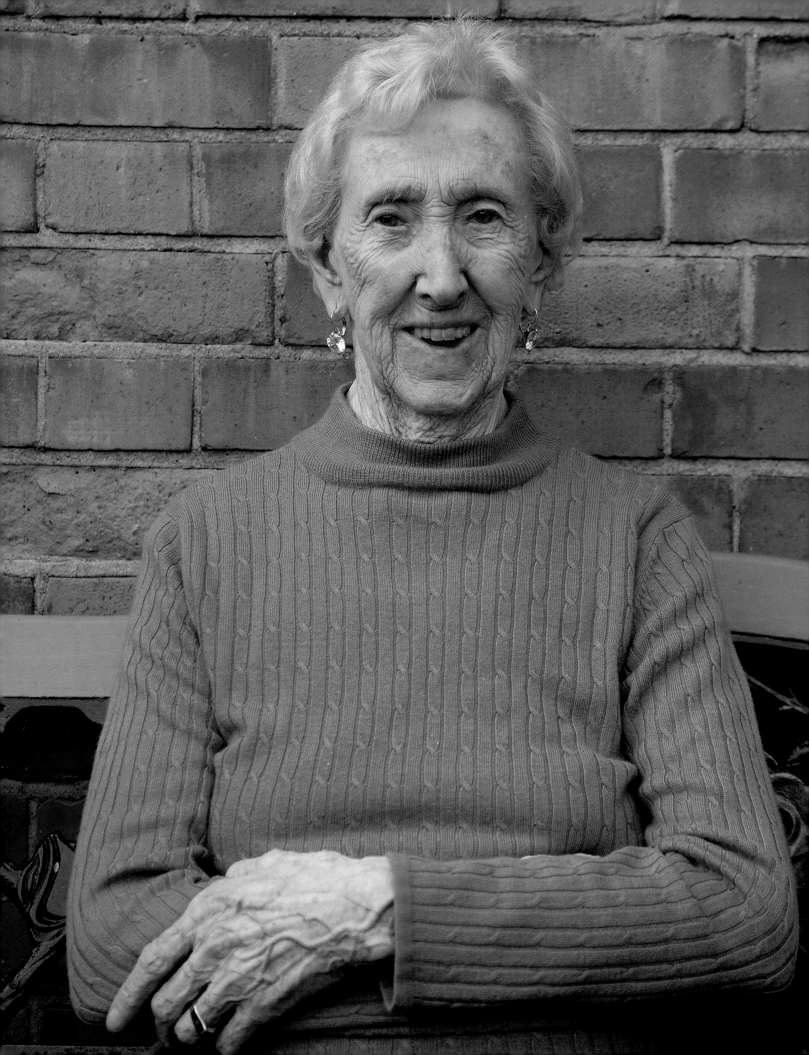

Betty Dempsey

Pearse Street, Dublin City

Mattress Maker's Assistant

Born 1921

Betty was born in Holles Street Hospital, Dublin, on 13 July 1921. Two days earlier, the British and Irish governments had agreed to call a truce to end the War of Independence. The docklands where Betty was raised remained the busiest part of the capital city. Throughout her childhood, the quaysides north and south of the River Liffey were overrun with people – the brave and the brawny, casuals and buttonmen, welders and carpenters, farriers and coalmen, gangers and tramps, alcoholics and shawlies, fisher-women, top-hatted gents and hordes of bare-footed children. Between them jostled piebald carthorses and skinny donkeys, rickety wagons, rusty black bicycles and the occasional spluttering truck. The air was frequently thick with cold, coal-hued smog. On the river itself, cargo ships, cattle boats, lighters and barges journeyed up and down, while deep voices bellowed out from the Hailing Station, directing skippers to the relevant berth.

Betty's family lived at 1 Hanover Street, one of four terraced, redbrick houses built directly behind T&C Martin's Timber Yards. Sarah, her mother, had been raised in one of the tenement houses around the corner on Sir John Rogerson's Quay. Michael, her father, trained as a candlemaker with Rathborne's of East Wall which, founded in 1488, is Ireland's oldest company. When Rathborne's hit a slump in the 1940s, he transferred to Dixons on Harmony Row where he specialised in making church and festive candles. 'The candles he made kept all the churches of Dublin going,' says Betty proudly. It also meant that the Dempseys' living room was always nicely illuminated at night. And there were plenty of wax candle butts to get the fire flamed up.

Betty was the second youngest of ten children, six boys and four girls, all raised in that same small house. Several of her brothers were at St Andrew's School on Pearse Street during the 1916 Rising when it served as a hotbed for young Republican messenger boys. In the school's roll books for 1916, the Rising is rather fetchingly described as the 'Poets' Rebellion'.

Betty was ten years old when her mother died and her eldest sister, Rose, duly took on the role of family matriarch. Gradually, the boys drifted away. Three worked on the coal boats that berthed alongside the Grand Canal quays. 'They'd be down in the hauls, shovelling coal or copper ore into big iron tubs all day long. There was a crane up on the wall and they'd heave the tub onto it, get down another tub and fill it again. That all happened just outside the door from where we lived!' Her other three brothers were carpenters – originally

next door in Martin's and, when that closed, across the river with W&L Crowe's on the North Wall. 'I'd watch them go off on the ferry, shovels across their shoulders.'

Across the street from her old house was the gloriously named Misery Hill. 'It was all fertiliser and timber yards in my day,' says Betty. 'And very smelly.' The hill apparently derives its name from an age when the corpses of those executed at Gallows Hill near Upper Baggot Street were carted there and strung up to rot as a warning to other would-be troublemakers.

Betty was fourteen years old when she first made her way to the Hilton Brothers mattress-making factory on Peterson's Lane, off Lombard Street. During the 1930s the company's ventilated double-spring mattresses transformed sleeping patterns across the world.

Betty was one of five women employed in the factory stitching and stretching all day long. 'My hair was jet black in those days, but there's no jet and no black in it now,' she laughs. Nearly sixty years later she can still recall the precise motions of mattress making.

'You stretch the canvas over each mattress, then catch each spring, lengthways and crossways. Turn the mattress over, get the next piece of canvas and do the same thing all over again. Then you box them all in with big nails and twine and send them off to the men who have a special machine that fills them with fibre and curled hair. Then it's job done and off they go to the shops.'

She continued to work there during the 'rough years' of the Second World War. By 1960, the firm employed 125 workers, men and women, and was making more upholstery than any other business in the country. The company also turned out upwards of 2,500 cinema and theatre tip chairs. However, that same year 39-year-old Betty and several other women were told their services were no longer needed. 'One day they just said, "we're very sorry, we haven't got enough work for you. Your cards will be ready next week." That was it. No redundancy. No nothing. After 25 years and I had never lost a day!'

Being unemployed in Dublin in 1960 was not an unusual place to be. By the 1960s, the docklands were in decline. The coal yards had abandoned carthorses in favour of trucks and the city was turning its back on the river. Betty's brothers and sisters were now living elsewhere. In fact, there was nobody around. 'It was all owned by the Gas Company from Pearse Street to Rogerson's Quay.' The Gas Company had even taken over the timber yard behind her house where her brothers had once worked. They used it to store their coal. 'I had to put up with all the dust and dirt,' she says. 'You can imagine how hard it was to keep the washing on the line clean!'

As inner-city Dublin became an increasingly forlorn landscape, Betty's spirits waned. 'I was left in that house on my own and I became very, very lonely.' Her solitary relief was line dancing which she took up in her late twenties. 'Old-time sequence dancing – and its coming back now!' she says, clapping her hands in delight. 'I've medals and plaques for it, and I would dance all day long if I could.'

In 1986, she closed the door of her family home and moved to more modern, drier quarters on Mount Street. 'The old house is all offices now,' she says. 'It's all changed so much. Even the mattress factory where I worked has become an apartment block.'

Although she still frequently returns to the docklands, Betty confesses she finds it all rather disorientating since the landscape of her childhood became a sea of concrete and glass. 'Ah it's a different place entirely,' she says. 'I'd sooner have it the way we were.'

Betty is a regular at the brilliant St Andrew's Resource Centre on Pearse Street which is committed to looking after the welfare of the older generation from the surrounding community. 'Andrew's is great for me,' she says. 'They taught me how to use the computer, you know? I can send emails and everything. I can only type with one finger, mind you, but they call me a silver surfer.'

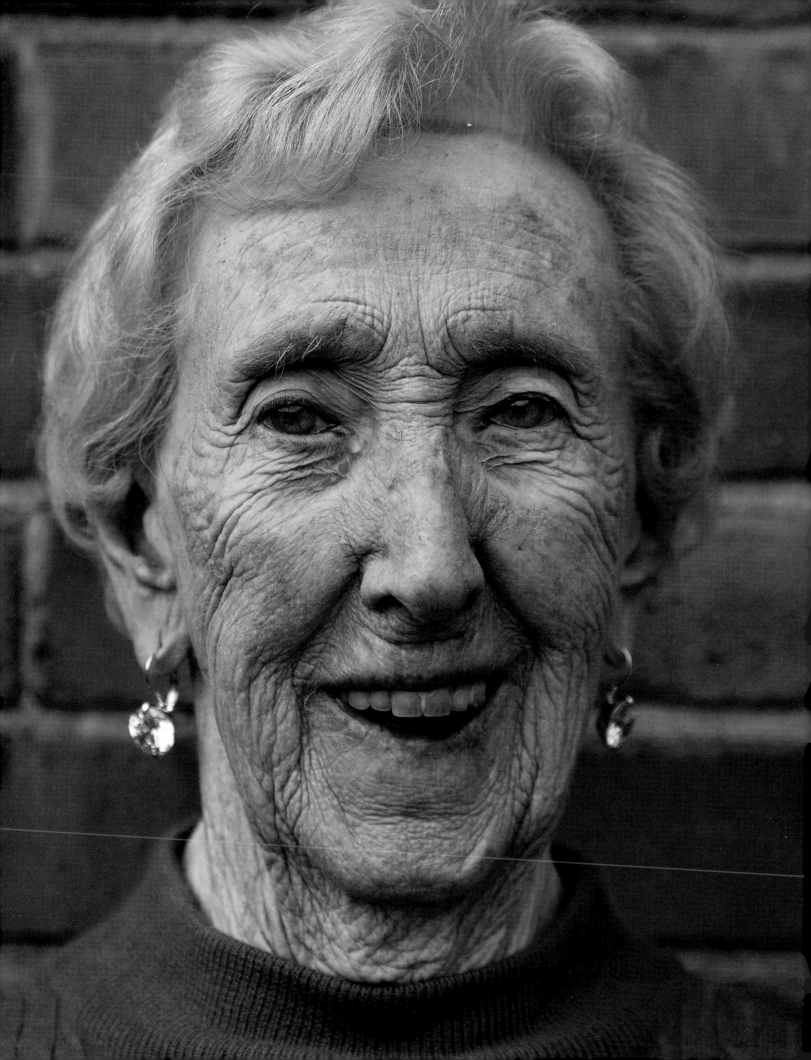

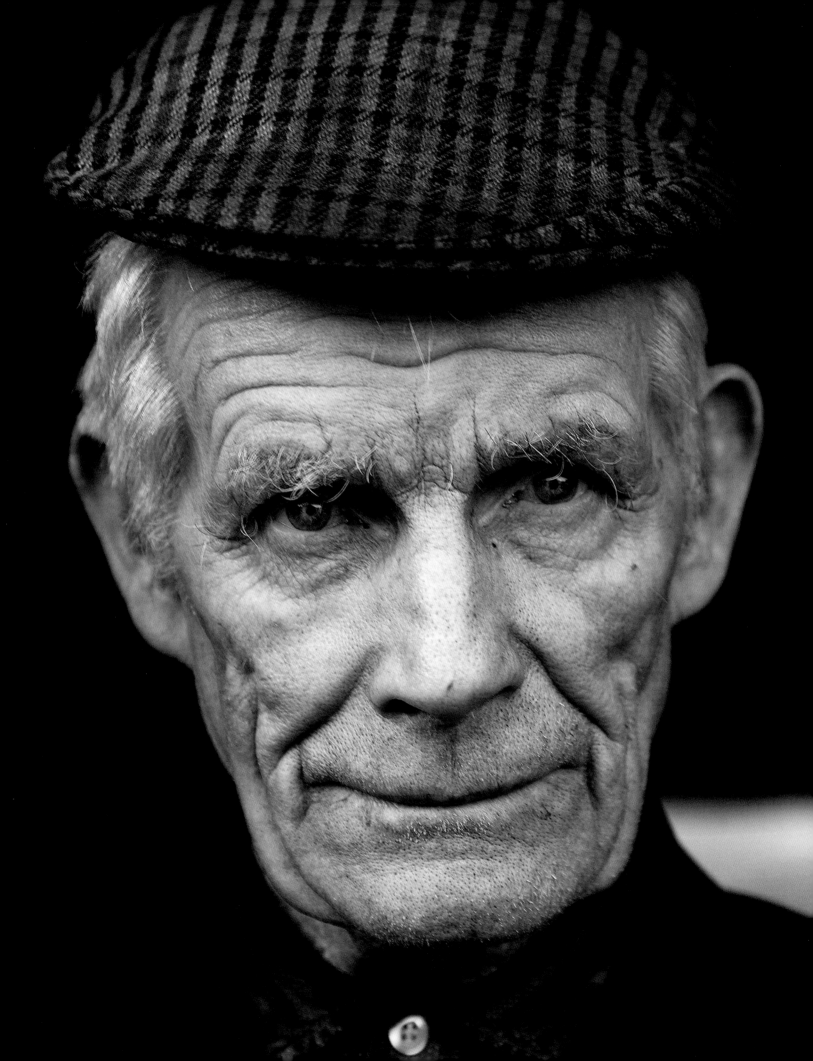

Joe Flynn

Arigna, County Roscommon

Coal Miner

Born 1923

Just outside the village of Arigna, a garrison of fifty massive white wind turbines stride along the top of Kilronan and Corry mountains, their rotating blades pumping electricity into the national grid. The sight makes a dramatic contrast to the tall chimney smouldering its black smoke into the sky over the Arigna Fuels factory where, somewhat ironically, smokeless coal briquettes are made. The Arigna community once depended entirely on coal but lest nostalgic minds be tempted to view the factory as the last surviving vestige of the great Arigna coal-mining days, bear in mind that the coal which burns in Arigna today is imported from the distant mines of China, Poland, the Ukraine and other lands.

There have been mines along the shores of Lough Allen since at least 1629 when the Earl of Cork and Sir Charles Coote, two wily English entrepreneurs, established an ironstone mine close to Arigna. It reputedly employed 3,000 men, all Dutch or English – the secrets of iron smelting were not to be bestowed on the native Irish. Perhaps this is why the early mine was destroyed during the 1641 Rebellion.

In 1765, a vast coal seam was discovered in the hills above Arigna. Twenty years later, three brothers called O'Reilly took the plunge and rebuilt an iron works, complete with its own horse-drawn railway line connecting the mine to the furnace. The O'Reillys' mine closed in 1838, but coal mining continued as it became an increasingly vital fuel for the heating of homes and hospitals, and for powering steam engines.

Demand for coal continued to expand to such an extent that, in 1920, the British government constructed a narrow-gauge railway to link the Arigna Valley with the iron collieries at Creevelea, fifty kilometres to the south. It was to be one of the last projects completed under British rule. Unfortunately, the new line was badly managed. There were not enough wagons or engines to transport the coal and mountains of coal were too often left exposed on the hillsides, soaking up the Irish rain.

Nonetheless, the Arigna mines continued to employ hundreds of people and to provide coal for businesses across Ireland throughout the 1930s and 1940s. Joe Flynn's father worked for an English company in Arigna which was later taken over by Layden's. Between 1930 and 1934, Layden's Arigna Collieries operated an overhead cable system between the siding in Arigna and their mines at Rover, Rockhill and Derrenavoggy. The rusty remnants of this short-lived ropeway still stand today.

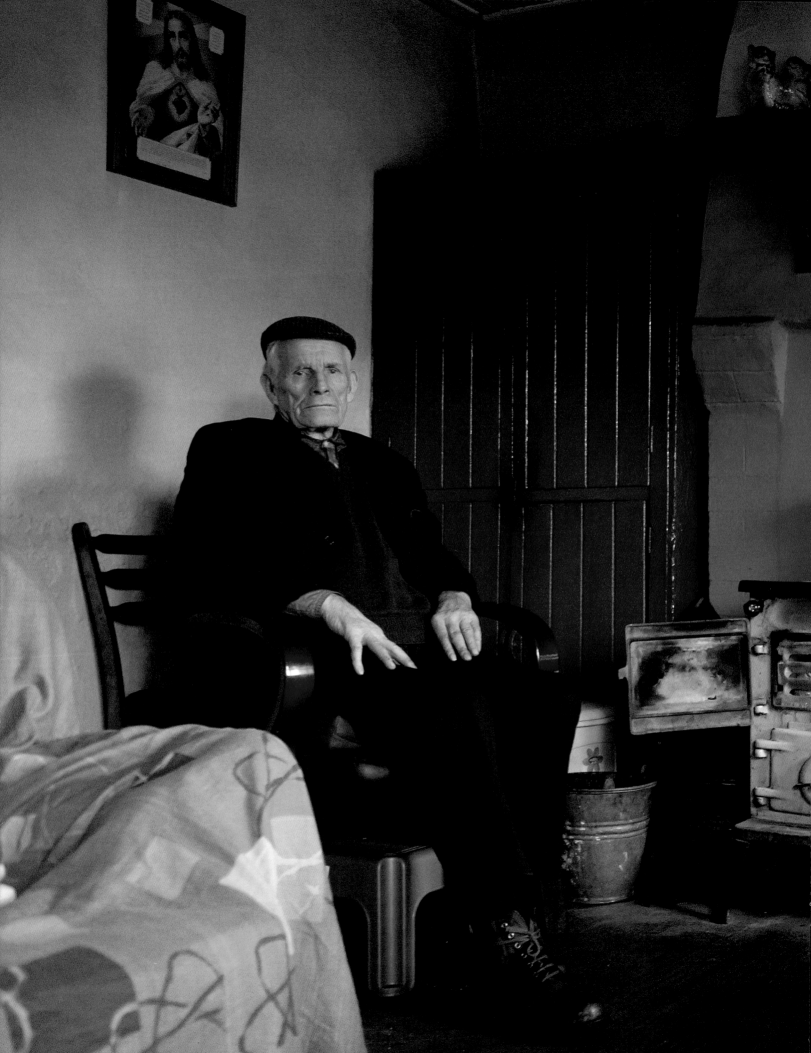

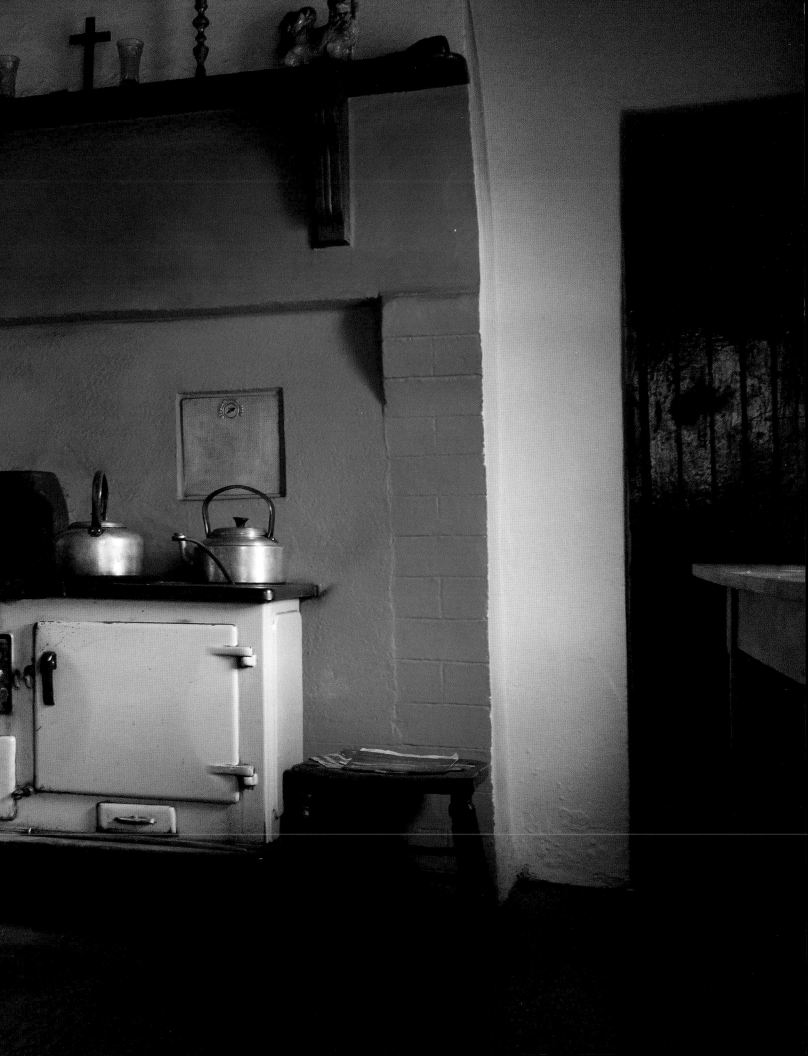

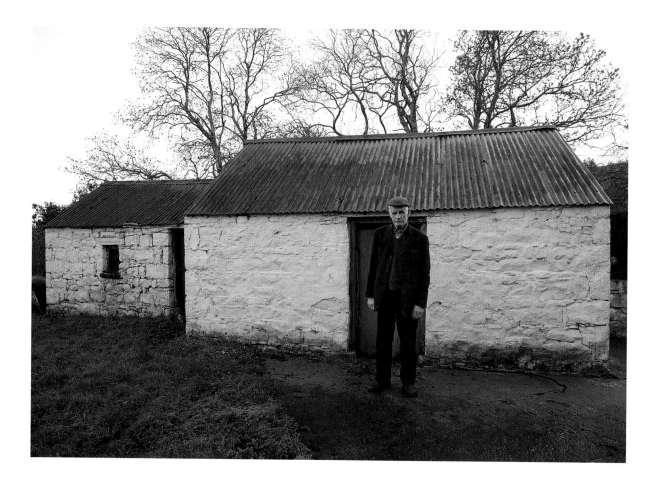

'My father's family were miners for hundreds of years in Arigna,' says Joe. His mother's family were of similar stock. 'They came from Drumkeeran in Leitrim and her brother was a miner and so were his sons.'

One of six children, this quiet, unassuming bachelor went to school in nearby Greaghnafarna. When he left school in 1939, his first job was with Roscommon County Council and at the age of sixteen he was to be found 'out with a shovel along the side of the road, cleaning drains'.

Coal miners were shaping up to be an endangered species in Ireland by the late 1930s. The Rover collieries on the northeastern side of Kilronan Mountain ceased operations in 1938, as did McDermott Roe's Colliery. Many of those who worked part time in the mines were spending more and more time back on their small farms.

However, with the outbreak of the Second World War, the demand for coal rocketed and in 1940, aged seventeen, Joe followed his father into the mines. He started his mining career as a 'drawer' with Layden's, working from eight in the morning until four in the afternoon, with two half-hour tea breaks – one at eleven o'clock, the other at two. In the wintertime, he rarely saw daylight but for Sunday. 'There were three or four hundred people in it that time,' he says. 'Good strong men from Donegal and Mayo mainly.'

'We were shovelling coal on the ton, all day. Drawing and shovelling it into the hutches. That's what they called the little wagons they used to put the stuff into. It was all rail at that time, a two-line rail with full wagons coming out and empty ones going back in, around and around and around.'

He likens the coal-cutting machine to a horse-drawn mower, slowly rumbling alongside the coalface, carving a 3-foot high swathe every day. Joe and his comrades then broke this coal up and shovelled it into the hutches. 'Aye, it was dangerous,' he says, 'but all mines are the same, wherever you're born, South Africa, Chile, Australia

or Arigna. There was no one killed in my day, but there'd always be stones falling, along the roof and around the sides.'

The Flynn homestead is in Lower Rover, the foothills of Kilronan Mountain, and beholds the rolling views towards Drumshanbo, County Leitrim. There was a strong sense of community in Joe's younger years which he recalls with unmistakable longing.

'We used to be kicking footballs around in the evenings and on Sundays. We'd be pitching and tossing and the money got plentiful. There was a shop up the road where you might have fifty or sixty young bucks playing it on Sundays. There's not many of them left now, not from my age.'

In 1957, the state-owned Electricity Supply Board established a power station at Arigna. Everyone realised that the main purpose of this station was to save the jobs of all those employed in the mines. In the meantime, Arigna was hooked up to the national grid.

The coal that Joe shovelled now burned in the Arigna power station, turning the turbines that electrified his own home. 'It was a big change compared to the lamp with the wick and paraffin oil,' he says. 'Still, I seen a man who used to kill pigs around November and salt them, and he'd do it all by lamplight.'

With electricity came television, which brought its own consequences. 'The houses around here used to be full of ramblers,' says Joe. 'Everyone would know everyone else. Then television came in and that finished it. Everyone got one in every house and they all quit their rambling.'

Both of Joe's brothers left Arigna at this stage, one to settle in Shepherd's Bush, London, another to work in the Drumkeeran power station on the shore of Lough Allen. Joe stayed on at the mines until 1967 when he retired to help his invalid mother and look after their 20-acre farm.

At its peak, the power station burned over 55,000 tons of coal a year but when foreign coal flooded the market in the 1980s, Arigna lost its viability and the mine closed down in 1990.

Joe says he was never tempted to emigrate or marry. Music is his private joy. Two of his mother's brothers played fiddle and Joe himself had a crack at the tin whistle when he was young. Some of the men he served alongside in the mines sang and whistled while they worked, 'old bits of song and new ones and all'. Joe doesn't rate his own whistling skills highly but mourns the recent dearth of music in Arigna.

'It used to be full of musicians up here,' he says. 'On both sides of the river, you'd hear them playing of a Sunday, with the dancing and all. I know there's lots of musicians in the country now – look at the fleadhs and all the young musicaneers who go there – but I don't think there's many around here now.'

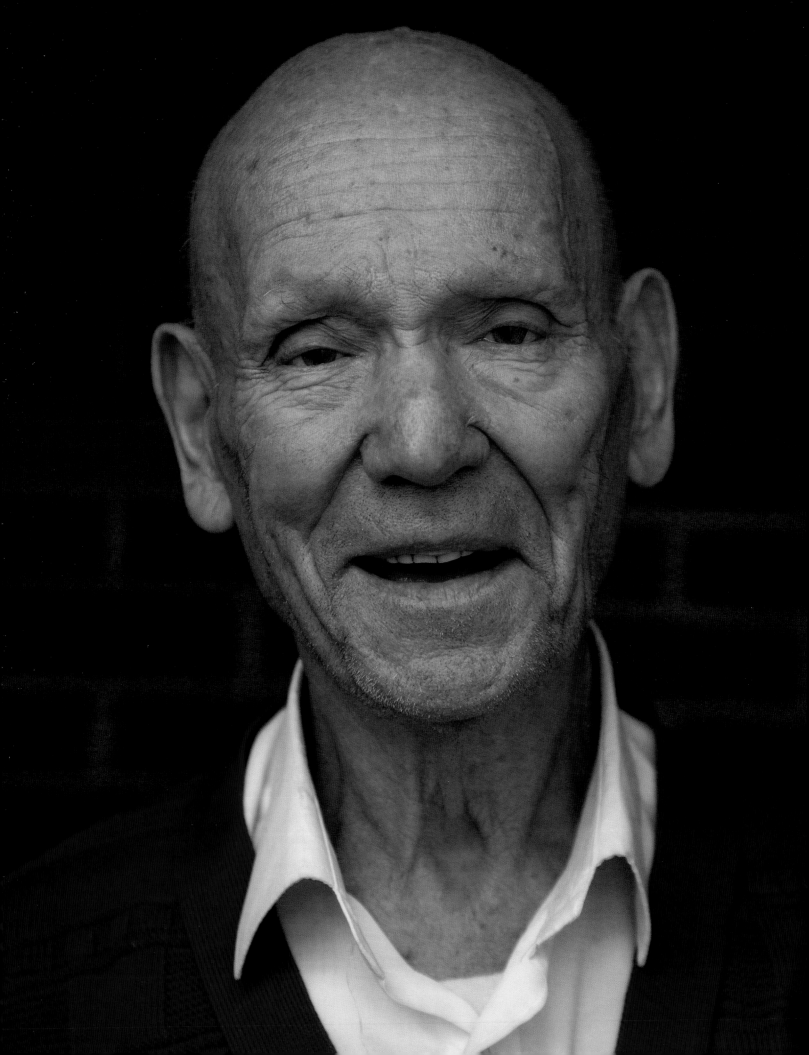

May Morris & Paddy Byrne

Castledermot, County Kildare

Factory Worker & Farm Labourer and Brewery Worker

Born 1913 and 1924

'The children today are like how kings and queens used to be years ago,' says May Morris. 'They are brought to school and picked up after. They wear lovely clothes and they go to lovely schools. I don't know anything about the teachers now, but they used to murder us!'

May and her brother Paddy attended a mixed school in Castledermot, the agricultural town on the Carlow–Kildare border where they both live. It was a roughshod building; plaster fell from the ceiling while they studied. Their teacher was a vicious old woman who never went anywhere without an ash rod. 'She had a way of hitting you on your knuckle that'd make you nearly faint!' says May, protectively clutching her hand ninety years later.

'I was always getting into trouble,' she says. 'Especially trying to read from the big old Bible. If there was a word I couldn't make out, she'd call me 'The Great May Byrne' and hit the knuckles again. The rod was so long that she couldn't miss us! But that was life. If a teacher hit a child today they'd be summoned. In them days, it didn't matter if they killed ye.'

May and Paddy were the second and eighth of eleven children born to James and Rosanna Byrne, a farming couple from Graney Cross on the road between Castledermot and Baltinglass, County Wicklow. It was, and still is, a quiet place, although in October 1922, 9-year-old May heard the shots of a Republican ambush on a Free State convoy at nearby Graney Bridge which left three soldiers dead.

May is still in awe about the generations before her. 'I look back on our mothers and fathers and I think, God they were terrific people. The patience and understanding they had with us children. We worked hard, but the weather had a lot to do with it. If it was a lovely day, you'd be out weeding, thinning turnips, picking spuds, all them sort of things. If it was miserable, we might be inside helping our mother make butter. Or sometimes she gave us four needles and a bundle of wool and told us to knit our winter socks.'

There were also animals to tend – four or five cows, a couple of pigs and a clatter of hens. To acquire fresh stock, the Byrnes would go to the market in Baltinglass. 'Those were great days,' she says. 'All the cattle grouped up on the street and all the children running free at the fair.' Young May once bought 'a pair of the finest chickens you ever saw' for five shillings from the 'higglers', Travellers who specialised in poultry.

Castledermot had its own horse fair back in those times, and Paddy remembers how the schools closed on Fair Day and 'the town would be black with horses from all around and everywhere'. There was generally no problem selling them either. 'During the war years, they'd sell them all because they needed horses in England to work down in the mines and things. Everything happened on the street at that time, no matter what town you went to. There were fairs until the time they got the marts. That closed up the trading on the street.'

Life was hard but, like most of their generation, the siblings agree that people were happier than they are now. 'And then we grew up and everything changed,' she laughs. 'Half the country was gone to England and the other half went to Canada and Australia!'

In early 1942, an Englishman appeared in Castledermot and recruited twenty women from the area to work in a munitions factory near Birmingham. 'And with ten shillings in my purse, I was the richest of those twenty,' says May. 'Honest to God, some of them hadn't a shilling.'

May didn't enjoy her first voyage across the sea. 'I was as sick as could be but, when the boat arrived, they gave me a cup of Oxo and a rope ladder and told us the way to get on shore. I was a good-looking lady in my day. A golden-haired beauty! But when I arrived in Birmingham, I was a skeleton, scared to death. Nobody knew what the future would be because the war was only at the start.'

She went to work at Guest, Keen & Nettlefod's factory in Smethwick. 'It was huge,' says May. 'Every day we got lost going into it. They started us off making very small screws. Then we were making stuff for aeroplanes. And then we were making bombs, filling old cans with whatever scrap we could find.'

The reality of war was never far away and whenever the air-raid sirens sounded, May and her colleagues hurried underground. 'You lived on your nerves,' she says. 'But there was always some singing and dancing downstairs. People were paid to keep the spirits up.'

May's personal spirits took a dive when the authorities intercepted a parcel from Ireland. 'My mother, Lord have mercy on her, sent me two slices of ham wrapped up in *The Nationalist*. When I got them, *The Nationalist* was in ribbons. They had everything cut out of it! I was summonsed and told, "If that happens again, you'll go to prison." The worst thing was I didn't get the ham.'

May stayed on at Nettlefold's after the war but several of those she worked with emigrated farther afield. 'Australia was just beginning to waken up and they were taking on anyone who could work in agriculture and building.' Amongst those who headed down under were four of Paddy and May's brothers. Three have since passed away, including Myles Byrne, who co-founded the Irish Club in Sydney, while another brother, Larry, still lives on the Gold Coast. During the 1950s, it was very cheap to get from Birmingham to Australia and May visited her brothers 'umpteen times', whenever they 'were having babies or getting married'. However, she found the Queensland climate too humid for her to consider settling.

In 1955, May transferred to a new factory where she spent her days making tarts. She also found herself a husband in the form of Joe Morris, an English war veteran who worked in Mitchell & Butler's brewery in Birmingham.

May returned home to see her parents occasionally but 'all we ever got was a week and that was never enough time to go home and enjoy ourselves'. However, as her parents grew older, she realised they needed her and after Joe's death she moved back to Ireland in 1980. 'I loved every bit of my life in Birmingham, but it's all brand new now. All the old buildings are gone. I was back there in 2006 visiting some of my friends, although a lot of them have gone as well.'

While May was making bombs in Blighty, Paddy was back in Ireland, working on the home farm, as well as on other farms around Graney Cross. 'It was a terrible wet time during the war years,' he says. 'We started

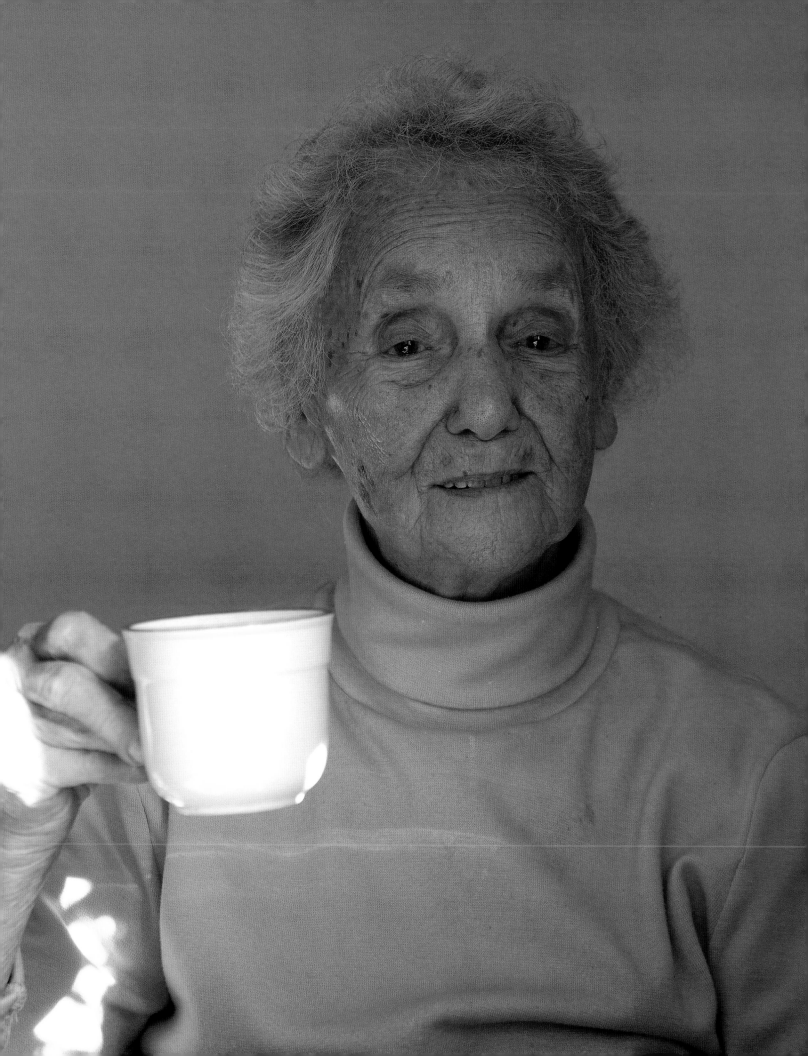

in the fields at eight o'clock in the morning. We went through the wheat, pulling out the thistles with our hands. Then we'd cut the wheat and stook it into little hand-stacks. And then we would draw them into sheds, or make them into ricks. We'd have brown bread or black bread for breakfast. And we wouldn't eat again until teatime, around four. They were long, hard days. All work and no play. It was horrible.'

On one such day, the men in the fields looked up to see a dogfight overhead. 'I never saw such a display,' says Paddy. 'A German bomber was going 200 miles an hour or more with the British fighters right behind him. They went on towards Wexford and the German crashed somewhere down there.'

During their childhood, Graney was a small but compact community, with a Catholic church, a blacksmith's forge, a pub and a shop. When the latter closed, Cope's of Castledermot became the only shop around, operating as a grocery, bakery, hardware shop, veterinary service and animal feed provider. The town was booming in the late 1940s when Paddy secured a job with Cope's as a deliveryman. 'We took a truck to Dublin or Waterford nearly every day, moving cement bags, hardware stuff, offal, the whole lot. We delivered oats to every stable on the Curragh.' Goods often arrived by train and Paddy would duly drive a horse and cart to the station, now closed, on the Mageny Road, three kilometres west of Castledermot.

'When I started at Cope's there were only five motor cars in Castledermot. Even the priest went about on a horse. And it was a big day when I saw my first V8. But then the traffic began to get heavier every day and it took longer and longer to get anywhere.'

In 1960, Paddy sailed for England where he spent the next twenty years working alongside Joe Morris at Mitchell & Butler's brewery in Birmingham. 'You had to take your turn at everything but I was more or less a racker. Filling the barrels. It was bloody hard work. You had got to be on your mettle all the time, up and down, up and down, like a hare. You couldn't let any of the beer go to waste.'

Paddy says he did not have a hard time being an Irishman in England. The street where he lived in Birmingham was exactly 1 mile long. 'All kinds of people lived on it, all colours and all types, and they'd all say, "Good morning, Paddy" or "Good evening" as the case may be. I never had a wrong word with anyone because I was there to earn my money and that was it.' His co-workers were mainly Irish, Indian and Jamaican and 'I made friends with the whole lot. Then automation came in and there was a lot of them let go.'

Paddy is a forward-thinking man. The bright blue Adidas trainers he wears are emblematic of his quiet, unassuming individuality. He was never a big drinker but enjoyed his bachelordom in other ways. He regularly attended the races at Ascot and Cheltenham, and he was an ardent supporter of West Bromwich Albion when Johnny Giles was manager. He also enjoyed watching the brewery's cricket team play. 'The drink was free so long as we clapped every few minutes.'

But Paddy's greatest passion was travel. 'I was born under a wandering star,' he says. And while he has explored most parts of Ireland, it is the wider world that appealed to him most. 'I've watched them dive from the Acapulco gorge, I've visited the Temple of Artemis in Turkey and I've travelled to Australia four times. But the loveliest country I have ever seen is Switzerland, a beautiful land.'

Paddy returned home in 1980 and secured a job in Castledermot with Kelly's Coachbuilders. He and May live together in a roadside cottage in Castledermot, not far from the place where they were both at school a long time ago. The town was beset with trouble when the main road from Dublin to Waterford ran through it. The jury is still out on whether a recent bypass will be of benefit but, with a round tower, two high crosses, an abbey and a popular annual threshing festival, there is certainly scope for positive evolution. 'Castledermot has changed one thousand per cent,' says Paddy. 'But this is my roost now and this is where I will stay.'

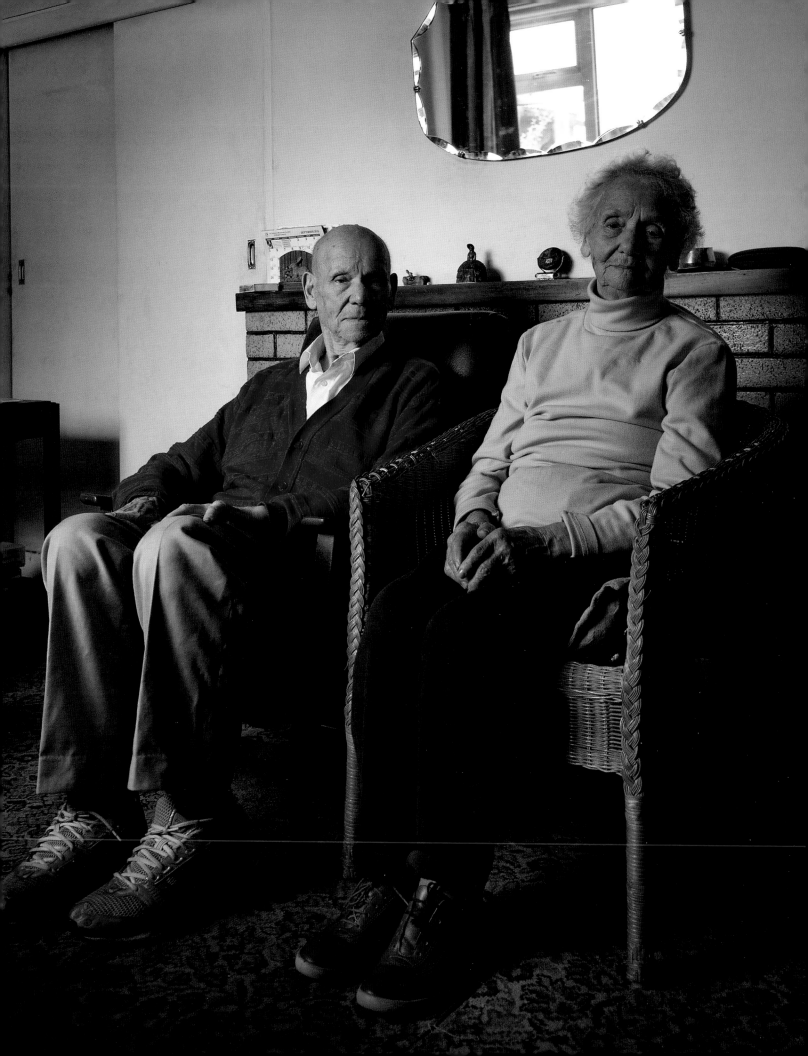

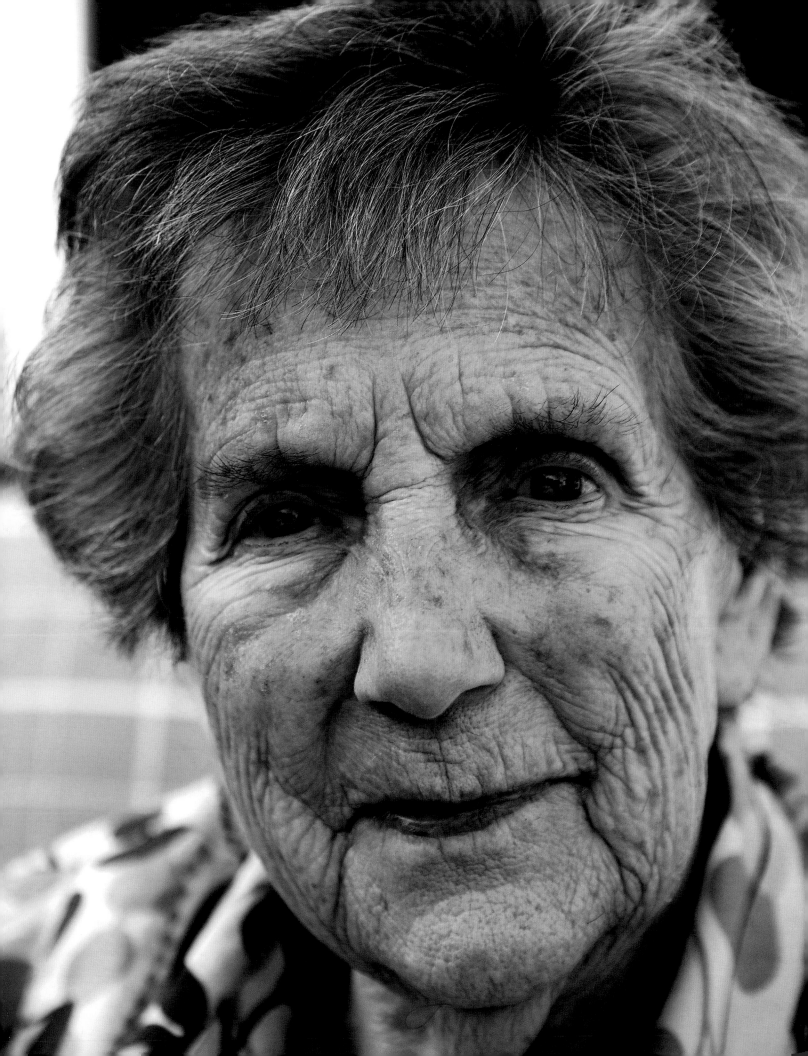

Paddy Tiernan

Donaghmore, County Tyrone

Clerk

Born 1921

'The funny thing is, I don't feel old inside,' says 90-year-old Paddy Tiernan. 'When I look in the mirror, I sometimes have no idea where this face came from. But I suppose I have seen a lot of change. If I think back to when I was a teenager, Ireland was such a different place.'

Paddy Tiernan shakes her head slowly, her youthful eyes beaming across the room. Her father John Arthurs was born in 1867 and worked as a porter at the railway station in Dungannon, County Tyrone.

It is believed that the Arthurs were originally Protestant but they had certainly converted to Catholicism by the time Paddy's grandfather, Hugh Arthurs, was born in 1836. Hugh, who owned a farm near the village of Donaghmore, lived long enough to glimpse baby Paddy, the youngest of twelve children born to his only son John and John's wife Mary (nee Mallon).

'My real name is Patricia, but my father was hoping for another boy so he called me Paddy,' she laughs. Having so many older siblings was a challenge, not least to the memory. 'I learned their names by saying them off like a rhyme,' she says. 'Hugh – Belly – Gertie – Henry – Suzie – Dolly – Francis – Melly – Naisha – Nuala – Bevin – and Me!'

Although the family side-stepped the conflict, the Troubles were never far away. On the very night Paddy was born in January 1921, the District Inspector was shot on the street in Dungannon. 'The doctor couldn't come out to our house because nobody was allowed to travel after the DI was shot,' she says. 'But that was such a terrible time all over the country.'

Ireland was still finding its feet after the multiple traumas of the influenza and war when 58-year-old John Arthurs succumbed to heart failure in 1925.

As well as working on the railway, John had been a farmer. 'It was a very small farm,' says Paddy. 'The land around there is generally poor so all you can do is have a few animals. We had cattle and pigs and chickens and a bit of grain for them. When I was a wee girl, I had loads of pet goats and rabbits. I was allowed anything provided I looked after them myself.'

The family travelled by horse and cart, although Paddy also learned to ride. 'When I was growing up there was no such thing as a saddle,' she says. 'You just got up on a horse bareback. It was a lovely feeling and gave you a great rapport with the animals.'

Paddy initially went to school in Donaghmore where the teacher was no less a soul than her own oldest brother, Hugh. 'I wouldn't recommend being taught by your brother,' she counsels. 'When anything went wrong, I was blamed. Mind you, I probably deserved it.' Being the youngest, she concedes, she was allowed to be 'more mischievous' than her brothers and sisters. 'My mother had got very mellow by the time I arrived. She was an absolutely fabulous woman. She came from a lovely little village called Moy in County Tyrone. She lived for twenty years after my father died and she was a terrific influence on me.

Paddy later went to the convent in Dungannon, a three-mile walk from the farm. 'I loved that school. I don't know if any of the sisters are left now, but they were wonderful women, terrific teachers.' However, in 1936, her mother sold the farm and relocated to Swords in County Dublin. 'All the family were working in England or in Dublin,' she explains. 'There was nobody working in the North and none of us wanted to run the farm.'

Paddy remained in Dungannon for a year to finish her secondary school at the convent, then she headed south to join her mother in Swords, arriving in 1937, the year the Irish Free State officially became Eire, or Ireland. 'I never had any connection south of the border. I hated having to leave all my friends in Tyrone. It was horrible saying goodbye. After I left, I kept in touch with some for a while, but then we drifted away. As my brother said, we'd meet up at weddings and funerals, and then it came to the stage where we only met at funerals!'

'Swords was new territory for me but actually it was terrific. It was a small village, very much on the outskirts of the city. Dublin airport was just a little shed in a field. We might see a plane take off once in a blue moon and we would be delighted. It took ages for the Swords bus to get in and out from Dublin because the roads were so desperate. That was one of the biggest differences between the North and the South of Ireland. The roads were so much better kept in the North.'

The raven-haired girl from Ulster was not long in Swords when she headed off to the Gaeltacht in County Galway to learn Irish. 'I learned Irish at school and I loved it. I loved the very sound of the language. And I loved the beautiful Connemara landscape. But I was astonished by the number from around there who had emigrated. There were no industries then. My mother was dead set against emigration.'

Such was Mary Arthurs abhorrence of emigration that none of her twelve children left Ireland until after her death in 1945. Thereafter, a few made their way to England.

Paddy left school aged seventeen and went to study at a commercial college near Parnell Square in Dublin. In 1943, she 'fell into Dublin Corporation' where she spent the next five years working as a clerk, 'short-hand typing and things', finishing up as secretary to the head of the Department of Public Health.

During this time she met Kevin Tiernan, a young man from County Louth who had been transferred to the same department. One of their first dates was to watch Marlene Dietrich perform at The Royal in Dublin. 'She didn't have a great voice,' says Paddy. 'But all she had to do was walk across the stage and she could entertain. She was absolutely amazing.'

Paddy and Kevin were married in 1948. 'And I had to stop working. That was the law with the corporation at that time. They would not employ married women. It was ridiculous because I loved my work and I didn't want to stop but I had to.'

Return trips to the North were rare. 'My father was an only child so we had no first cousins on his side, and we only had a few on my mother's side.' In February 1983, she drove home in a van that carried the coffin of one of her sisters. This was just days after the kidnap of Shergar, the record-breaking Derby winner. Their van was stopped at the border where a polite young British soldier poked his head through the window and said, 'Allo, ma'am, got an 'orse in the boot?'

In 1975, Paddy and Kevin moved to the house in Goatstown, south of Dublin, where she lives today. They celebrated their sixtieth wedding anniversary in January 2008 and Kevin passed away less than two weeks later.

In some ways, she is relieved that the Celtic Tiger has come to a halt. 'The recession has brought a lot of people back to their senses. Young people have been burdened with far too much. When I was growing up we didn't have too much materially but, my goodness, we had great fun.'

'I think I must have mellowed with age and become much more accepting,' she says. 'I am a Catholic and I am still a believer. If everyone actually kept the Ten Commandments, this would be Utopia. But I couldn't get terribly steamed up about the Church as an institution. I think there is more harm done by organised religion than by anything else in this world.'

'I love people and I find everyone interesting. I have always enjoyed listening to other people. You wouldn't think that because I talk so much! But there was a time when I could walk and talk and see and hear. Now I wear a hearing aid and I'm blind in one eye and the only thing I can do is talk.'

Although her sight has waned in recent years, Paddy remains exceptionally sharp-witted and enthusiastic for all things new. Her daughter Angela recently gave her an iPod onto which she has downloaded huge numbers of books, and Paddy now listens to them at leisure.

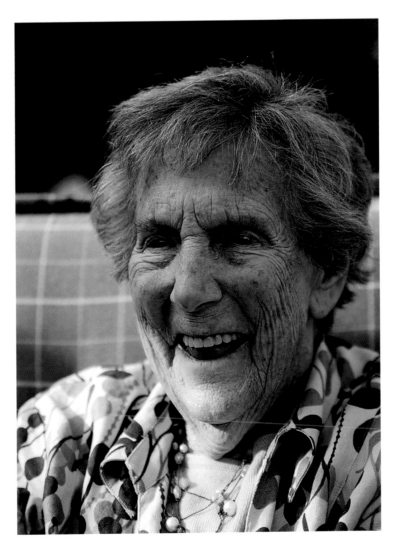

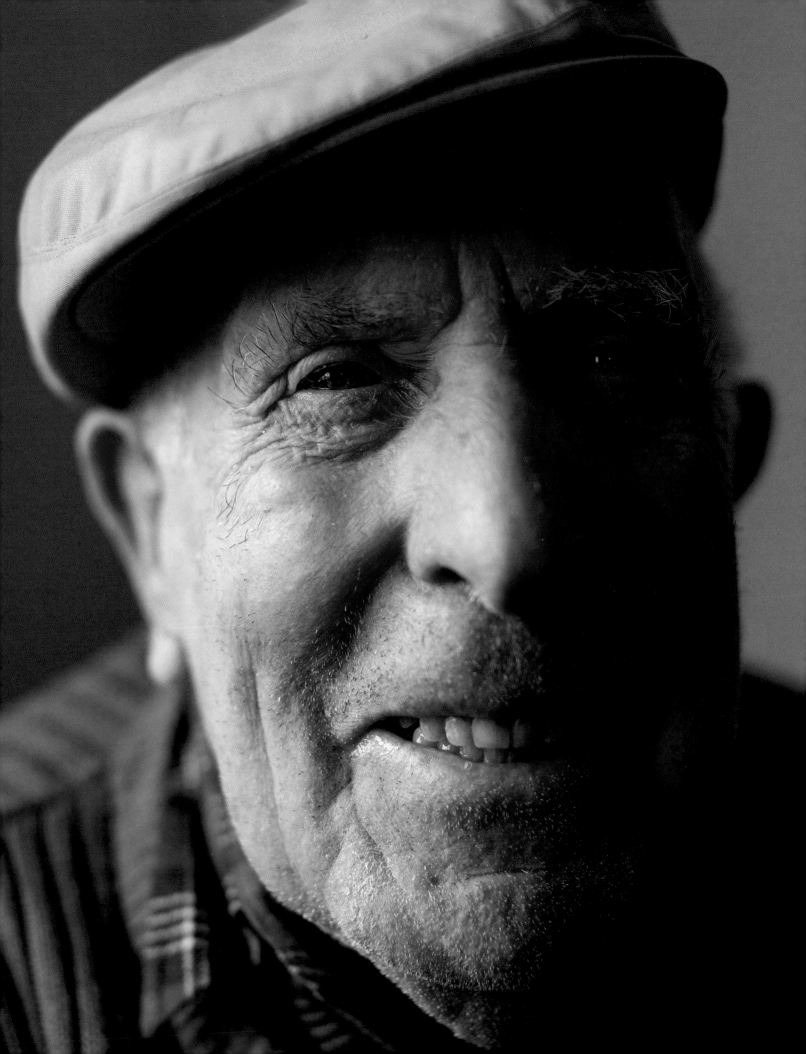

John William Seoighe

Currach Oarsman & Hooker Sailor

Rossaveal, County Galway

Born 1919

There is something about John William Seoighe that instantly connects him to the ancient world, to a time when the grizzle-cheeked fishermen of Ireland's Atlantic coast synchronised their oars with those of the great mariners who sailed the oceans from the Barbary Coast to the Basque and over the far horizon to the cod-plenty waters of the New World. His words are seeped in salty adventure and the richness of marine life. Just to look at him brings to mind the Paul Henry painting of the agile, woolly-jumpered fishermen launching their currach.

John William must have launched ten thousand currachs in his time. Together with three of his Seoighe cousins, he won a record four All-Ireland rowing titles, a three-in-a-row between 1956 and 1958 and a fourth in 1961. They also won numerous Galway hooker regattas along Connemara and the coast of County Clare. And when he wasn't racing, John William was making his money carrying turf from his island home to the people on the Aran Islands.

The Seoighe family has been rooted in the Irish-speaking traditions of Connemara's island life for centuries. The first named was Pádraig, born in Carna in the mid-1700s, who set himself up as a boat-builder by the pier on the island of Inish Barra.

Pádraig's grandson Seán Seoige was born on the island shortly before the Great Famine of the 1840s. 'It was like a cloud that came over the land,' says John William. 'But living on an island was much better than the mainland, because they had the seafood.'

Seán was John William's grandfather and he too made his money by bringing turf from Inish Barra to the Aran Islands. He sailed in a 30-foot boat called *Bláth na hÓighe* (*Flower of Youth*), built by Máirtín Ó Cathasaigh of Mweenish Island.

Seán married Nan O'Donnell whose family had moved to Inish Barra from Roundstone in the early nineteenth century. In about 1902, their second son William and his new bride Peg moved to the island of Inse Gaine, or Sand Island, where they raised three sons and five daughters.

John William, their youngest son, was born on a spring tide in 1919. His childhood ambition was to build boats and he secretly constructed a miniature hooker, complete with sails. He longed to test it on the sea but

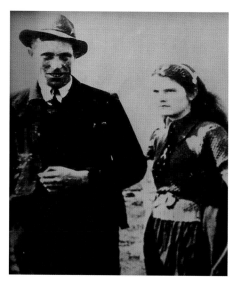

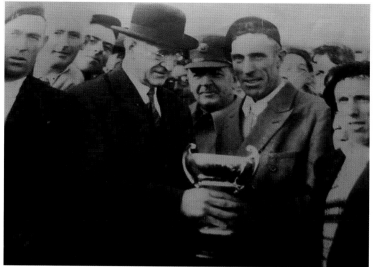

he knew his parents would never let him near the perilous waters. So one day he dropped the boat out of his bedroom window for his young cousin John Babín to catch. But, one way or another, it landed on his father's head instead. 'And, gwargh!' recalls John. 'He didn't know what was going on and where did such a thing come from?' Realising the boys 'were headed for the sea with it', his mother swiftly threw the boat on the fire.

John William went to school on Lettermore Island. There was a special path he could walk along to get there at low tide in the mornings but, when school was finished, the only way home was a one mile row by currach. 'My brother Michael would row over and get me. There was a place on the rocks where he could see me from the island. I'd walk up and down there for a while, he'd see me and land the boat. We rowed back together and that's the reason I could row. Ah, I was fit as a fiddle then.' He certainly was. Indeed, there are probably no shoulders more powerful than those of a currach rower. 'Sailing, sailing, sailing. That was everything to me.'

John William was fourteen years old when he began delivering turf. 'My father came down with a sickness in his body and he wasn't able to go on the boat anymore. My two brothers were a lot older than me and they did not like to sail. So I began sailing into the Aran Islands and out again, ten or twelve miles each time, with my cousin John Babín. We were over every two or three days. It was a tricky journey with the currents and the breakers and you couldn't make it every day. Maybe you'd be almost there and you'd see how the waves were breaking and you'd have to get away again.'

But opportunities in Connemara were scarce during the 1930s and England was the place to go. Shortly after he left school, John William made his way to a house in Huddersfield, West Yorkshire, where six young Inish Barra islanders were living together. These included his sister Margaret, his cousin John Babín, John Babín's sister and John William's future brother-in-law Michael Conneely, 'a rough looking character who had a lot of Irish flag tattoos on him'.

One evening, John William and Margaret were supping a cup of tea in the kitchen when twelve detectives burst into the house with search warrants. 'They didn't leave a penny without turning it,' marvels John William. 'They even opened up my accordion and checked inside.' For the next few weeks, plain-clothes British agents kept a close watch on the household, following them onto buses and into parks. 'They thought that we were a lot of IRAs but we didn't even know what IRA meant,' says John William.

In any case, one night the Irishmen decided they'd had enough. 'We packed our cases, wet washing and all,

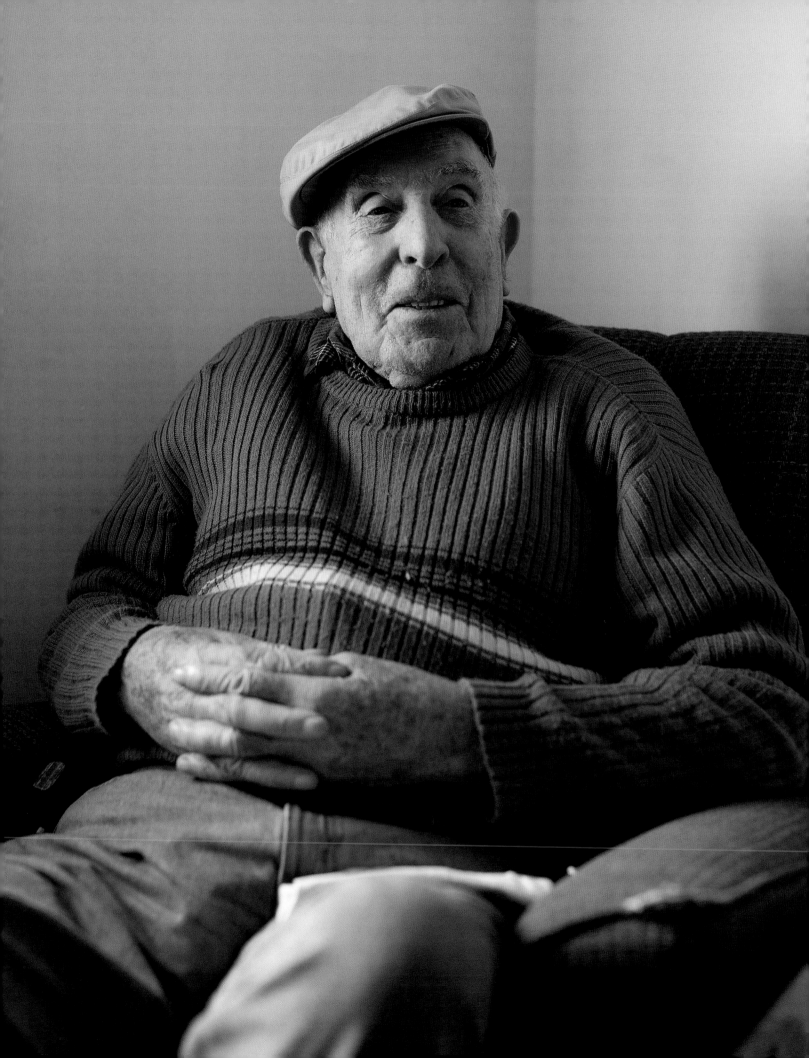

and, at two o'clock in the night, four of us got into a cab and told him to drive to Manchester. So that was it, bye bye Huddersfield.'

From Manchester, they made their way to a kip house in London. John Babín journeyed in a new suit but when they awoke, his suit had vanished. 'He was in bad humour that day,' recalls John William, 'but that was the day we heard about Jersey Island!'

The four men duly sailed to Jersey. Once they landed, they split into pairs and set off to find work. Shortly after they left, John William turned to John Babín and said, 'Arra, why don't we give the others a chance to get a job and maybe they might find work for the lot of us. We'll go back and get something to eat and have a good day for ourselves.' As they sat down to eat, the other two returned having had the very same idea. 'Ya, bastards, ye!'

But, at length, they all found work and they spent the summer on Jersey digging potatoes. 'That was one of the nicest islands I ever met in my life.' And then one day, John Babín uttered the forbidden words. 'Wouldn't it be a lovely day to be sailing over Golam Head?' The four men looked at one another, said 'What are we waiting for?' and by the end of the week they were back in Connemara.

Towards the end of 1942, John William made his way back to England to work as a signalman directing trains and buses in and out of Crewe Station in Cheshire. 'All the Englishmen were out in the war,' he explains, 'so they had women driving the buses and trains.' One afternoon, a corps of American Marines arrived, numbering amongst them Big Andy McDonough, a 6-foot-6 high and utterly fearless Irishman who was raised in Carna and later emigrated to New York. John William had met him during his childhood. 'What in the name of God brought you over here?' asked Big Andy. 'Go back home and get away from these English buggers! They're no good to anybody. We're after coming 3,000 miles to fight their war for them.'

In September 1943, John William was married in Lettermore to Bridget Conneely of Inish Barra island, with whom he had eight children. As well as fishing for lobsters and scallops, he was again bringing turf to the Aran Islands, and on down to Kinvara, and sometimes to Ballyvaughan and New Quay, County Clare.

Some voyages were more peculiar than others, but none more so than the dark November night when he and John Babín were returning home from a trip to the Aran Islands. As they came around Golam Head, 'so close that I nearly hit it', John William noticed a shadow trailing them. 'And when I looked down, boy, what was coming up after but another boat exactly like the one we had. She was only four lengths behind us, but you could hear her whistling through the water. Shuhhhhhhhh. I was never afraid of anything in my time, but I know she was there. So close, but she didn't come any closer. And there was nobody in it. Nobody was steering it. John saw her too. But she gave us no bother whatsoever.' As they rounded Dinish Point, the vessel vanished from sight. But that night the two cousins stood on Inish Barra looking back out across Kilkieran Bay. 'The night was still so beautiful that you could see everything and Christ didn't we see her passing by, going up the bay with three black sails on.'

John William smiles widely as he tells this tale, his eyes opening wider with every passing wave. He clearly relishes stories of the Otherworld and his baritone voice rumbles cheerily as he recalls other mysterious encounters. For instance, the story of Mweenish Island, ancestral home of his wife's people, the Conneelys, where a callous land agent once tried to burn their house down for non-payment of rent. The agent had already destroyed a handful of houses on nearby Feenish Island. When the burning party set out for Mweenish, the priest urged all the islanders to sink to their knees and pray. God heard the people's cry and a thunderbolt shot out from the Heavens and struck the agent dead.

When the 'Big Wind' tore through Ireland in 1839, it blew the roof off the Conneelys' home. Ten years later, the family relocated to Inish Barra where Bridget's father Hughie made his living by transporting goods on a Galway

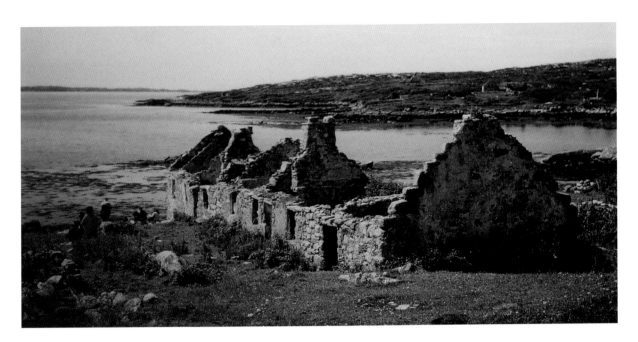

Hooker between Galway city and the towns of Roundstone and Clifden. One day Hughie and his wife were down by the shore, harvesting seaweed. His wife returned home early to make the dinner but Hughie never made it home. 'Whatever happened between, he got drowned,' says John William. 'My wife was only a year old at the time. And it was a strange thing but when our children were coming down near the sea by where he drowned, they would look up and see a man sitting on the wall. It was their grandfather. He was warning them about the sea.'

Bridget never trusted the sea after her father's death. After their marriage, she and John William originally lived in her family house right on the island's shoreline. At high tide, the choppy ocean water frequently came flooding though the front door. In 1957, some of Bridget's cousins moved east to 'the short-grass country' of County Meath. With much relief, the Seoighes loaded their boat with dressers and beds, sailed around the island and moved into the vacated house.

John William continued to fish and distribute turf through the 1950s and 1960s but Inish Barra was an increasingly depressing place to live. The number of houses on the island had fallen sharply from its nineteenth-century high of forty to just eight by 1964, the year the Seoighes left. John William and Bridget's two eldest daughters were already living in Boston. When their third girl decided to join them, John William concluded enough was enough, and packed his wife and six younger children onto a boat. They sailed out from Inish Barra early in the morning, docked in Galway, made their way to Shannon airport and the whole family flew off to a new life in Boston.

John William and Bridget stayed in Boston for six years. He worked as a carpenter and built his own house. 'But you'd always be thinking of the old sod,' he says. In the summer of 1970, homesickness got the better of him and he and Bridget returned to Ireland and bought a new house in Galway city with money from the sale of their Boston home. 'When we got tired of that, we decided to go back to Connemara again. I got this piece of land and we built this house for us to live.'

John William now lives with his son Pádraig, daughter-in-law Cáit and two young grandchildren, Róisin and Colm, an extremely talented pair, well known in the west for their singing, dancing and acting prowess. Róisin featured in the Irish-language drama *Malartú Intinne* and has toured abroad with President Mary McAleese. It pleases John William greatly that his children and grandchildren still sail and fish in the waters of Inish Barra over which he himself navigated so many times.

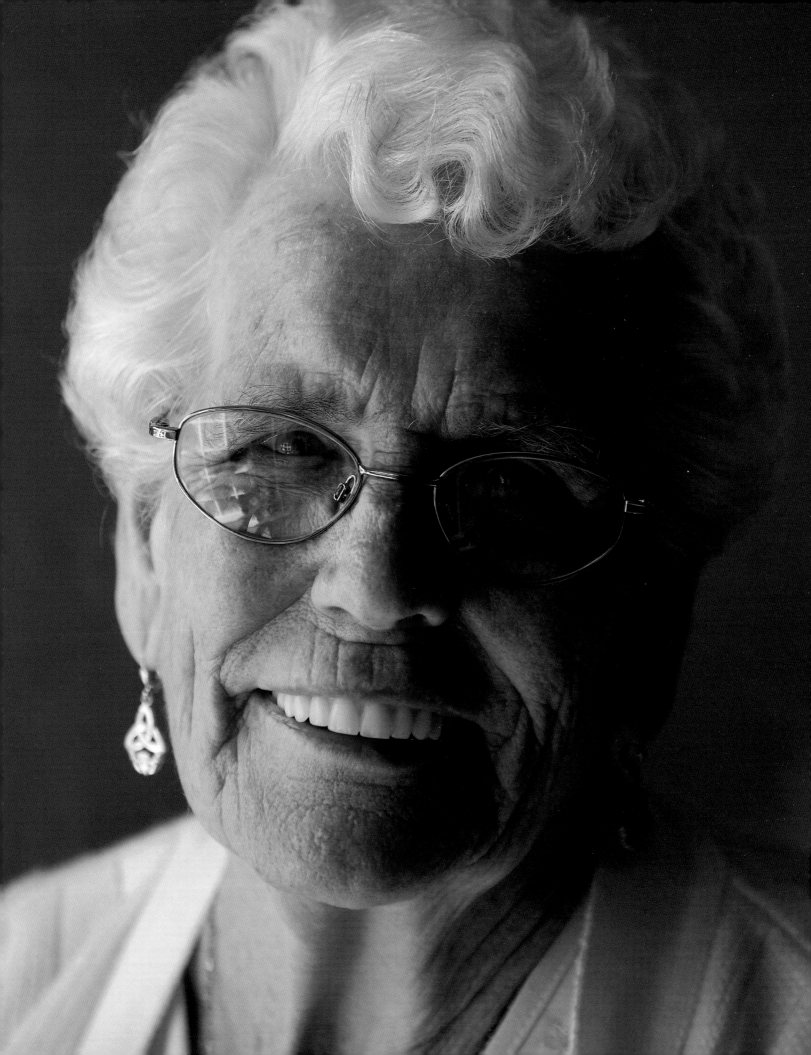

Connie Brennan

Inchicore, Dublin City

Child Minder, Housekeeper & Hotel Cleaner

Born 1929

'We're unclaimed treasures, all of us,' says Connie Brennan of herself and her two spinster friends. 'They say that only the mugs get married and the best china is left on the top shelf.'

Born in Rathdrum, County Wicklow, in 1929, Connie was one of three daughters of Jim Brennan, a Guinness deliveryman, and his wife Elizabeth. She was just a toddler when her mother passed away. Her father then married Margaret Redmond, 'a lovely woman' who worked between Fortune's pub and Smith's chemist in Inchicore.

Connie was educated at the Model School in Inchicore where the poet Thomas Kinsella was a year above her. She recalls her childhood as a cheerful period when 'everyone played out on the street', hopscotch, marbles and rope-swinging around the old gas lampposts.

But there was a policeman who objected to street games. Connie recalls a time when 'the lads were playing football and next thing he was coming and they all flew off', leaving a sickly child called Michael Reilly behind. 'Michael was minding goal, standing on all the coats, when the policeman came. He brought him back to Mrs Reilly and fined the poor woman. Wasn't that a terrible thing to do? To fine a poor mother because her sick little boy was playing football on the street! Michael didn't live long after that anyway.'

In her early twenties, Connie made her way west to Swinford, County Mayo, where she found work as a cleaner in a boarding school. She then looked after a young family whose mother had passed away in childbirth, before taking work as a housekeeper for a priest who lived near Knock and later on Achill Island.

After she left Mayo, Connie went to work as a childminder for a family who lived in part of Dundrum Castle. She then spent nine years working as housekeeper to Michael Hayes, a Fine Gael senator and former Minister for Education who became Professor of Irish at University College Dublin in 1951.

During the 1960s, Connie began working as a cleaner at the Montrose Hotel on the Stillorgan Road where she remained for the next twenty-seven years. She would cycle across from Inchicore on a black High Nelly bicycle and spend her days cleaning the bedrooms and 'making it all beautiful'.

Connie had been brimming with mischief since time began. When her friend Maureen hesitantly heads off to have her portrait taken for this book, Connie yells after her, 'Smile and the world smiles with you, weep and you weep alone.'

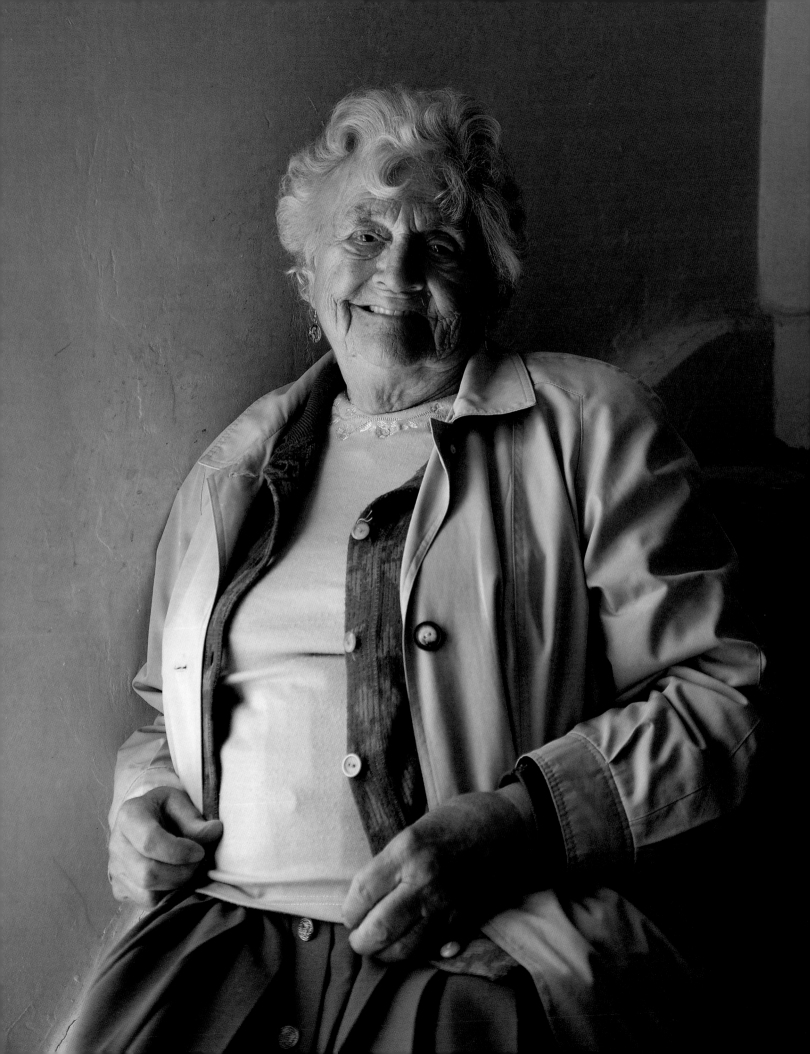

Maureen Tierney

Inchicore, Dublin City

Laundry & Factory Worker

Born 1920

'Maureen is the oldest swinger in town,' laughs her life-long friend Jenny Cullen. Born in 1920, when the Tans were on the prowl, she was reared at her grandmother's house, O'Donoghue Street, which runs parallel to the old Great Southern & Western Railway Works in Inchicore. Her grandmother, Catherine Tierney, was a Kildare woman born at the tail end of the Great Famine. In the 1870s, Catherine moved to Dublin, married Maureen's grandfather and had two sons, Patrick and William. Patrick Tierney, Maureen's father, was a labourer at the Inchicore Works where they made and restored wagons and carriages. Back then, the works also incorporated paint shops, a saw mill, a gas plant, a creosote plant and a boiler-making facility. 'Everyone worked at Inchicore Works at that time,' says Maureen. 'They'd come out in droves on their bikes. You couldn't cross the road for all the bikes. You don't see anything like that now.'

The Tierneys lived directly opposite Peader Kearney, the Republican composer best known for 'Amhrán na bhFiann' ('The Soldier's Song'), the rebel song of 1916 that became the Irish national anthem in 1926. 'We were all in and out of people's houses that time,' she says, and the Kearneys' house was no exception. Another neighbour, Jack Tighe, was a noted melodeon player, while the Murphys of Railway Avenue were legendary for their musical evenings. Maureen could sing well but dancing was her thing. 'Ah, there'd always be dancing,' she says. 'Ballroom dancing on the street corners – one, two, three and a hop.'

'Sure, she's still dancing!' interjects her friend Connie Brennan. 'We had a bit of a do in Bluebell yesterday and Maureen was up doing the line dancing. The fellows were up dancing and all. They weren't so bad, considering they're all grandfathers.'

Maureen went to school at the nearby Scoil Mhuire gan Smál which was founded by the Missionary Oblates of Mary Immaculate. This French Catholic order established their Irish headquarters in a farm by the Inchicore Works in 1854. By the 1870s, they had inspired the railwaymen to construct a new church for Inchicore, which was consecrated in 1903. Arguably the most powerful of the Oblates was Fr William Ring who led a pilgrimage to Lourdes in 1883 and for whom Ring Street is named. 'A lot of the streets around here are named for the Oblates,' says Maureen. 'Like Fr Nash and Fr O'Doherty.'

During Maureen's childhood, the Oblates began leading torch-lit processions through the streets of Inchicore.

In 1927, over 3,000 people attended the first such procession. The following year, work began on the construction of a concrete replica of the Lourdes grotto beside the Oblates' church. Maureen's father was amongst the railwaymen from Inchicore who helped complete the work in 1930. Maureen has a clear memory of heading out in her blue cloak on a spring morning that same year to join practically every other young girl she knew on a procession to the grotto. There, they stood silent witness amongst a crowd of 100,000 as Archbishop Byrne gave the grotto his blessing. Catholicism remains an important part of Maureen's daily life and she continues to worship at the Oblate church.

Maureen was a 13-year-old schoolgirl in Goldenbridge when her mother died in 1933. With her older sister already in a convent in Newry, Maureen was obliged to take on the maternal role. The following year, she left school to look after her two younger brothers, Tommy and Paddy. Her uncle William worked as a van driver for the Metropolitan Laundry, located just behind the jail in Inchicore and, in 1937, William helped secure his 17-year-old niece a job at the laundry, where she remained for the next twenty-six years. 'I worked from eight in the morning until nine at night, pressing and ironing shirts, or cleaning and pleating coats for the nurses at Vincent's Hospital. The money was very bad and it was hard work.'

Meanwhile, her brothers grew up and found employment. Tommy, 'the only one who got married out of the family', worked at 'anything and everything', while Paddy joined their father on the railway. Both brothers have since passed away.

'So I'm free now!' she chuckles.

'But she was very good,' adds Jenny. 'She also looked after her elderly neighbours like Mrs Johnson. She'd call in to see her before she went to work every morning, to see was she all right. Then she'd cycle to the laundry, do her day's work and cycle home and look in on them again.'

After she left the laundry, Maureen moved to the Mono Containers factory on the Jamestown Road where she spent the next twenty years making lollipop bags and waxed cartons for HB ice cream, as well as paper bags for Lyons tea. Her hands automatically give a display of just how the cardboard was to be folded around the ice cream blocks. 'We were only making the boxes though,' she says. 'Unfortunately the ice cream didn't come with it.'

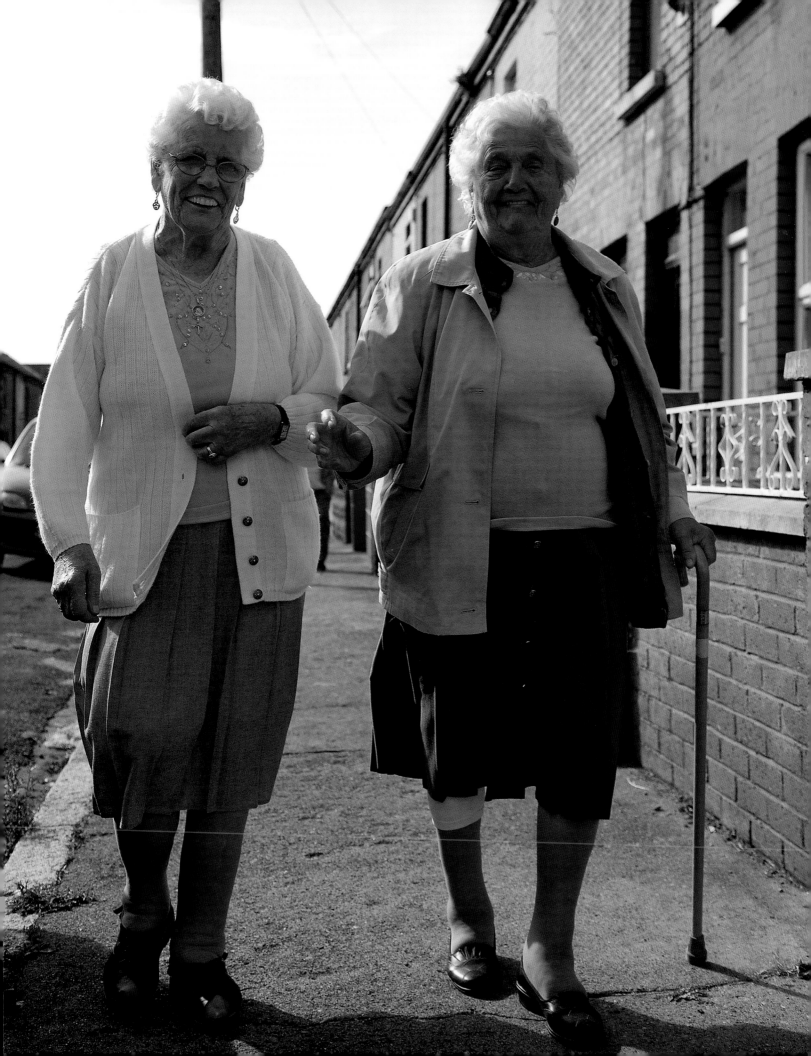

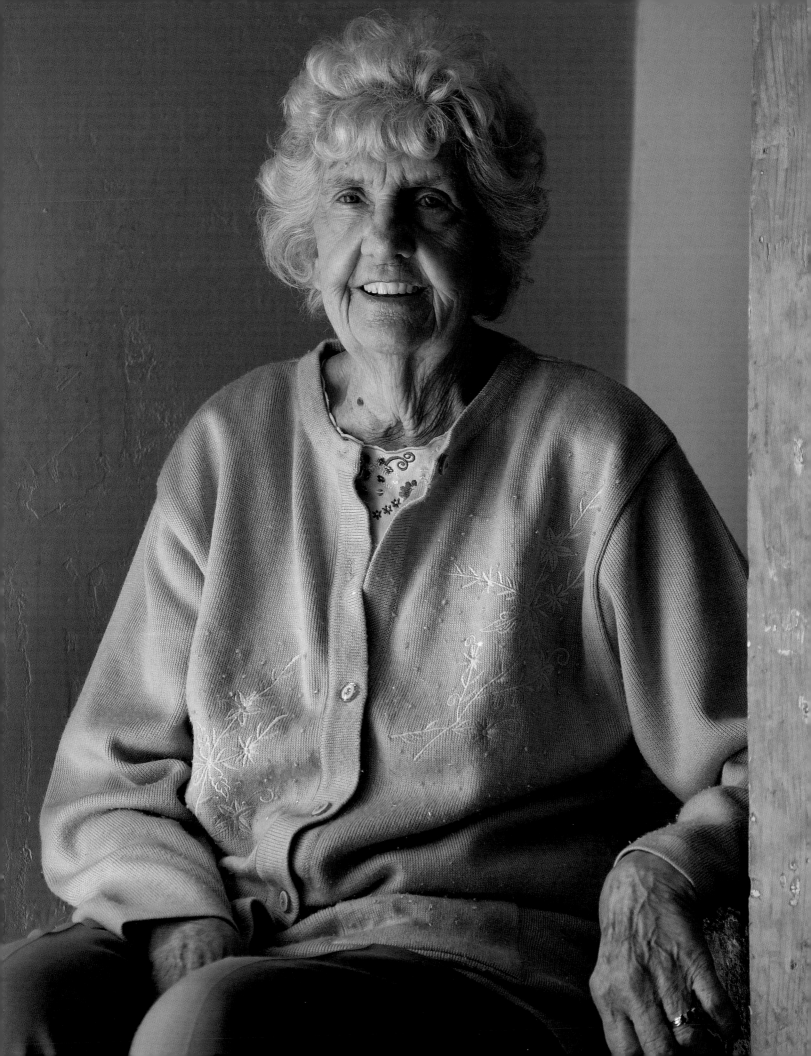

Jenny Cullen

Inchicore, Dublin City

Factory Worker

1925–2010

'You hear the young people say, "I'm going down to the village." That's what they call Inchicore. But I never knew it to be called "the Village" and I was born and reared here. It was like a village, but we called it "Inchicore".'

So opined the late Jenny Cullen, christened Jane, who was born on Nash Street in 1925. Her father was a railway man, as were her two brothers. They lived in a tenement house with a small plot of land to the rear, from where she could see over the wall as far as the Brickworks. Jenny and her three sisters went to the same school in Goldenbridge, where her friends Maureen Tierney and Mary Parkinson went. One of their teachers was a permanently suspicious creature. 'She'd ask what you had for breakfast, then look down your throat to see were you telling lies.'

After school, she walked to the Mono Containers factory on Jamestown Road where she spent over thirty years, working alongside Maureen, making containers for ice creams and yoghurts. After the ladies were made redundant in the early 1970s, Jenny found employment with Coopers (now Wellcome Ireland), boxing up pharmaceutical pills and medicines.

One of Jenny's icons was Lugs Brannigan, the no-nonsense garda detective who had once worked as a fitter on the Great Southern Railways with her brothers. Lugs had an unorthodox technique for maintaining order. When he found someone misbehaving, he banged their head off the nearest wall. Or if there were two or more of them, maybe he'd bang their heads together. And then the luckless miscreants would be sent on their way, without charge, but the message was loud and ringingly clear.

'It's a pity we haven't got a few more of him around now,' mused Jenny. 'Lugs was the only man who could keep order. He didn't like people hanging around in groups. But what he hated most was a woman being ill-treated.'

Other Dublin legends whom Jenny recalled included Tommy 'Bang Bang' Dudley, a cowboy aficionado famed for staging mock shootouts on trams and double-decker buses, the always heavily clad Johnny Forty-Coats and Kitty Ennis, who used to throw buckets of water over anyone who came too close to her house.

A woman of much gentility and sweet humour, Jenny unexpectedly passed away just a few months after these photos were taken.

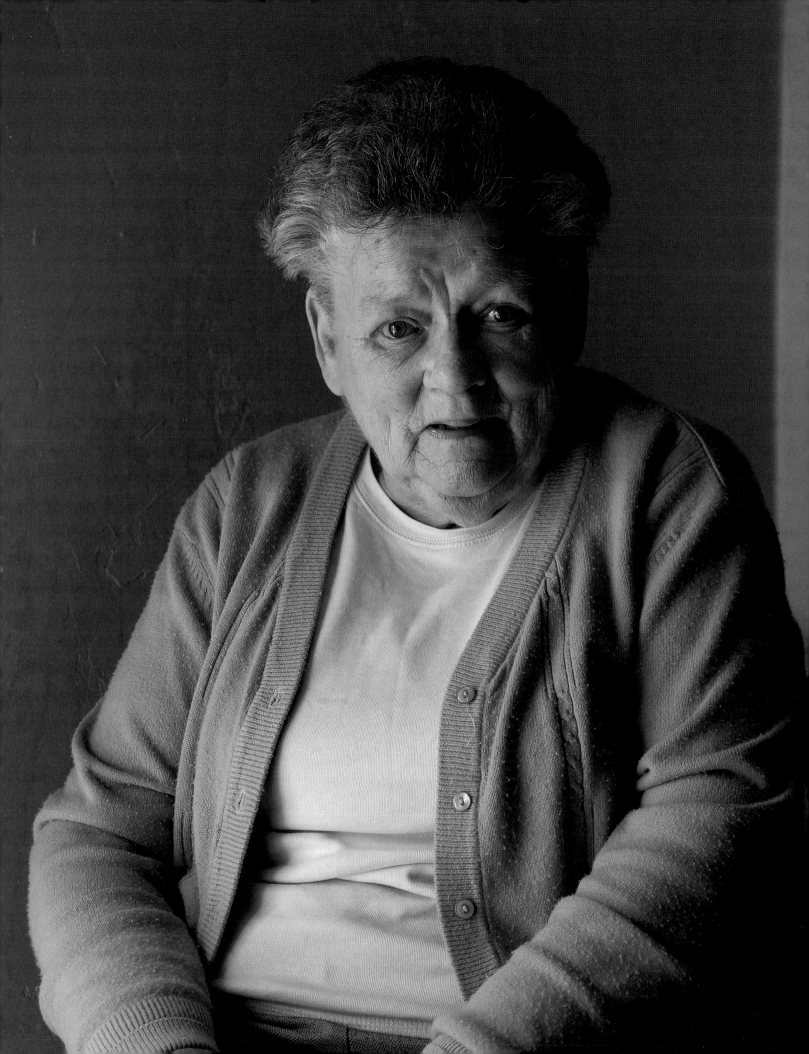

Mary Parkinson

Inchicore, Dublin City

Garment Manufacturer & Record Saleswoman

Born 1932

Mary Parkinson is the only one of the four Inchicore ladies in this book who married. She was born in the Marian Year of 1932, and named accordingly. In her younger years, she worked at Bull's religious depository at 21 Suffolk Street in Dublin. The company was established in the late Victorian Age by Cornelius Bull. His son was the inventor Lucien Bull CBE, who became the first man to record a million images per second in 1952. Bull's originally specialised in the manufacture of church furniture but, by the time Mary got there, she was employed to make priests' vestments.

Three years into her time at Bull's, a bout of peritoneal tuberculosis knocked her for six and she was unable to work for several years. She then found employment with a textile firm in Chapelizod, before crossing the Irish Sea and arriving in London bang on schedule to lap up some of the Swinging Sixties.

Mary was well placed to enjoy the musical storm that enveloped the world that decade, working in a record shop owned by a company called Electric and Musical Industries Ltd, which is rather better known by the acronym EMI. Boasting such acts as The Beatles, The Beach Boys, Frank Sinatra and Nat King Cole, EMI was the most successful recording company in the world during the 1960s.

After seven years in London, Mary returned to Dublin with an Irish husband. He was employed as a compositor with *The Irish Times*. 'He set up all the typing,' she explains. 'He had the rough job, as the fellow says, hand-setting the whole lot, getting all the fonts and print sizes right. He left just before the computers came.'

Mary reckons one of the greatest changes in Inchicore is the disappearance of the rivers. 'There used to be streams and rivers everywhere,' she says. 'I remember one down the back of Jamestown Court which we used to fall into all the time.' These ancient waterways are now all tucked away under roads, tenements and industrial warehouses.

Tenement life has also altered dramatically. 'There'd have been a lot of animals around here when I was young,' she says. 'You'd always hear the pigs squealing. There was an abattoir down by St Michael's Church. In the mornings, you would hear the cocks crowing. One of my neighbours had ducks that would go mad anytime it started raining.'

As well as being the youngest of the Inchicore ladies, Mary is the only one of the four who drives. 'The rest of us can only drive people around the bend,' adds Connie.

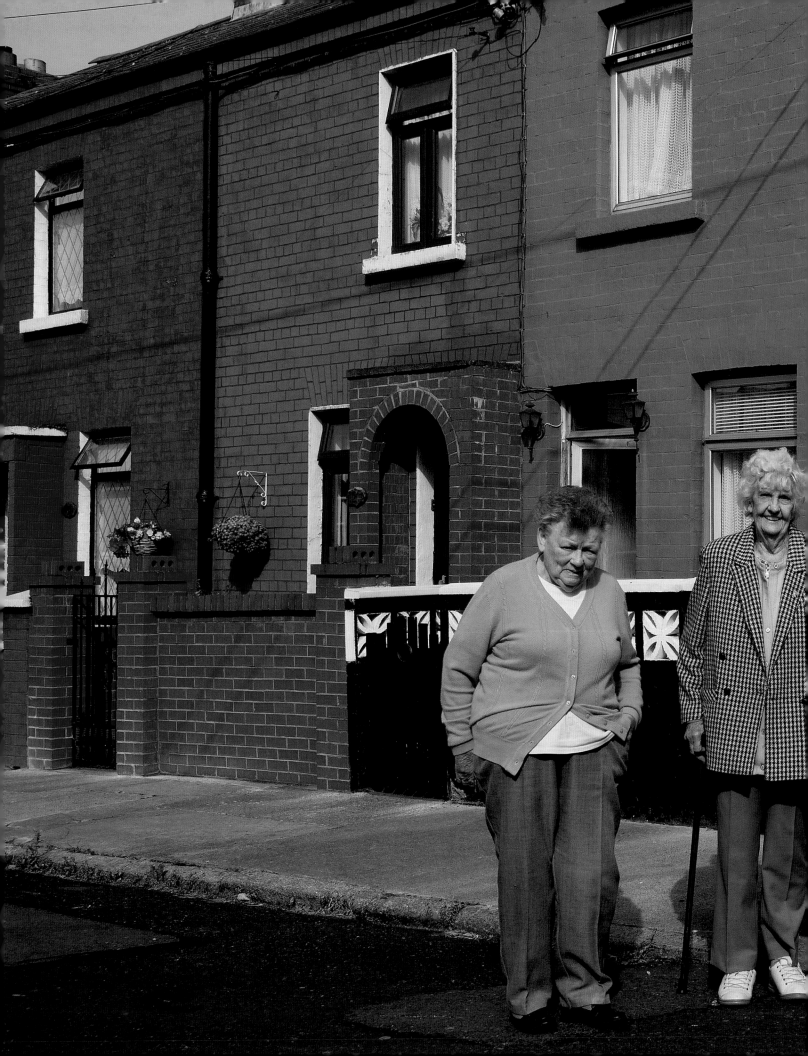

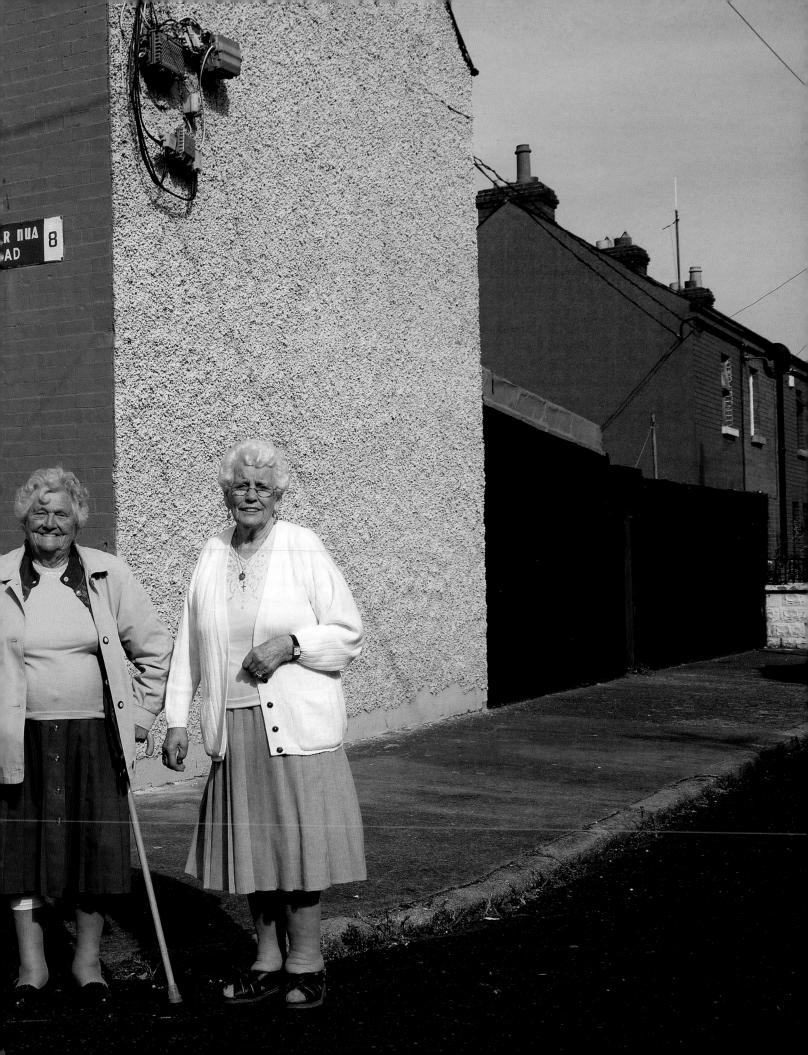

Acknowledgments

As always, there are a huge number of people who have helped us find, meet and talk to the characters in this volume, as well as those who have helped to promote the Vanishing Ireland project in wider fields.

We thank our beautiful wives Ally Bunbury and Joanna Fennell, and our increasingly adorable children – Bella, Jemima, Mimi, Bay and William.

We would particularly like to thank David Hasslacher, Eoghan Ryan, Bernard Stack, Katie Theasby, Cllr John McCartin, Jasper McCarthy (McCarthy's of Fethard), Sue Kilbracken, Mathew Forde, Miriam Moore, Lisnavagh House (www. lisnavagh.com), Marcus and Olga Williams (Errislannan), Josie Keany, Lisa Daly, Siobhan Cronin, Angela Delaney, Ben and Jessica Rathdonnell and *Nationwide*.

Thanks also to the following for help along the way: Betty Ashe (St Andrew's Resource Centre, Dublin), Henry Bauress, Denis Bergin, Bethany Nursing Home (Tyrrellspass), Owen Binchy, Alex and Daria Blackwell, Joanne Blennerhassett, Mike and Pooh Bolton, Patricia Bogue, Alice Boyle, Larry Breen, Ed Brennan, Frances Browne, Gill Browne, Siobhan Buchanan Johnson, Bay Bunbury, Clive Burgess, Edwin and Nora Burgess. Natalie Byrne, Seán Carberry (Ireland of the Welcomes), Claire McGovern (*Leitrim Observer*), Laura Coates (*Leinster Leader*), Vanessa Codd, Sile Coleman, John Colgan, Patrick Cooney, Mario Corrigan (Local Studies, Kildare Libraries), Jacinta Cotter, Julia Coyle (The Quay House), Cyril Cullen, Colette Cully, Ruth Cunney, Annette Daly, James Davitt, Wendy Deegan, Emma Deering, Hazel Dickinson, Deaglán de Paor, Tom Donovan, Lorraine Dormer, Eoghan Doyle (Kildare County Council), James Durney, Bruce Edwards, Rita Edwards, Annette Egan (and her mum), Caitriona Egan, Harry and Nicola Everard, Lorna Farrell (Moate Library), Lesley Fennell, William Fennell Jr., Alex Findlater, Marie Fitzgerald, Imelda Fox, Siobhán Garrigan, Joe Germaine, Trevor Gillespie, Keith Glasgow, Paul Gorry, Mary Claire Grealy, Sharon Greene-Douglas, Tom Halligan, John Hamrock, Declan Harte, Richard Hasslacher, Spencer and Fiona Hawkins, Olivia Hazell, Renate Helnwein, Lorna Hill, Lynn Hill, Shane Hogan (Areaman Productions), Jacqui Hynes, Philip Jacob, Emma Jeffcock, Arthur Johnson, Duncan and Lady Ana Johnson, Ted Johnson, Cecil Johnston, Philip Judge, Bernd Kaiser, Padraig Keaney (Gowla), Morgan Kavanagh, Jed Kelly, Connie Kelleher, Martin Kelly, Dave Kennedy. Róisín Kenny, Vinny Kenny, Marcella Corcoran Kennedy, Mary Kate Kenyon, Max Kulow, Yvonne Lane (Moate Museum and Historical Society), Quaker Library, Christina Lowry, Fiona McGrath, Johnny and Lucy Madden, Martina Maher, Des Marnane, Natasha Martin, Niall Martin, Mark McLoughlin, Helen McMahon, Nicholas McNicholas, Ella McSweeney (Ear to the Ground), Dr Marie Milner, Tessa Molloy, Joe Mooney, Lisa Moore, Seamie Moore, Leo Moran, Donnchadh Morgan, Christopher Moriarty (Friends Historical Library), Olive Morrin, Michael Mullally, Hugh and Sara Murphy, Vinny Murphy (McCarthy's of Fethard), Martina Neilan, Isabella Rose Nolan, Gearoid O'Brien, Lar O'Brien (Fr Murphy Heritage Centre, Boolavogue), Seán Ó Cearnaigh, Estelle O'Driscoll, Kay O'Leary, Thomas and Veronica O'Malley, John Onions, Mark Onions, Lucy O'Reilly (Kells Historical & Archaeological Society), Peter O'Reilly, Margaret O'Sullivan, Suzanne Pegley, Peg Prenderville, Chris and Ellie Pringle, Michael Purcell, Billy Quin, Tara Quirke, Charlie Raben, Michaela Raben, Lar Redmond, Mervyn Richardson, Claire Roche, Eibhlin Roche (Guinness Archives), Jonah Roche, Jack Rogers, Maggie Ryan, Dr Andrew Rynne, Padraig and Cait Seoighe, Ann Marie Sheehan, Jessica Slingsby, Aoife Smithwick, Thalia Smithwick O'Brien, Ercus Stewart SC, Tim Supple, Kieran Swords, Tom and Sasha Sykes, Stephen Talbot, Jim Tancred, Lorraine Teevan, Phonsie Ware, John Ward, Lorraine Ward, Meriel White, Guy Williams, Reg Youster (Kildare. ie), Zetland Country House.